35⁰⁰

D0744593

DISCARDED
Richmond Public Library

An Artist against the Third Reich

Ernst Barlach, 1933–1938

The conflict between Ernst Barlach, the most important German sculptor of the time, and the Third Reich is a remarkable episode in Hitler's war against modern art. Rather than accept repression passively, Barlach denounced the confiscation and destruction of his work as ideologically inspired and continued on his independent course. The author's discussion of Barlach's art and of his insistence on creative freedom is joined to an analysis of his opponents' motives and tactics. Hitler's ill-informed rantings against modernism in German art were nevertheless an internally consistent and politically effective critique of liberal culture. That despite Hitler's strictures some National Socialists advocated a "Nordic modernism" and tried to win Barlach to their cause exemplifies the cultural crosscurrents running through the Third Reich. Peter Paret's closely focused study of an artist in a time of crisis seamlessly combines the history of modern Germany and the history of modern art.

Peter Paret is Mellon Professor in the Humanities Emeritus of the Institute for Advanced Study in Princeton and Spruance Professor of International History Emeritus of Stanford University. He is a Fellow of the American Academy of Arts and Sciences, a member of the American Philosophical Society, and recipient of the Society's Thomas Jefferson Medal. The German government has awarded him the Officer's Cross of the Order of Merit. His research is divided between two fields: the role of war in history, on which, among other works, he has written the well-known intellectual biography *Clausewitz and the State* (1976); and the relationship between art and society. He is the author of *The Berlin Secession: Modernism and Its Enemies in Imperial Germany* (1980); a study of the decline of German liberalism as seen through art, *Art as History* (1988); and a collection of essays, *German Encounters with Modernism, 1840–1945* (2001). He combined his two areas of research in *Imagined Battles: Reflections of War in European Art* (1997).

An Artist against the Third Reich

Ernst Barlach, 1933–1938

PETER PARET

Institute for Advanced Study, Princeton

CAMBRIDGE
UNIVERSITY PRESS

31143007049506
700.92 Par
Paret, Peter.
An artist against the
Third Reich : Ernst
Barlach, 1933-1938

PUBLISHED BY THE PRESS SYNDICATE OF THE UNIVERSITY OF CAMBRIDGE
The Pitt Building, Trumpington Street, Cambridge, United Kingdom

CAMBRIDGE UNIVERSITY PRESS
The Edinburgh Building, Cambridge CB2 2RU, UK
40 West 20th Street, New York, NY 10011-4211, USA
477 Williamstown Road, Port Melbourne, VIC 3207, Australia
Ruiz de Alarcón 13, 28014 Madrid, Spain
Dock House, The Waterfront, Cape Town 8001, South Africa

http://www.cambridge.org

© Peter Paret 2003

This book is in copyright. Subject to statutory exception
and to the provisions of relevant collective licensing agreements,
no reproduction of any part may take place without
the written permission of Cambridge University Press.

First published 2003

Printed in the United States of America

Typefaces Janson Text 11/16 pt. *and* Berliner Grotesk *System* LATEX 2$_\varepsilon$ [TB]

A catalog record for this book is available from the British Library.

Library of Congress Cataloging in Publication Data

Paret, Peter.
An artist against the Third Reich : Ernst Barlach, 1933–1938 / Peter Paret.
 p. cm.
Includes bibliographical references and index.
ISBN 0-521-82138-x (hardback)
1. Barlach, Ernst, 1870–1938. 2. National socialism and art. 3. Germany – Politics
and government – 1933–1945. 4. Modernism (Art) – Germany. I. Title.
N6888.B35 P37 2002
700′.92–dc21 2002073616

ISBN 0 521 82138 x hardback

Those who created the Third Reich [will] determine not only its political but also its cultural development.

 – Adolf Hitler, speech at the Reich party rally, 1934

Nothing can be more certain than that art is not subject to the strictures of a political view of the world.

 – Ernst Barlach to the sculptor Adolf Wamper, 1934

Contents

Illustrations

The illustrations follow p. 192. Height, width, and depth in millimeters.

Acknowledgments

I should like to express my gratitude to the Ernst Barlach Stiftung in Güstrow, to its director, Volker Probst, for making the foundation's archive available to me, and to Helga Thieme, senior staff member, who with unfailing kindness assisted me at every stage of this work. For help in obtaining National Socialist publications and newspapers, I thank my former student, Donald Abenheim, now at the Naval Post-Graduate School in Monterey, and Elena Danielson, director of the Hoover Institution Archive of Stanford University.

Four colleagues took time from their own work to read the manuscript and give me the benefits of their criticism: Beth Irwin Lewis of The College of Wooster, Christopher Browning of the University of North Carolina at Chapel Hill, J. Lionel Gossman of Princeton University, and my son Paul of the University of Connecticut at Storrs. I am greatly in their debt. I must also thank the two anonymous scholars – a happy accident revealed the identity of one of them – for the helpful comments and

queries contained in their evaluations of the manuscript for the publisher.

For permission to reproduce works of Barlach and a bronze by Käthe Kollwitz, I thank the Ernst und Hans Barlach GbR Lizenzverwaltung Ratzeburg, and the other institutions and individuals named in the List of Illustrations. I owe thanks to the Institute for Advanced Study for making funds available to cover the cost of the illustrations, and to Terrie Bramley of the School of Historical Studies at the Institute, who as often before was a great and dependable help in preparing the text.

Finally, I want to express my appreciation to Cambridge University Press in New York – to Alan Gold, senior production controller, who designed the book; and to four editors with whom I worked before: Beatrice Rehl, Senior Editor, Arts and Classics, who suggested that I submit the manuscript to the Press; Susan Greenberg, for editing the text carefully and with empathy; and Camilla T. Knapp, production editor, and Lewis Bateman, Senior Editor for Political Science and History, who guided text and illustrations through the Press without losing sight of the whole over masses of detail.

The book itself expresses, however inadequately, my gratitude to my parents for introducing me to Barlach's work – my mother, who as a young woman saw his first one-man show; and my father, whom Barlach, in a letter of 1936, agreeably apostrophized as "Philosopher and Swabian."

Introduction

Ernst Barlach's art, and the difficulties it caused him after January 1933, are mere details in the history of National Socialist Germany. In the history of twentieth-century art, on the contrary, his sculptures of 1933 and later, among them some of his most powerful figures, occupy an assured place. His literary work – he published his first play in 1912 – had slowed somewhat by the time Hitler gained power; a novel, *The Stolen Moon*, remained unfinished. But in essays and in his extensive correspondence with artists and others who sought him out as the dictatorship took hold, his reflections on art and its place in a degraded society rose to new levels of expressiveness. In Barlach's life, finally, his years in the Third Reich, which were also his last years, were discordant and tragic.

That Barlach's work became an issue for the cultural leadership of the Reich lent it a measure, however circumscribed, of political significance. To the regime's claim of control over the arts, Barlach responded by asserting, in statements and through his work, his

freedom to sculpt as he chose. His declarations of artistic independence took courage and heartened a few artists and members of the public; but inevitably, their resonance was limited. Barlach's intransigence might trouble officials, his work shown in a gallery or reproduced in a catalogue or book could reveal the hollowness of state-sponsored art and open a chink in the compact front bonding people, party, and Führer; but neither Barlach nor any other artist posed problems that the party and the police could not readily master.

If, nevertheless, National Socialism paid constant and anxious attention to the arts, and endowed them with a symbolic significance that the German people was never allowed to forget, it was for two reasons: the regime's insistence on uniform obedience to stated and even implied policy in public and private life; and the political and personal meaning that the arts possessed for Hitler. It was largely his doing that in the political conflicts leading to the Third Reich, the arts – and none more so than painting and sculpture – were used to identify the political and racial enemies of German resurgence. After Hitler became chancellor, he tried to shape the arts into a defining force of the new Germany. As the Reich head of press affairs, Otto Dietrich, warned a journalist who was planning to write on cultural matters: "Just because of the Führer's interest in the fine arts, the greatest possible caution is indicated in one's formulations."[1] But Hitler also knew that the arts were no more than auxiliaries in the political wars. Artists might persuade or confuse – they were not a power in their own right.

Barlach would have agreed. In a response to right-wing denunciations of his person and his sculpture in the 1920s, he described himself and artists in general only somewhat ironically as a "sliver," shaved off by vast forces of cultural and political change,

"a crumbling bit of nothingness, caught between earthquakes and torrents of lava."[2] But the same essay, in which he draws this apocalyptic image of disjunction and isolation, also demonstrates the close connection of the artist and his environment. The larger world, which rarely concerns itself with aesthetic matters, was after all sufficiently interested in Barlach's art to attack it; and he, in turn, responded with considerable energy. Although his work was not intentionally political, it marked some of the major issues in Weimar politics. In particular, his war memorials were drawn into party conflicts over the legacy of the World War. The confrontation of the artist with his critics reveals much about both.

That is also true of Barlach's relations with the Third Reich: of his rejection of its values and his efforts to work in the face of interference and hostility, and of the attempts of some National Socialists to silence him, while others tried to win him over to their cause. That men at the highest levels of the regime condemned Barlach for betraying his German heritage by creating art that polluted German culture, is typical of the brutality – intellectual no less than physical – that characterized National Socialism. The specific leads back to the general. Barlach's life and work bear on German history as the country passed from republic to Third Reich and moved toward war and extermination; the impact of National Socialism on Barlach, and his reactions to it, are of consequence to his biography and to the history of modern art.

1

Hitler

When Hitler became chancellor of the Reich in January 1933, and the National Socialist revolution began to bend the machinery of the German state into instruments of intimidation and repression, Ernst Barlach was among the artists who expected difficulties in the times ahead. "We feel we are sitting on a volcano," he wrote to a friend as the republic was dying. "The nationalist terror will probably outlast me . . . storm signals everywhere."[1] In the years immediately preceding, several of his sculptures had become targets of nationalist criticism; pressure from right-wing organizations led to the cancellation of a publicly funded project; in 1931 National Socialists protested his design for a war memorial in Hamburg. The objectors, who did not hesitate to deface one of his monuments, were motivated in part by the message his work conveyed, or was thought to convey, in part by its stylistic characteristics. Public opinion on the right condemned him as a modernist, whose work revealed an offensively un-German spirit. That Barlach also wrote plays, which were respectfully received

by the avant-garde, added to the image of an artist who rejected native values and veered into alien realms.

Official interference with his work came gradually. As the regime consolidated its power and started on the road to radicalization the pressures on Barlach increased. He experienced neither physical violence nor imprisonment, and even in the regime's early years many people were treated worse than he. But attacks on his work by party leaders and denunciations in the press intimidated some of his public. Agreements to exhibit his sculpture and to stage his plays were broken, and he soon learned that the protection of the law against violating contracts and publishing false charges no longer applied. In time, matters became worse.

To understand Barlach's situation, and the conflict with the leaders and cultural functionaries of the Third Reich to which it led, it is necessary to look at both sides: Barlach's personality, and his life and work before 1933 on the one hand, the motivation and methods of his opponents on the other; at his efforts to achieve clarity in his work, in the face of a coercive system that used myth and densely circular reasoning to justify repression.

Because Barlach was not a Jew and had not been politically active in the Weimar Republic, the new men in power might have shrugged him off as an unimportant survivor of an earlier age had Hitler not attributed deep ideological meaning to the arts. In particular, he regarded modernism in painting and sculpture – which to him meant any significant departure from conventionally perceived reality, other than its idealization – as a virus that not only metaphorically but in reality attacked the racial substance of the German people. The republic had betrayed Germany's true values; National Socialism would restore them. Hitler's interest in the arts, far from being a marginal luxury he permitted

himself, touched the core of his politics and demanded political expression.

By the 1920s, when he was writing *Mein Kampf* after the failed Munich putsch, Hitler had fused the ideas of his adolescence and early maturity into a world view that despite its delusions and historical absurdities became a powerful political weapon. Its comprehensiveness matched the grandiose scale of his ambitions. Repeated assurances of his respect for the law notwithstanding, he did not think or act like other politicians, who promote themselves in association with a particular program or interest, but pursued unlimited power to reshape a country and society, which otherwise, he claimed, the immutable laws of history condemned to ruin. These laws centered on two poles: race and conflict. Race made conflict inevitable and spread it to every area of human activity. Conflict gave race its deepest meaning, that of the struggle between good and evil.

Races formed at the dawn of time with qualities and values that became unchanging, Hitler declared in an early speech, the main points of which he was to repeat in countless variations for the rest of his life.[2] If a race possessed certain qualities, which are transmitted to the individual through his blood, it could create a state with which to defend itself against competitors and enemies. "On the other hand, a race that lacks these qualities must be destructive of races and states, whether the individual is good or evil."[3] But the power of the state rested not only on military and economic strength, it was also dependent on the cultural potency of society. In gray prehistory, the Nordic races, "which we designate as Aryan," founded "all subsequent high cultures.... We know that Egypt was raised to its cultural heights by Aryan settlers, as were Persia and Greece. The settlers were blond, blue-eyed Aryans, and we know that apart from these states no other cultural

states were founded anywhere on earth." Inferior and mixed races, and most of all the Jews, were unable to develop "independent, great, creative cultural states."[4] Over many centuries the Jews were nomads, scattered as parasites among superior races across the globe. But their rootlessness made them an international power. Their loyalty is attached to a borderless nonstate, the survival of which places all other states and races in mortal danger. They corrupt the social and cultural values of those among whom they live, dilute their racial substance, subvert their institutions, and destroy their energy. Everywhere the life force of the superior race is threatened by its malignant counterforce, the Jews, whose destructive work gains support from mongrel races across the world.

This scheme of history, cobbled together from scraps of nineteenth-century racial theses, Gobineau's identification of Greeks as Aryans, and social Darwinism, summed up for Hitler the timeless truths of society and politics and provided the basis for his analysis of the condition of Germany after the lost world war. In the age-old division between racial good and evil that he proclaimed, Germans were victims. For over two thousand years their neighbors had divided them politically and weakened them with infusions of alien blood. The betrayal of the army in 1918 by Marxists and cowards and the imposition of a republic were only the latest steps in a long process of corruption. Yet the country's Aryan core persisted. Eliminating the Jews from German life would bring about its regeneration. Restoring their racial purity would turn the Germans and their national community into a true *Volksgemeinschaft*, which is also a *Kampfgemeinschaft* – a community of warriors. Its historic task was to conquer land in Eastern Europe and Russia so that the German people could survive and grow. The twin processes of healing the race and expanding its

territory would succeed if Germany entrusted itself to a leader who was prepared to wage war against the internal enemy as well as against foreign rivals. He would lead National Socialism to power, purify and reeducate society, and forge the nation into a weapon that ensured German permanence in the world.

It indicates the confusion and moral dislocations agitating Central Europe after the war, that many Germans could welcome or at least tolerate these fantasies on the course of world history. Once taken as fact or as metaphoric summaries of basic historical phenomena, Hitler's shopworn but for that reason familiar racial delusions coalesced into a consequential sequence, stretching from past to present and future. His message was infused with new, unusual energy because he linked his definition of politics as racial conflict to the promise – which always superseded his assurances of legality – that political power in Germany could be achieved by revolutionary, violent means. That this, at least, was not verbiage, but an article of faith on which Hitler and his followers acted, was demonstrated by storm troopers' beating up critics at party rallies, the murder of political opponents, and the attempted putsch in Munich, which resulted in the martyrdom of fallen party members, as well as other symbols: the "blood banner" carried at the head of the demonstration, and the "blood medal" awarded to surviving marchers, symbols on which National Socialism fed until its last days.

Hitler's emphasis on the "cultural state" in his enumeration of the main political forces in world history again points to his association of art and politics. No doubt, the bonding of culture and the state was a rhetorical device. It gave his message of power politics an impressive idealistic sheen. But Hitler's habitual references to high culture in politics, and as politics, also reflected the ideas of the rebellious adolescent and failed art student, who had sought

the drama of ruler and ruled, of force and betrayal, in works of art. Not every powerful state is a cultural state, he taught his listeners and readers; but even a state that shielded a superior race would not survive unless it nurtured a culture that reflected the character of the race. He saw culture both as an indicator of a people's racial health and – if it expressed the true qualities of the race – as its stimulus. A political benefit accrued: Culture and the arts could raise a people's energy and vitality. Consequently, he concluded in his already cited speech of August 1920, the Jew's efforts to destroy German culture were particularly dangerous: "We know what he has done in art, how painting today is a travesty of everything we call genuine feeling."[5] He continued with comparisons drawn from the media of his deepest sympathies, sculpture and music: "Do we really believe," he asked, referring to a sculpture by Max Klinger, surrounded by Gustav Klimt's murals, which had been the centerpiece of the famous 1902 exhibition of the Vienna Secession, "that, for instance, Klinger's statue of Beethoven doesn't reflect an inner experience and true feeling, or that a Beethoven symphony isn't also a reflection of an inner experience, a genuine inner experience, in contrast to the other kind, which is superficial and fraudulent, and put on this earth for the purpose of gradually eradicating healthy attitudes, and of gradually whipping people into a state in which no one knows whether the environment is mad or he."[6] An odd technique, one may think, to arouse a mob in a beer hall by imputing mythic political values to a classical symphony and a modern, multimaterial, polychrome sculpture. The immediate impact of Hitler's words may be doubted; not so their deep meaning to the speaker, for whom Klinger's *Beethoven* and its carefully modulated setting were forerunners of the total design centered on the great man that in later years was to mark his public appearances.

As was true of much of his ideology, the meaning Hitler gave to the "cultural state" perverted, by way of his reading of nationalist and racist texts, a concept of German idealist and romantic philosophy. But not all his adaptations falsified the original. Not only did he find the splendor and theatricality he craved in Wagner's operas, he embraced an inescapable message in their texts. Wagner the dramatist traced human conflict in terms of black and white, shaded by the betrayal and self-betrayal of the pure. To the antagonists of the good and honorable he repeatedly gave traits drawn from the classic arsenal of anti-Semitism: Alberich, cursed by his lust for gold; Beckmesser, originally named after a hostile music critic of partly Jewish ancestry, who not only steals the composition of a noble German but makes love to a gentile maiden; the dark seductress Kundry, at last saved from an evil yet self-tortured existence, but only at the cost of her life. Wagner's racist fantasies were given further resonance by his anti-Semitic tracts, which called for the elimination of Jews from Germany – although the composer's violent vocabulary aimed at conversion and assimilation rather than annihilation. Wagner's anti-Semitism supported Hitler's belief in a racial divide, just as his genius confirmed Hitler's sense of Germany's subsequent cultural decline.

When Hitler met Winifred Wagner, the composer's daughter-in-law – psychologically his most significant encounter with a member of the conservative cultural elite – the aesthetic and political affinities in his thinking took on tangible, personal form. The first meeting soon expanded into a strangely intimate relationship between "Uncle Adolf" and the Wagner family. Winifred remained a frank admirer even after 1945. Through her, Hitler met both the prophet of resurgent Germanness, Houston Stewart Chamberlain, who had married Richard Wagner's daughter, Eva

von Bülow, and another fanatically nationalist relative, Wagner's stepdaughter Daniela. In 1905 Daniela's husband, the art historian Henry Thode, had delivered a series of public lectures at the University of Heidelberg, in which he proclaimed a contemporary art of innately Teutonic character and branded the work of the most prominent German-Jewish painter of the time, Max Liebermann, as derivative and un-German.[7] Thode's lectures, which attracted a large audience, were an important step in the process of lending intellectual respectability to the increasingly virulent anti-Semitism of the Wilhelmine age. After the collapse of the empire, Liebermann was elected president of the Prussian Academy of Arts, and in this prominent position personified to the right the Weimar Republic's surrender to Jews.

After the First World War Hitler sought in vain for an artist in any medium who towered over Germany as Wagner had. He felt that even lesser nineteenth-century figures, the south-German genre- and portrait painters whom he particularly liked – including such talented, serious artists as Carl Spitzweg and Wilhelm Leibl – had no successors of comparable ability. What he took to be the mediocrity of the artists of his own generation – especially painters, even those who had not been infected by international modernism – indicated to Hitler how deeply German art was wounded. But as the artists who had gone over to the modernist enemy became fashionable, and their works began to be bought by the state museums, both became useful targets for opponents of the republic. Expressionist and cubist paintings that outraged the "natural way of seeing," figurative works by Otto Dix and George Grosz that denied the grandeur of war and of patriotic sacrifice, the right saw as evidence – often more telling than statistics or fine ideological distinctions – of the abyss separating the republic from the feelings and beliefs of decent Germans. For

Hitler these were daubs that perverted the twin ideals of art: noble or pleasing realism, and service to the state. Each corrupt work was a bacillus carrying the pestilence that was enveloping the country. In their aggregate, and in their impressive physicality, they revealed the depth of decadence to which Weimar Germany had fallen.

In the war for political power, the attack on modernism was an appealing strategy. It could build on the dislike or suspicion of modern art that had a long history in Germany. Perhaps nowhere was modernism in art and design as widely accepted as in Germany, and nowhere was it as strongly opposed and turned into a political issue. Hitler never clearly defined the substance of modernism, as he saw it. But his many references to art in speeches from the early 1920s to the Second World War, and in his monologues and "table talks," allow a reconstruction. Modernism denied the value of a recognizable, if idealized, transfer of reality from life to canvas or to sculptured stone or bronze. It accepted distortion and abstraction. It was driven by belief in change, by the movement from one style to another, by the denial of a permanent standard, which in the fine arts reflected the absolute good and bad on opposing sides of the racial divide that shaped the real world. Finally, modernism rejected any appeal to the values and particular experiences of the German people. Its source and motivation were international; it was a stateless art, silent about what was specifically German, or driven by hatred of Germany. Modernism confused rather than clarified; it threatened the link between a healthy people and its leaders, and it did so as a conscious or an unknowing tool of the Jewish drive for world disruption and domination.

Hitler's deeply emotional attacks on the varieties of modernism – and in his eyes incessant variety was one of modernism's worst sins – are easily dismissed as the ranting of a

half-educated fanatic. They were that, but with all their absurdities they were also a consequential element in his critique of Western liberal culture and politics. The heterogeneity and diversity of modernism, the new forms it constantly assumed, reflected an open society, in which people determined their own values. The muddle and conflicts to which this led offended Hitler's need for unanimity, for the disciplined subjection of all to one vision and one will. The dangers that internal differences posed to Germany were exacerbated in his mind by the presence of an alien race that derived its vast power from sources throughout the world.

In his speeches and in *Mein Kampf*, Hitler used the arts to make tangible the racial conflicts that he saw lurking behind the political tragedies of German history. "The Jew is nothing but a destroyer of culture," he declared in 1922. "He never possessed a culture of his own, just as he never possessed idealism. He ruins a people's culture in order to destroy the nation."[8] At the time of his first meeting with Winifred Wagner, Hitler equated what he declared to be the greatest achievement in the arts since the Middle Ages with the ethnicity of its theme: "The artist Richard Wagner impresses us as great because in all his works he depicted a heroic people in its Germanness."[9] In earlier speeches he had already formulated the basic definition: "Everything great is national." Every true artist's work was inspired by the spirit and attitudes of his nation, the protective political shell that encased the race. Only the Jew had no nation. And since he lived as an alien among other peoples, "he falsifies the spirit . . . of these peoples – in particular of the German people." "National" art – its nature and substance left undefined – was a source of strength; "international" art, whether created by foreigners or by their native dupes, was a source of weakness, most effectively exploited by the "international people," the Jews. From this it followed, according to Hitler, "that

in art and science everything international is nothing but kitsch."
Because art that expresses international values does not originate
in national culture it cannot represent genuine ideals; at most it
stands for the Jewish goal of national destruction. "One need only
look at the so-called art of the cubists, futurists, etc., to recog-
nize immediately that it is the corruption of art through the alien
Jewish spirit."[10]

Basic to these assertions is the concept of race, which for Hitler
not only marked ethnic differences but also was the ultimate in-
dicator of superiority and inferiority. He believed in the scale of
racial value, and he also knew that to make the abstraction of
race a politically effective weapon some people must be identi-
fied as racially inferior. In turn, their racial categorization jus-
tified already existing antagonisms toward inferior groups – not
least Hitler's own antagonism toward the Jews, which by the time
he was twenty was "total, implacable, and uncompromising."[11]
The antithesis of the inferior but dangerously destructive Jew was
the German, who in Hitler's early speeches often stood for other
strands of the Aryan race as well. They create their own cultures,
which differ from German culture, but they also obey healthy
historical imperatives. The affinities of the superior races were
greater than their differences.

German cultural and political self-determination was threat-
ened by inferior races. Coexistence and assimilation weaken the
superior race. The Jews especially were not only inferior, they
were also driven by aggressive intent. Culture was one of their
weapons; they manipulated it as they manipulated international
finance or corrupted the institutions of democratic states. In the
fight to regain German autonomy, art was one of the elements
that influenced people's feelings and judgment. A work of art may
seem apolitical, but the artist seeks a public and therefore the

work's theme and execution take on political significance. For the politician, the arts possessed additional importance as symbols of political issues and conflicts. To protect Germans against false values required uniform, consistent definitions of the healthy and the corrupt in art as much as in other forms of expression. Techniques and styles of art change over time, but genuine art is always grounded in native sources, which reflect unchanging values. Consequently art based on international concepts is unhealthy and false, as is a rapid succession of styles, which substitutes fashion for permanency – an argument that makes modernism, whether international or national, unacceptable. The passages on culture in Hitler's speeches reiterate two themes – both inherent in National Socialist ideology: the political importance of culture, and the Jewish threat to German culture, which is one more reason for identifying the Jew as Germany's great enemy.

Even sceptics who rejected the assumptions on which these and similar assertions were based could be impressed with a politician who took art and culture seriously enough to find in their modern development and in what he regarded as its deformations both cause and evidence for the misery that had befallen the country. The speaker's verbal violence that generally followed on his initial gravitas might be justified by his sense that the German way of life was threatened. But although Hitler named the threats, he often left their particulars and his intended countermeasures unstated. Were the Jewish despoilers of German culture recent immigrants from Poland and Russia, or Germans with one Jewish great-grandfather? What was the precise meaning of "international" and of the expansive "etc." following on "cubists" and "futurists"? These matters were left to later definition. As has been noted, apart from a few principal demands, the party's program and the methods of its political tactics before 1933 were impenetrable and

unpredictable.[12] Hitler understood that it was premature to be too specific, although on some matters concerning cultural policies his vagueness continued for a time even after he became chancellor. But his unwillingness to enter into details also took account of the fact that the party's views on art had not yet fully coalesced.

Most of the senior party leaders did not share Hitler's interest in the arts. For some, cultural issues possessed meaning only so far as they provided them with an opportunity to strike at the opposition. Typical was Friedrich Hildebrandt, who rose from farm laborer to head the party in the state of Mecklenburg and after Hitler became chancellor was among the first to teach Barlach what to expect in the new Germany. Others, like Wilhelm Frick, the future Reich minister of the interior, had received a university education but relied on advisors in an area in which they took only a casual interest.[13] Only a few of the "old fighters" were truly engaged in the arts, the later Reich youth leader, Baldur von Schirach, for one, who as governor of Vienna during the war angered Hitler by supporting an exhibition of artists whose work could no longer be shown in Germany. Of greater importance were two men whose mutual antagonism was reinforced by the opposite positions they took on art and its place in the National Socialist movement: Joseph Goebbels and Alfred Rosenberg.

Goebbels was not unreceptive to modern art. In 1924, after walking through the modern collection of the Wallraf-Richartz-Museum in Cologne, he noted in his diary that he had seen much that was worthless, but also a few good things: paintings by Max Slevogt, a leading representative of what is sometimes called German impressionism, van Gogh, Nolde, and Böcklin. Above all, Goebbels wrote, he was "gripped by a sculpture, Barlach's *The Berserker* [Fig. 4]. The true spirit of expressionism! Brevity raised to the level of grandiose interpretation" – a reading of the complex

figure that its creator would have dismissed with a shrug.[14] Nine years later, after the National Socialist takeover, his diary refers obscurely to a conflict between or over artists, and, Goebbels adds: "Is Nolde a bolshevik or a painter? Theme for a dissertation."[15] But he took care to keep his opinions to himself and to some intimates. Only Jewish artists, in whatever style they worked, provoked his blanket rejection. After he became the party's leader in Berlin in 1926, his newspaper *Der Angriff* directed paroxysms of rage and ridicule at Max Liebermann and his "co-religionists."

Rosenberg, who saw himself as the party's foreign policy expert and its chief ideologue, followed a more consistent but politically less astute line. In 1929 he founded the Kampfbund für deutsche Kultur – League for German Culture – which worked to alert the public to "the links between race, art, science, and the ethical and soldierly virtues."[16] After the war, as he awaited sentencing from the war crimes tribunal in Nürnberg, Rosenberg said more plainly that the league's mission in the war against modern art, much of which he regarded as a fraud perpetrated by Jewish art dealers, "was to arouse the conscience of creators and supporters of art against the flood of degeneracy spreading from Berlin" – words that linked the government of the republic and the art galleries of its capital as the common enemy.[17] Although organized with National Socialist support, the league pretended autonomy. Its sponsors included a number of reputable academics – notably the art historian Heinrich Wölfflin – some of whom distanced themselves again when the offensive character of the league became apparent, and an array of eugenic aesthetes and racial mystics. Its most sophisticated members stretched their tolerance for modernism as far as the more subdued works of early impressionism. But their true loyalty lay with the German romantics and realists, and to such more recent successors as Böcklin, Leibl, and

Thoma – artists whose work, it was hoped, would inspire the present generation of German artists to advance toward a nativist art, but one that was more assertively patriotic than its nineteenth-century predecessors. After Hitler became chancellor, Rosenberg expected the league to be taken into the party as the ideological guardian of German art. Its senior officials were given appointments in various ministries, but the league was never fully integrated into the new system, and it quietly disbanded in 1937. Its leader remained free to issue as many inflammatory comments on the arts in Germany as he wished.

In the years leading up to the victory of National Socialism, and for some time afterwards, Rosenberg and Goebbels personified two extremes in the party's perception and evaluation of modernism. Where Hitler stood was not as self-evident as his speeches might suggest. He denied the validity of modernism, which he contrasted with racially timeless concepts of representation. But he was also scathing about those who, like many of Rosenberg's followers, longed to return to the art of the early and mid-nineteenth-century romantics, an art that might accommodate personal tempests and passions, but generally remained in the shelter of idyllic bourgeois passivity. Hitler instead called for an art that celebrated the drama of National Socialist struggle and triumph. Somehow, the aesthetics of the great Renaissance masters, whether German or foreign – the Dürers and Titians – had to be combined with the values of a disciplined, combative mass movement. The finality of Hitler's judgment on what art was appropriate for the new Germany was never in doubt, but as long as his speeches were not followed by program proposals, or, after January 1933, by specific policies, an area of uncertainty remained, which could offer scope to a variety of stylistic directions.

In the Reichstag elections of 1928 the National Socialists were still a splinter party, winning only a little over 2.5 percent of the vote. Two years later, helped by the continuing paralysis of the major parties and the deepening economic crisis, the movement gained over 18 percent, a result that rose beyond 37 percent in the Reichstag elections of July 1932. The inclusion at the end of 1929 of National Socialists in a coalition government of the state of Thuringia signaled the party's increasing power. Hitler's associate in the Munich putsch, Wilhelm Frick, was placed in charge of the state's departments of the interior and education. Goebbels gloated that the party would now teach people the meaning of ruthless activism.[18] Frick and his National Socialist and radical conservative advisors, among them such populist fanatics as Paul Schultze-Naumburg of Rosenberg's league, reorganized the school system and such institutions of higher education as the successor academy of the Bauhaus, replaced faculty, censored books and films, and removed from the Weimar museum works by Barlach and others that did not express the "Nordic-Germanic" spirit. The reform measures included the effacement by coats of whitewash of Oskar Schlemmer's elegantly abstract wall paintings in the stairwell of the Staatliche Bauhochschule in Weimar and the removal of his reliefs from the hallways. The destruction of his work and the purification of the museum puzzled the artist. In his diary he described the government's treatment of culture as reactionary, because it was directed "not at art with political tendencies, but at purely artistic, aesthetic works, which are equated with bolshevism merely because they are innovative, different, individualistic. The iconoclastic assault on the Weimar museum struck at just those artists whose supremely German character and sensibility were beyond doubt," among whom Schlemmer counted himself.[19]

Schlemmer, who in 1933 and later was to show more critical judgment and courage in confronting National Socialism than many of his peers, failed to recognize that his belief in a mysterious "German sensibility" placed him at one with the rowdies who destroyed his painting. But any number of modernist artists held related views. Expressionists, followers of the *Neue Sachlichkeit*, members of experimental groups of the left and the center could employ terms of ethnic-aesthetic singularity as readily and with as much conscious or unconscious arrogance as did Frick's iconoclastic prophets of a nativist, Teutonic art in Weimar. These views had their roots in the historical and philosophic recognition of cultural differences, a major intellectual development in Europe, with a long history not only in Germany. The new insights were not at first, or inevitably, associated with categories of superiority and inferiority. In 1895, when the twenty-five-year-old Barlach wrote from Paris: "Long live the victorious German spirit!" he was not asserting that German culture and art stood above all others – and nothing was further from his mind than apportioning aesthetic quality according to racial or national identity. Instead he tried to draw distinctions between French and German art, warning German artists (and himself) to follow their native bent and not copy the French: "It is too stupid to make a model of French art and French taste – too stupid, for we will never attain either [denn die...werden wir doch nie erreichen]."[20] But the recognition of cultural particularity lent itself to political and racial perversion, which by the end of the nineteenth century had seeped deeply into German culture and art, and which Hitler now tapped with notable effect. In the end, the concept of an aesthetics defined by race and fatherland damaged not only the constantly invoked "German sensibility" of artists and public, but, what was worse, their common sense. Encasing art in an Aryan mystique

brought about the very kitsch with which Hitler branded interna-
tional modernism, even if its themes and style differed. Above all,
the aesthetic message of National Socialism confused and weak-
ened the "creators and supporters of culture" in a society already
reeling from economic and social crises, until they could no longer
withstand their own worst enemies.

2

Barlach

On 23 January 1933, Barlach delivered a talk in the series "Artists on Their Times" on the national radio network. The text, written a month or two earlier, was complex, allusive, and a casual listener would have had difficulty following it. Barlach himself later criticized his convoluted sentences. Still, the address also included plain speaking, and no one could have missed its defense of the autonomy of the creative individual, "whose freedom was being choked every day in the thicket of spiky ideologies." At the end, in an apparent reference to the political rhetoric of the day, Barlach called attention to the conflict between two races – between those who possess spiritual values and those who do not – a conflict "as old as the world"; and demanded, "in defiantly outspoken partisanship, . . . that those pushed into a corner be given freedom to breathe."[1]

Some days after the broadcast Hitler was appointed chancellor. Within weeks Barlach learned that Käthe Kollwitz and Heinrich Mann were resigning from the Prussian Academy of Arts, of which

he, too, was a member. In a letter to the president of the academy he asked, combining his request for information with an assertion of personal principle, whether these distinguished personalities were leaving of their own free will: "Although I do not belong to any of the currently unpopular parties, I find the differentiation between two rights – the artist's freedom of expression and that of the citizen – unacceptable."[2] A flash of good news surprised him: He was awarded the Order Pour le mérite, an important honor in the arts and sciences, to which one was elected by the members of the order, not appointed by the state, which, as he noted, would never have chosen him.[3] Later he learned that two artists were largely responsible for his election: the same Käthe Kollwitz who had just been forced out of the academy, and Max Liebermann, who, being Jewish, also soon resigned.

Güstrow, the country town in Mecklenburg where Barlach had lived for over twenty years, was located in a traditionally conservative, nationalist part of Germany. In the state elections of Mecklenburg-Schwerin in June 1932, the National Socialists emerged as the strongest of four parties, with 49 percent of the vote.[4] Now that the party controlled the national government, local members and sympathizers felt free to throw their weight around. Barlach received anonymous threats, found insulting notes and signs posted on his front door, and believed that his mail was being opened – a suspicion that from then on he frequently expressed in letters to his friends. When he was informed that several of his public monuments were threatened with demolition, he felt compelled to withdraw from the project of a war memorial for the Baltic port of Stralsund, for which he had already made extensive studies. Planned performances of his plays, exhibitions, and publications were canceled, "as if on command." But his enemies did not identify themselves. "I am being robbed

of my livelihood," he wrote in May; "but no one wants to have done it, no one admits responsibility. The canine cowardliness of this glorious age makes one blush to the tip of one's ears at the thought of being German."[5]

That Barlach's work was rejected as incompatible with the new Germany was not surprising and might not require an explanation. But in the early months of 1933 the dividing line between the acceptable and the unacceptable in art was not yet firmly drawn. The representation of men and women in some of Barlach's sculptures was certainly a reason why official voices lost no time in declaring his work unfit for the new Germany. But it was not the only reason, and the condemnation of his style was more ambiguous than appears at first sight. Indeed, the stylistic and formal complexities of modernism rarely interested his critics. Even when they did turn to aesthetic theory, ideology and politics tended to blind them to issues that had engaged German sculptors since the end of the nineteenth century, when Adolf von Hildebrand defined tectonic structure, elimination of the anecdotal, and concentration on the core motif as the basis of a new sculptural art.

In the 1920s and 1930s Barlach was usually considered an expressionist, a classification that persists, though not without opposition. Peter Selz represents the majority view in declaring Barlach to be "the most significant exponent of expressionism in sculpture."[6] More precise seem to me the editors of the catalogue of the exhibition *Paris-Berlin* at the Centre Pompidou, who place him "near, but at the edge of expressionism."[7] That Barlach liked to sculpt by carving directly in wood, and that in his forties he took up the woodcut as a favored medium – both methods often associated with "primitive" art – contributed to the expressionist attribution, as does his occasional borrowing or adaptation of ethnographic motifs. *The Fettered Witch* of 1926 [Fig. 20], whose

frowning face is reminiscent of an African mask, may be a case
in point. But expressionism's common revolutionary pathos and
its violent rejection of previous ways of imaging the world are
no more characteristic of Barlach's art than is the aggressive lay-
ing bare of conflicts within the individual and in society. The
poor and persecuted, beggars and witches, are certainly among
Barlach's important subjects. Witches, a friend noted, accompa-
nied him through life like pet animals.[8] But he gives them and the
other outsiders that populate his work a solidity and self-assurance
even in states of crisis that is alien to the work of such combative
expressionist searchers for trauma as Kokoschka or Meidner.

If Barlach's position in the history of modern art is ambiguous,
so is the meaning of expressionism. It is, after all, a famously inde-
finable, elastic term. The essence of expressionism is easier sensed
than it is explained by means of clearly delineated characteristics
that are not contained in other modernist movements. As a clas-
sification of a phase in the history of art, expressionism has value;
but the term is subject to too many qualifications and exceptions
to be of much use as an interpretive device. Calling Barlach an
expressionist has not added to the understanding of his work –
nor, perhaps, to the understanding of expressionism.

The defining characteristic that such early interpreters of ex-
pressionism as Franz Landsberger found in the "will to alter com-
monly perceived reality" by manipulating form and color was
hardly unique. Even less helpful is the concept of "inner neces-
sity," in which Kandinsky among others placed great stock. It
might help explain the unfamiliar, but it does nothing to distin-
guish one modernist work from another. Presumably the artist's
determination and ability to express feelings and ideas in a search-
ing and truthful manner lie at the root of every worthwhile work
of art, whether created in defiance of convention or seemingly

in accord with it. A thoughtful, sophisticated analysis of Barlach's changing relationship to the avant-garde of his youth and maturity concludes that "the amalgamation of the ethical and the aesthetic distinguishes expressionism from other varieties of modern art" and was also "the determining element of Barlach's art."[9] The interaction of the two certainly marked every aspect of his work; but of how many artists, of all times and styles, can it not be said that they attempt to combine the aesthetic and the ethical?

Barlach himself was, at the very least, uneasy about having the label applied to him. He complained of the "expressionistic" staging of his plays, and his frequent comment that he lacked "any elective affinity with styles and schools" deserves attention, even if artists are not necessarily the best interpreters of their own work.[10]

What matters here, in any case, is less what expressionism is, than what National Socialism imagined it to be. Above all, the term – which, incidentally, Hitler seems not to have used – was a label for "destructive modernism" in general. Specifically, expressionism was branded as diseased, fraudulent, and revolutionary. It was associated with deformation, or alternately with abstraction, blatant eroticism, and with the emotional reshaping of face and body to convey – emphatically or with detachment, but never critically – the passions and conflicts of the deracinated city-dweller, who had lost touch with people and nation; it was the art, as Rosenberg declared, "of the race-destroying metropolis."[11]

It is hard to imagine an artist whose work was farther removed from the metropolis and all it represents than Barlach, and the openly erotic is absent from his sculpture. Deformation and distortion, stripped of their assumed political baggage, are certainly found in many of his figures, but they cannot be said to dominate his work as a whole. Nor are they unique to expressionism.

An example is the *The Reunion* of 1926 [Fig. 21]. The postures of Jesus and Thomas, their naked feet grasping the earth, the out-sized head of Jesus, and the two men's strongly worked, dramatic faces fit the usual expressionist conception. If any of Barlach's sculptures qualified for the 1937 exhibition of degenerate art, it was *The Reunion*. But it is not surprising that it was the only one of his sculptures selected. Many of his early and later pieces – such major achievements as *The Lonely Man* of 1911 [Fig. 6], for instance, or the *Reading Monks* of 1932 [Fig. 29] – do seem to stand at the outermost edge of expressionism – especially as National Socialism defined the term! Even *The Berserker* [Fig. 4] – the figure that appealed to Goebbels, in part, perhaps, for the "typically expressionist" violence of its name – becomes in Barlach's hands a suave composition of smoothly rounded triangular and rectangular forms, their surfaces evenly worked rather than agitated. The figure's appearance contrasts with its alarming label. It may not be beside the point to note that many of Barlach's sculptures were not named by the artist, but by others, such as the art historian Grete Ring, a staff member of the gallery that for decades represented Barlach. Had *The Berserker* been given a less charged attribution – *Japanese Sword Dancer*, for instance – its name might be less likely to influence its interpretation.

Barlach's sculpture is figurative. He usually avoided radical dis-tortion, but his men and women are rarely of a specific time and place. To paraphrase Walter Hinderer's observation on Barlach's dramas, which applies equally well to his sculptures and graph-ics: They are characterized by a combination of abstraction and imagery, by the idealization of reality. The realistic element of the particular is reduced so that the artist can formulate a general truth.[12] Or, as Barlach wrote: "Truths are temporary, the truth . . . remains."[13] Nevertheless, many of his figures reveal a specific

cultural identity, and that so much of his sculptural work is in wood, after preliminary studies in clay, reinforces the relationship with the north-German past. At times he seems a late descendant of German Gothic wood carvers. But it is indicative of Barlach's unusual place in modern sculpture that these affinities are absent in some of his most powerful pieces, just as his borrowings from non-Western art are occasional. That the intermittent presence of these elements goes together with a basic and highly individual consistency of tone may bring us closer to an understanding of his art. Except for his earliest efforts, a sculpture or graphic by Barlach is immediately recognizable as his work. Technical and formal characteristics certainly contribute to this recognition, but more important is Barlach's ability to integrate emotion and form. With only a few exceptions, each of Barlach's sculptures conveys the artist's sense of humanity, which he knows how to convert into the figure's own emotional message.

Unlike the great majority of his contemporaries, whatever their style, Barlach did not sculpt the naked body. Robes and cloaks – as timeless and universal as nakedness – envelop many of his figures and help create their distinctive, strongly defined mass. With their large planes and sparse detail they achieve a unity of form that reaches beneath the surface of posture, movement, and gesture to express character and mood. Perhaps no living person ever looked like *The Lonely Man*, even if the components of the figure – facial features, hair, hands, feet, posture, and expression – are of a stylized realism. But many men and women, in all their time-bound specificity, remind us of the impression conveyed by *The Lonely Man*, as he searches for the unknown in the void between himself and the viewer. A comparison of Barlach's figures with such powerful sculptural statements as Lehmbruck's elongations or Kirchner's aggressive borrowings from primitivism suggests

why some National Socialists were reluctant or unwilling to condemn him on the basis of his style. The emotional content of his work was another matter.

Barlach was at one with the most honored sculptors of the Third Reich in seeking harmony and calm in many of his figures. But it was the calm of the solitary, reflective man or woman that interested him, not the calm of the German warrior, his female comrade at his side, both serving the race, one looking forward to battle, the other to motherhood. That National Socialism would reject themes that celebrated the autonomous individual goes without saying. But the offense was primarily thematic, less one of style.

However strong the component of realism in his work, Barlach's concept of the sculpted or carved figure and its relationship to the environment was innovative and at times revolutionary. His sculptures lean forward or backward into space, or extend horizontally, running, as *The Avenger* [Fig. 11], or *The Berserker* [Fig. 4], who impressed Goebbels, until they actually float [Figs. 9 and 22]. Often they convey absolute stillness as members of large, linear groups, and it is the group that transmits the movement the figures themselves lack. Some are made specifically to stand under Gothic arches or between buttresses, and by uniting the Middle Ages with the present they create new variants of aesthetic expression. A further characteristic, often hidden by the massive solidity of many of the figures, is an astonishing lightness and grace, as exemplified by an undated drawing of a woman facing the wind [Fig. 19]. All these are fresh statements of a highly individualistic concept and execution. It may be the more surprising, therefore, that now and then Barlach falls back to commonplaces that seem to have come from the pattern books of the Wilhelmine empire – the German variant of the Victorian age. An example of these occasional regressions to the familiar and derivative – Barlach's friend,

Friedrich Schult, called them "volkstümlich" – a word difficult to translate, its meaning encompassing "popular" and "traditional" – are the large wood reliefs framing a fireplace of 1916, at least one or two of which are not far removed from the platitudes of home decoration for the well-to-do [Fig. 14].[14] Other examples are a few of Barlach's porcelain figures, for instance, *Woman Walking* of 1910 [Fig. 5]. A late representative in a different mode is *The Jolly Peg-Leg* of 1934 [Fig. 32], despite his physical autonomy a descendant of the satirical figures in Wilhelm Busch's drawings that delighted the German public in the second half of the nineteenth century [Fig. 33]. Compared with the great majority of Barlach's very large oeuvre, these closely observed popular types with strong touches of conventional bourgeois imagery evince a lessening of emotional content and an increase in narrative character. They are weaker as interpretations, stronger as illustrations – which is not to say that they lack quality. The head of *The Jolly Peg-Leg* – to mention only this work – is a realistic tour de force, and when seen from the side and rear, the figure loses its touches of caricature and takes on a powerfully vibrant simplicity. But it is probable that references to the familiar helped in the 1920s and 1930s, and still help today, to make Barlach's work more widely accessible. To some extent – that is, for some people – the familiar elements attach themselves to his other, more unusual sculptures. The strange and the disturbing suddenly becomes less challenging. Their common touch also confused some of his critics in the 1920s and 1930s. It is noticeable that even such a virulent enemy of Barlach's work as Rosenberg habitually granted the artist talent and technical ability before condemning him as degenerate and un-German.

Aside from his work, certain aspects of Barlach's career could appear questionable or worse under National Socialist standards,

although so far as his racial antecedents were concerned he had no difficulty in documenting generations of gentile ancestors: His father, a physician, and his mother came from old middle-class families in Holstein, north of Hamburg. As a young man he passed through the usual academic training, but his breakthrough to a personal vision did not occur until the age of thirty-six, in 1906, when he traveled for nearly two months through southern Russia. In his autobiography he dismisses the assertion, occasionally encountered in the literature, that the Russian experience made him a sculptor; but he was always grateful for the liberating experience of Russia's vast space, its villages and farms, and its poor, hardworking peasants [Fig. 2]. After his return to Germany he made two small ceramic figures of beggars [Fig. 3]. They were still indebted to the elegantly flowing lines of art nouveau that marked his early work, but had taken on a new sternness and solidity. Many years later, referring to these pieces, he noted that he saw beggars as "symbols of the human condition in its nakedness between heaven and earth."[15] The figures were included in the 1907 exhibition of the Berlin Secession, where they achieved a modest success and led to a meeting between the artist and the Secession's business manager, the art dealer and publisher Paul Cassirer.

Three elements came together at this juncture, which were to burden Barlach's reputation in the nationalist and populist camps, and later with National Socialists. The frequency with which his Russian journey and the occasional appearance of Russian themes in his sculptures and graphics was raised against him in the 1920s and 1930s, indicates how strongly some Germans reacted to a German artist "finding himself" in a Slavic and consequently inferior culture. Barlach's links with Cassirer and with the Berlin Secession, of which he soon became a member, were further

negatives. The Secession was an artists' organization founded some years earlier in opposition to the Prussian state's art exhibition and patronage policies, which welcomed and were influenced by the conservative preferences of Emperor William II. Under its president, Max Liebermann, the Secession soon became a force for international and German modernism, and its influence spread from Berlin throughout the country. Essentially it was an apolitical group. Many of its members would have been content with a more evenhanded version of the status quo; but the ideological terms in which radical conservatives cast the German debate over modern art inevitably placed the Secession in the forefront of cultural opposition.[16]

An independent modernist line was pursued by the Secession's business manager, Cassirer, in his own gallery and publishing firm. In 1908 he offered Barlach a contract, which guaranteed the artist an annual income regardless of sales of his work. Some years later, Cassirer became Barlach's publisher as well, bringing out Barlach's first drama in 1912, followed by other plays and by volumes and portfolios of illustrations to his plays and to such other works as the *Walpurgisnacht* in Goethe's *Faust*, Schiller's *Ode to Joy*, and *Franziskus* by the modern poet Adolf von Hatzfeld. During the First World War the professional association between Barlach and his publisher and dealer grew into a firm friendship.

Liebermann and Cassirer were members of assimilated Jewish families, well represented in business, scholarship, and the professions. From a racist point of view, successful Jews, some converted to Christianity and married to gentiles, posed an even more insidious threat to German values than did the poor Jewish immigrants from Eastern Europe, whose alien appearance and behavior shocked the young Hitler when he encountered them in the streets of Vienna. For many anti-Semites, international

modernism was one of the poisons this Jewish elite continued to introduce into the German bloodstream and was representative of the broader Jewish threat, which a nativist opposition, reaching from the highest social groups to farmers and the petite bourgeoisie, sought to counter. Emblematic were Henry Thode's 1905 lectures, which sounded the alarm of cultural decay, and attacked not only Liebermann for being a dangerously un-German artist, but also the unnamed Berlin art dealer, who corrupted German taste with his seductive, worthless products. In one of his early speeches after the First World War, Hitler went beyond Thode and named names, singling out "the millionaire Paul Cassirer, who, by the way, also pretends to be a proletarian" – evidently a reference to Cassirer's liberalism. Hitler continued that Cassirer did everything in his power "to increase the chaos of our day, confuse the people, and at the same time always fishes in troubled waters."[17] The racist concepts defined in cultivated German by Thode and others like him, were soon repeated by populist rowdies in terms that foreshadowed what Victor Klemperer was to call the *lingua tertii imperii*. Gentiles who collaborated with the "alien element in German art" were branded *Judenknechte* or *Judengenossen* – minions or accomplices of Jews – labels that retained their insulting value and were given new destructive power under National Socialism.[18]

That Barlach appeared untouched by even the most casual type of social anti-Semitism certainly contributed to his difficulties in the 1930s, as did his connections, extending over many years, with the Berlin Secession and Cassirer. But although past associations could be very damaging in the Third Reich, they did not necessarily lead to professional disbarment. Two figurative sculptors prominent in the history of the Secession, Fritz Klimsch and Georg Kolbe, continued to have rewarding careers

after 1933. Kolbe, in particular, looked back on a long, produc-
tive relationship with Cassirer, of whom he made a telling portrait
bust, now in the Alte Nationalgalerie in Berlin. The Third Reich
removed several of Kolbe's monuments, among them, as might
have been expected, a monument to Heinrich Heine, and the
Rathenau Fountain, with its portrait reliefs of the Jewish indus-
trialist Emil Rathenau and his son Walther, the republic's foreign
minister, whom radical nationalists murdered in 1922. Despite
his compromising record, however, Kolbe was able to exhibit and
sell his work after 1933, including a statue of a young woman,
which Hitler acquired for the respectable sum of 18,000 marks.
By 1935, an SS publication could print a photograph of his fig-
ure of a decathlon fighter to illustrate the healthy contrast to the
work of a modernist sculptor who employed primitive motifs.[19]
He was awarded the Goethe Medal; Klimsch, first proposed for
that medal, was given the even more important Eagle Plaque of the
Reich. During the Second World War both men were classified as
"irreplaceable artists," which, although they were too old for mil-
itary service, attested to their privileged standing. After Barlach
withdrew from the competition for the Stralsund war memorial,
Kolbe was given the commission. In place of Barlach's model – a
Pieta in the form of a cross, constructed of a sorrowing woman
and the stiff corpse of a soldier stretched across her lap – Kolbe
sculpted two men in idealized, taut nakedness, the older behind
and slightly above the younger, both men grasping the hilt of a
massive two-handed sword thrust vertically in the ground at their
feet [Figs. 30 and 31]. The two approaches to the subject could
not have been more different. Barlach's pair addresses the facts
of death and grief; Kolbe's heroes celebrate the sacrifice of one
generation, and the duty of youth to follow its elders' example. A
monument that accommodated such readings erased the impact

that Kolbe's association with the forces of Berlin modernism un-
doubtedly had on the new rulers. Barlach's interpretation would
only heighten their suspicions.

Technically and formally, Kolbe was far superior to the sculptors
most favored by Hitler, men like Arno Breker and Joseph Thorak,
who set the standards for official sculpture in the Third Reich. Nor
was he a member of the party or a sympathizer with its racism
and populism. Nevertheless, Kolbe's Stralsund monument met
every demand of National Socialist aesthetics. Even without runic
emblems, or any symbolic object other than a sword, the work's
heroizing fusion of naked masculinity, national power, and the
grandeur of self-sacrifice represents everything that the nation's
new leaders demanded of art, and everything that Barlach's art
lacked and resisted.[20]

A few members of the Berlin Secession had been politically on
the left, but Barlach's politics should have given the Third Reich
no cause for concern. His point of view in public affairs might be
summed up as moderately liberal, with conservative tendencies.
He was free of the sense of class distinctions usual in a member
of the educated middle classes, but he had no confidence in pub-
lic opinion, whether in matters of politics or of art. Neither his
plays nor his account of his first forty years, published in 1928,
contain unambiguously political statements. In 1914 he accepted
the German invasion of Belgium as a necessary defensive measure,
and when called up hoped to serve at the front, even though he was
no longer young and suffered from an irregular heartbeat.[21] By
1916, reacting to the seemingly endless killing, he turned against
the war, and in a series of powerful lithographs in *Der Bildermann*,
a journal Paul Cassirer published twice a month from the spring
of 1916 to the end of the year, pleaded for peace among nations,
again without addressing the issue of war and peace in political

terms [Figs. 12 and 13]. At the end of the war he declined to take part in efforts to reorganize art institutions according to revolutionary principles. "Those who derive sufficient motivation and conviction from their work need not respond to the pressure to organize and propagandize," he wrote a friend at the time. He continued, "Human beings are not equal; what do they want with equal rights!" – but added that some coming changes were justified and would benefit many.[22] He felt no regret at the passing of the empire, and had no difficulty in accepting the republic, but his name was not associated either then or later with parties or movements. The most damaging political complaint that the right could raise against him was that in 1928 he was listed with hundreds of others in a communist-inspired petition opposing the expenditure for a new warship. It turned out that his name had been included without his knowledge.

The subjects of Barlach's sculptures, and his approach to them, reflect his distance from partisan politics. He shows men and women struggling to come to terms with their personality and character and with the indifference or hostility of their fellow human beings. In some sculptures, emotion erupts into violence – *The Avenger* [Fig. 11] is an example. In others – *The Fettered Witch* [Fig. 20], for instance – the outside world overpowers the individual. But even these figures, highly charged with the artist's empathy, make no overt political statement. Their very lack of propagandistic symbolism at least made it possible to overlook their implied rejection of any ideology that uses people as raw material for its own purposes.

With Barlach's war memorials, however, any well-meant evasion of their message became very difficult. These were the works that aroused National Socialist opposition to such a pitch that possibly attenuating circumstances – Barlach's figurative sculpture,

his service in the army, the fact that other artists whom the new regime accepted had also been members of the Berlin Secession and exhibited their work in the Cassirer Gallery, and that Barlach had never joined the radical left – became immaterial.

Barlach's war memorials are stations in a progression of sorrow and empathy stretching from the First World War to the end of the Weimar Republic and beyond. He took the first steps in the six lithographs on the subject of violence and of the war's human cost he contributed to *Der Bildermann*. The front page of the last issue, dated 24 December 1916, carried Barlach's lithograph of the *mater dolorosa*, floating on clouds, surrounded by a double circle of swords and rays of light, pleading for an end to the bloodshed: *Dona nobis pacem*.[23]

The theme of death continued to lie heavily on him and his work. It was in recognition of this preoccupation that in 1918 the Prussian Ministry of Culture asked him to design a crucifix that could be mass-produced for use in military cemeteries. His first version was rejected; a second was awarded a prize but seems not to have gone into production. Two-and-a-half years later, when he agreed to make a memorial tablet for the Nicolai Church in Kiel, he returned to his lithograph of the Mother of God for the design [Fig. 16]. On an oak panel, her figure in relief, surrounded by seven swords pointed at her, the one in the center suggesting a crucifix, floats on clouds above the legend in the region's low-German dialect: "My heart bleeds with grief. But you give me strength," and the dates 1914–1918. The appeal of the earlier lithograph, "Give us peace," was converted into a remembrance of the dead. The panel contains no reference to patriotism, duty, combat, or heroism, none of the multitude of symbols and rhetorical imagery linking the soldier's experience and fate with the survivor's feelings, that festooned the memorials erected by the

hundreds in German churches, parks, and squares in the 1920s. Barlach's tablet referred to the war merely by the two dates and by the circle of swords. The legend's message was limited to grief and to God's help in bearing it.[24]

The unspoken, implicit statement of Barlach's panel was raised to a higher level of silence in his next memorial. In 1926 the local and regional church authorities decided to honor the members of the Güstrow dome congregation killed in the war, by commissioning a monument in the form of an inscribed boulder. It was to be installed in an open space outside the church – a massive brick structure, begun in the 1220s, which combined Romanesque and Gothic features. Instead of the frequently employed concept of a memorial boulder, Barlach offered to design a monument to be placed inside the church.[25] He waived a fee, asking only for reimbursement of his expenses, and after some hesitation his proposal was accepted. In May 1927 the completed work was installed in the northeast aisle of the dome: a bronze figure – often called an angel – more than seven feet long, suspended on two segmented iron rods from the keystone of the vaulted ceiling [Figs. 22, 23]. The figure floats somewhat above eye level over a circular, late-Renaissance railing, originally made for a baptismal font but now encircling a stone plate in which the dates 1914–1918 were engraved. After the Second World War, the dates 1939–1945 were added. The only other reference to the monument's purpose is a book on a stand near the wall of the aisle, in which the names of the 234 fallen members of the congregation are recorded.

The motif of the horizontally extended body, lying, running, or floating, had already occupied Barlach before the war, and he was to take it up again. Early sketches in which the trunk of the figure rears up, its head lifted to the sky, gave way to a level, outstretched form, the head facing forward, eyes closed, and the arms – at first

extended with hands folded over the stomach – in the final version crossed over the chest. Sketches show the figure with different male and female faces, among them the profile of Paul Cassirer, who had died the previous year.[26] Eventually Barlach decided, apparently without conscious intent, on a stylized image of Käthe Kollwitz, which also bears a resemblance to his companion, Marga Böhmer. Both women had eyes set wide apart over high cheekbones and wore their hair short, falling evenly down the sides of the head, a style that matches the cap- or hoodlike mop of hair already indicated in Barlach's first studies. The hair of the figure, a solid, curved plane, cut off at the line of the jaw, restates the full, smooth robe and hood that cover the angel's body and legs to its feet.

The appearance of the work and the emotional and intellectual awareness of its purpose are linked. But the two can be separated, at least intermittently, until the work's purpose is recalled. That the figure hovers motionless in one of the arched vaults of the church, suspended in subdued daylight, which Barlach took care to modulate by adjusting the color of the glass in the three windows nearby, expands the visual impact of its assured modeling and rich surface. The work and its placement in space send contrasting impressions. Its volume and substance are very apparent, and yet the figure may seem light and even small. It conveys an extraordinary stillness, in part because it floats; but seen from some angles between pillars of the nave, its dark mass appears threatening and charged with power. How much the particular setting entered into the modeling and placement of the figure becomes even more apparent when the sculpture in its original location is compared with the cast installed after the war in the Antonites Church in Cologne, and with two other casts hung in bright and angular modern exhibition spaces.

In conception and execution, the floating figure in Güstrow, far more than the memorial tablet in Kiel, became part of its medieval, north-German church setting – the vaulted ceiling, monolithic granite pillars, and whitewashed brick walls, which hid the remnants of old frescoes and bright decorations. Barlach took the obvious affinity of some of his work with medieval sculpture seriously, and continued to test it, his exploration culminating in the three figures he made for niches in the brick facade of the fourteenth-century St. Catherine's Church in Lübeck [Fig. 26]. But the particular space that he chose for the sculpture also leads to its transition from work of art to memorial. Viewers can hardly ignore the relationship of the figure – its popular name "the angel" points the way – to the architecture of a past age that is dedicated to the worship of God. By itself, the sculpture would have made a moral statement. Perhaps its setting in the cathedral narrows the message, but also clarifies it, and makes it more broadly understood. The floating figure becomes a statement about the war and its costs, a comment on a disaster that to many Germans in the 1920s would still have the power of an immediate experience.

From the start, many visitors to the dome found the sculpture a convincing work of art. Its message of remembrance, for some no more than an incidental element in the aesthetic whole, was embraced by others. But the work also disappointed and offended. Some people rejected the figure's stylized representation of a woman and its suspension from the ceiling, but even more strongly its silence about the purpose for which the 234 men had died. That the customary assertions of duty and honor were missing from the monument deprived survivors of the expected justification for the deaths. The seemingly calculated omission might signify that the dome and the artist questioned whether any justification was possible, or even that they declared it was not. The pain

and rage this triggered still jumps out from the texts of national-
ist protests when the figure was installed. To a young enthusiast
who, although puzzled by the work, sent the artist a poem in its
praise, Barlach replied that a work of this kind "is inexplicable and
yet clear – and it is convincing when encountered by eyes such as
yours." He added: "that this same work is badly misunderstood,
rejected, abused, and ridiculed you probably know."[27]

During these years, a number of congregations and municipal-
ities planning to erect war memorials turned to Barlach. That he
was increasingly controversial in the area of public sculpture did
not dissuade adherents of modern art, nor were more conservative
circles always immune to his growing prominence. Even before he
completed the Güstrow memorial, he was offered a major project
in Kiel. In the summer of 1927, Leo Kestenberg, who with Paul
Cassirer had edited *Der Bildermann* during the war and now served
as a senior official in the Prussian Ministry of Culture, secured an-
other important commission for Barlach: the gift of a war monu-
ment from the Prussian state to the cathedral in Magdeburg. The
following year, Malchin, a town twenty-five miles east of Güstrow,
invited Barlach to design a memorial; and from the beginning of
1930 on he corresponded with the Hamburg city planner, Fritz
Schumacher, over plans for a monument. In 1932, finally, the vet-
erans' associations of Stralsund asked him to submit plans for a
monument, a project that political developments would prevent
Barlach from completing.

The bronze statue of a winged man armed with a two-handed
sword, standing on the back of a wild beast, that Barlach made for
the University Church in Kiel, is actually not a war memorial, but a
monument to humanistic ideals in an academic setting [Fig. 24]. In
Barlach's careful formulation, the sculpture represents the mind
and spirit "rising (elevating oneself) above suffering (suffering

here means being captive to instinct, drives, and to earthly ambition and fate)."[28] The sculpture, over fifteen feet high from the paws of the beast to the tip of the sword, is a metaphor executed in terms of a stylized naturalism. The animal is a powerful modern descendant of medieval heraldic beasts; at most, the man's – or angel's – expression, which conveys not triumph but reflection, might be expected to irritate conservative critics. But no particular political direction could have claimed the work's message of insight and self-control exclusively as its own. A cynical interpretation might even suggest that *The Fighter of the Spirit* could be seen as a metaphor of a traditional German concept, dear to dueling university students and drill sergeants: the need to conquer the *innere Schweinehund* – the pig within oneself, here meaning fear, cowardice, and other self-serving instincts that men must conquer. The negative reactions that came as soon as the sculpture was put in place on the first day of December 1928 have therefore no obvious explanation. But the work was criticized by the "same circles" that had found the floating angel distasteful. "All right-wing parties join in the fight," Barlach wrote in these days. He noted that someone had even broken the sword or bent it out of shape – the word he used, *abgebogen*, leaves the extent of the damage unclear.[29] Possibly the idea of a large monument honoring the courage of mind and spirit instead of military service to one's country was taken as an affront by the right.

The attacks on *The Fighter of the Spirit* and on its maker, largely the work of the conservative national veterans' association, Der Stahlhelm, helped put an end to the projected monument for Malchin. The Stahlhelm's ladies' auxiliary added to the uproar by repeating the communist falsification that Barlach had signed a communist appeal opposing construction of an armed cruiser. The denunciation of Barlach as un-German was strengthened by

the accusation that he was a Jew, who owed his success to the manipulations of a Jewish art dealer, an accusation that was supported by quotations from a scurrilous article on Paul Cassirer in the anti-Semitic *Manual of the Jewish Question.*[30]

Barlach's gentile descent was beyond doubt, which, incidentally, could not be claimed for the Stahlhelm's second-in-command and Reich chancellor candidate, Theodor Duesterberg. But as Barlach wrote in an essay reviewing the episode, even "if I were a Jew and a communist, might I not have found a design for my work that evoked memories of the past, a memorial that would allow the hundreds [of casualties] to return in symbolic form, and let them know that their true and last quality, their renunciation of life, which others have not had to sacrifice, will always remain in our memory?"[31] He demanded a correction and an apology from the Stahlhelm, which the organization's regional commander answered with gloating evasiveness: The Stahlhelm had not acted officially, and could not be held responsible "if one or the other comrade" expressed a personal opinion.

Even before the bronze figure for Kiel was cast, Barlach began preparations for the monument destined for the Magdeburg cathedral, which he noted would be the largest and most demanding wood sculpture he had yet attempted. Seven feet high and five feet wide, it consists of three soldiers grouped around a cross on which a column of dates from 1914 to 1918 is carved [Fig. 25]. The tall man in the center, a bandage wrapped around his head, rests his hands on the horizontal bar of the cross. Two shorter soldiers stand on his left and right. One wears a cape with a large collar and a stylized, shallow version of the spiked helmet still issued at the beginning of the war; the other a belted uniform coat and a deep helmet, suggesting the design introduced in 1915, which soon became a symbol of the German army. They look slightly to the right

at something invisible, while the man in the center looks toward and beyond the viewer. At their feet are three further figures, cut off at the chest as they emerge from the ground or sink into it: The tallest, again in the center, is a skeleton, a steel helmet on its skull, looking at the ground. The skeleton is flanked by a veiled woman, her clenched hands pressed against one another, and by a bare-headed man, holding both hands against his head in amazement or horror. His chest is covered by an abstract assemblage of curves and disks, one of the strongest parts of the entire work, generally thought to represent a gas mask, rising like a visage of Moloch out of the ground. The violent gestures and expressions of the second bank of figures contrast with the immobility of the men above, whose stillness Käthe Kollwitz admired. Together the two rows of soldiers and civilians, in their midst the skeleton, which with a slight inclination of its skull breaks the group's horizontal and vertical grid, form a modern dance of death.

The monument was placed in a niche of the northwest apse of the cathedral, on a high pedestal covered with wood paneling, divided into three shallow arches. They make up a third row of three units, which serves as a transition between the massive wooden group and the stone and masonry of the great interior space of the church. When the monument was restored to its original location after the war, it was put on a narrow, shapeless slab, close to the cathedral floor, contrary to the artist's intention, and until it was recently placed on a new pedestal some of its impact was lost.

In the Magdeburg monument a work by Barlach for once incorporated immediate, easily recognizable references to the world war – the army coat and belt buckle of one of the men, the gas mask, and the three helmets – even if only the skeleton's German steel helmet is rendered with reasonable accuracy, and the helmet worn by the man on the viewer's left, which surrounds and

hides his face, is a clear distortion. The sculpture, Barlach wrote soon after completing it, "grew out of a realistic conception of images.... The true-to-life figures [*Wirklichkeitsgestalten*] of my memorial to the dead are arranged to harmonize with the vaulted arch [in which they stand], and each gives witness as a component of a higher reality."[32]

But the unambiguous references to the events that occasioned the memorial did nothing to calm its critics. On the contrary, no work by Barlach was more vilified than the group in Magdeburg. Its interpretation of the German military aroused storms of indignation, triggered initially by the spiked helmet of one of the soldiers. Its shape, somewhat flattened by Barlach, was said to resemble the peaked cloth cap of the early Red Army. Inevitably, the stolid face beneath was identified as Slavic. Of the works of art in the Weimar Republic that directly addressed the war – in contrast to images of the war's impact on society in the form of cripples, widows, beggars – only Otto Dix's painting *The Trench* received comparable abuse. After the National Socialist takeover, Rosenberg summed up the view of the right in an essay that was repeatedly reprinted: With "the small, half-idiotically staring, mixed variants of indefinable human types in Soviet helmets," the artist had created a travesty and besmirched the German soldier.[33]

The accusation that Barlach placed Slavic features on figures meant to be German was repeated in 1931 when his most recent memorial was dedicated in Hamburg. The ceremony, already constrained by the growing power of National Socialism, was subdued. The monument, located at the edge of the city hall square, by the side of a branch of the Alster River, was a collaborative effort [Fig. 27]. The competition jury had rejected Barlach's entry in favor of a sixty-nine-foot-high limestone stele proposed by the architect Klaus Hoffmann. The authorities were then persuaded to

entrust Barlach with the design on the reverse of the stele. The side
of the slab facing the city hall bore the words: "Forty Thousand
Sons of the City Gave Their Lives for You" – a statement imply-
ing voluntary sacrifice that Barlach regarded as humbug, but had
to accept. The patriotic rhetoric was contradicted by his design
on the reverse: the large outline, incised in the stone, of a woman
consoling and protecting her child. Barlach's conception and ex-
ecution enraged the right. The local National Socialists declared
the image un-German and demanded its removal, although the
head of the party's Hamburg section angered Rosenberg by pri-
vately acknowledging the artist's great gifts.[34] How closely this
form of patriotism was related to feelings of racial superiority was
demonstrated once again by the further objection that the woman
and her child were unmistakably Slavic or Mongolian. In fact, the
woman – who is often sentimentally described as pregnant, al-
though her body does not seem to indicate this – has the long,
narrow skull, straight nose, and firm chin of the idealized Aryan.
But her expression and stance are not heroically accepting of patri-
otic sacrifice. She is worn and sad. These qualities, and the absence
of nationalistic embellishments on the monument, marked her as
racially inferior. Ideology aside, Barlach's design is not among his
best works. Even people who found the conception appealing ex-
pressed doubts. Käthe Kollwitz – perhaps swayed by her special
sensitivity to the idea of sacrifice – preferred the words to the
image, and the design, which at some times of the day is nearly
invisible, has not aged as well as the stele. Barlach's mother and
child never became popular in Hamburg; today, among hundreds
of postcards of city views, cards showing Barlach's design on the
monument are exceedingly rare.

Barlach's memorials grew out of his experience of the war. He
was a soldier only briefly, fascinated by the prospect of combat,

"the central reality," but basic training revealed that his age and weak heart made him unfit for active service. Sooner than many he began to doubt that Germany could win the war. The millions of casualties on all sides, for which he could find no justification, challenged him morally and as an artist. When he turned to the making of memorials some years after the fighting ended, he remained focused on the tragedy of death, and he rejected as desecration all efforts at "explanation." In his sculptures, which are without patriotic avowals in the customary vocabulary of iron crosses, oak leaves, and eagles, he strives only to recall the dead and the grief of their survivors.

But inevitably his universal human note had political resonance. Sculptures that do not evoke the memory of the dead in patriotic terms of a duty owed and paid, or in ideological terms of the triumph of justice, but grieve over inexplicable loss, have nothing to say about the supreme authority – the nation and the state – in the service of which the men died. They ignore the distinction between friend and enemy, patriot and traitor, even between superior and inferior races; they appeal only to all-embracing humanity. When the normative power of the nation and fatherland is denied, not in a work of art in an avant-garde gallery, but by a monument in a public place, sanctioned, even sponsored, by the state, the message may seem even more shocking. Barlach may not have realized that he made political statements in his memorials – that they were political statements! – but it is not surprising that people who rejected these works did so largely on political grounds. It was not their formal attributes that offended many Germans, but their message.

In all of his memorials Barlach refuses to justify or ennoble death, a refusal that may appear to enjoy official sanction because it is expressed by a public monument. But in one respect the

Magdeburg memorial differs from the others, and this difference may help explain the particularly intense dislike it encountered on the right. The group lacks the grace of the floating angel, and the almost musical clarity of *The Fighter of the Spirit*. Any sound it may strike would be muffled and funereal. In its concentration on death, the work approaches an attitude and a mood that at the time affected many segments of German society and culture: the conversion of death into a continually evoked cultic force. In sanitized and idealized form in novels, poems, and plays, and in the fine and applied arts, death was even worshipped as admirable and desirable in itself. Much of this aestheticizing was no more than an attempt to come to terms with the death of nearly two million Germans in the war. But ameliorating the horror in this way easily turned into its glorification. Groups on the right – especially those on the extreme fringe, but also cultured mourners for a time gone by – steeped themselves in the cult of death, which they built into their political longings and programs, and which eventually was to find a new pragmatic expression in the administrative and legal systems of the Third Reich, its military policies, and its treatment of the populations in the occupied territories and of the Jews.

At first glance, at least, the Magdeburg monument could be taken as an artifact of the formal celebration of death, even if it lacked the dark, cultic pleasure in the process and the outcome. Barlach had appropriated a mood; but he did not exploit it for the expected purpose. Rather than glorifying, and glorying in, the frightful, he removed its decor and brought the viewer back to naked reality. He revealed the cult for the grimy fantasy that it was: a fantasy that had moved far from love of country. That act of revelation and desecration its adherents or dupes would not forgive him.

3

Nordic Modernism

And yet, despite compelling evidence that the country was entering a new phase in which freedom, whether of the artist or the citizen, was becoming illusory, Barlach perceived signs that seemed to promise toleration and even approval of his work. He knew that Germany had been overwhelmed by a revolution that was nationalistic, fanatic, and infused with the cult of violence. In his own circle he observed changes brought about by questionable or openly illegal measures. Artists were expelled from their teaching positions, museum officials were dismissed, galleries were forced to close, friends and acquaintances emigrated – among them Leo Kestenberg, to whom Barlach owed the commission for the Magdeburg memorial, and with whom he now exchanged affectionate letters, which, he thought, were opened by some newly installed office of postal censorship. What was not clear to him was how long this phase of intimidation and uncertainty would last; nor could he predict how it would end – in a new, more conservative, but nevertheless lawful social order, or in anarchy.

To a cousin who had been advised to join the party and improve it from within, he wrote that the advice was good: "Fermentation is badly needed."[1] He still did not realize that National Socialism could only grow worse. It gave him intermittent encouragement that in these confused times two of his sculptures were sent to the Chicago World's Fair and other works to the Venice Biennale, and that admirers still sought him out to discuss exhibitions and public readings of his plays. In June 1933 a newly formed association of National Socialist and nationalist artists issued a violent attack on expressionism but took care not to include Barlach: "It is not true that the members of the Brücke continue the traditions of the old German art, as Barlach does, for instance."[2] In the same days, as will be seen, he received a more substantial, official sign of approval from within the ranks of organized National Socialism itself.

In the new uncertain political atmosphere, Barlach did not consider emigration an option.[3] As contracts were broken and buyers who had already taken possession of sculptures were unable to pay, his economic situation worsened. He could not continue mortgage payments on a house with an attached studio that he had built three years earlier, and he had to let his housekeeper go – to his relief, since although an honest, hardworking woman, she was moody and a "sincere admirer of Hitler." The works in his studio and in one or two galleries constituted his most valuable resource; but even had he been able to pay for their transport, he was unlikely to be allowed to take them out of the country. Now in his sixties, in uncertain health, plagued by angina, he was physically and emotionally dependent on a relationship with a younger woman, Marga Böhmer, whom he had met in 1924 when her husband Bernhard Böhmer moved to Güstrow to work as his assistant. The Böhmers soon separated on amicable terms,

and Böhmer married again. He remained in Güstrow and be-
gan to help Barlach with his business dealings, while his former
wife and Barlach formed a close romantic and working relation-
ship. After Barlach's death, Marga Böhmer devoted herself to his
memory and his art, and preserved much that might otherwise
have been stolen or destroyed during the Second World War, the
Russian occupation, and the communist regime in East Germany,
which in the 1950s would still reject Barlach as a socially unen-
lightened creator of dull working-class types lacking the vitality
and social consciousness of the true worker and peasant.[4] Marga
Böhmer would have followed Barlach wherever he went; but with
little money and few prospects the couple could think of leaving
Germany only as a last resort.

Like Barlach, many Germans during these early months were
left in doubt over the ultimate shape of the new order, although it
was certain that socialism and liberalism no longer had a place in
the country's politics, and that the integration of Jews in German
life was being reversed – the extent of the reversal still remaining
unclear. Formally Hitler led a coalition government, and for a
time upper-class and bourgeois conservatives could believe that
he and his minions would do the dirty work of destroying the
republic, after which the state, whether a restored monarchy or
a new authoritarian hybrid, would fall under their control. But
the conservatives' own ranks were already corroded by radical
populism; they proved helpless against the new men, and their
parties, like those of the left, soon disappeared.

Largely as the result of the conservative parties' inept maneu-
vers, Hitler had gained executive authority in Germany. His ambi-
tion and purpose now demanded reshaping according to National
Socialist principles the ministries and agencies of the Reich and
of the governments of the constituent states. His party invaded

the administration, forcing dismissals, making new appointments, and reorganizing institutions – processes that the party's private army, the SA, encouraged with demonstrations and acts of terror. Before the end of the year the leadership announced that the union of party and state had been accomplished. Actually, their unification remained incomplete. However corrupted and twisted out of shape, the ministries and the bureaucracy retained a degree of independence, and once party members came to occupy government positions their relations with comrades in parallel party offices were rarely free of friction. Nor was National Socialism itself compact and of one mind. The movement had brought together men and women of diverse political opinions and feelings, ranging from conservatism in its many class-based varieties to radical populism and to a now abandoned faith in socialism or communism. They were united in the belief or hope that party and Führer could change the country, elevate and give new authority to the grand concepts of the German people and nation, fortify social cohesion, end the most severe poverty, and restore German power in the world. On specifics, however, expectations differed, and with its rapid growth after January 1933 the party's character changed. It became less populist, more middle class, than the SA, which in turn was losing power to its elitist and ideologically cohesive sibling, the SS. The murder of Ernst Röhm and other SA leaders in June 1934 set the stamp on its decline and taught even the last doubters that the socialist component of National Socialism would receive only scraps from the table.

The political views of Hitler and his followers were mirrored in their attitude toward the arts. Again, unanimity could not be expected, at least not until the Führer expressed his ideas in greater detail and developed specific policies in the cultural sphere. But

as in politics, the general tendency ran toward uniformity, even if Goebbels, unlike Hitler and Rosenberg, believed that a degree of diversity, as long as it was firmly controlled, would benefit the regime. That artists could not be drilled like soldiers was readily admitted – Goebbels prided himself on proclaiming this truth in increasingly fanciful variations. But however greatly artistic individuality and creativity were praised, they were judged by their relationship to the German people and nation. A work's nearness to the defining racial and historical universals determined the artist's worth. Since its beginnings, National Socialism had rejected twentieth-century modernism on account of its individualism, separation from the customary, and disdain for the easily comprehensible. Artists were condemned for choosing their own way, without regard for the ability and willingness of the German people to follow. Their remoteness from the public was taken as proof of their inferiority and of the alien nature and destructive power of their work, whether the evil was intended or the artists were naive victims of Germany's cultural rivals and enemies. National Socialists took for granted that the artist, like every other German, must be incorporated into the new system, which meant be controlled and, if necessary, educated – negatively by being kept from exploring certain styles and subjects, positively through patronage. And here, too, as was true for their opinions on the specifics of domestic and foreign policy, people's preferences varied, ranging from extremes of realism, which in always new versions restated the basic vocabulary of National Socialist beliefs, to sophisticated interpretations that extended thematically and stylistically over vast areas of Western culture and that combined rather than separated German and foreign insights. Efforts to create a European-wide National Socialism were a related phenomenon in the ideological sphere.

The structure and methods of government that the National Socialist revolution developed allowed some space for this diversity. The reality behind its facade of disciplined uniformity has been characterized as unintended chaos – the result of the ambitions of dozens of party leaders and subleaders, which Hitler accepted and exploited rather than suppressed. This mass of competing, often relatively autonomous departments and offices, forming a many-headed system of state, semiofficial, and party bureaucracies, was held together by the Führer – whose ultimate authority the bureaucratic confusion did not question – by his principal assistants, and by the secret police. If it was politically expedient, the senior leaders did not hesitate to interfere with the workings of institutions they themselves had put in place. Their actions were further energized by widespread faith in the Führer, a trust that often translated into efforts to anticipate his intentions and fulfill them – the attitude that Ian Kershaw has labeled "working toward the Führer," which proved crucial in making the system function. Ideals and personal interests meshed. Duplications and friction notwithstanding, members of the party and of the dozens of associated and coordinated organizations expected that the combination of old and new power structures would strengthen the country while allowing them to achieve status and security. On the more senior levels, people hoped for power and wealth. The party-state maze offered them career opportunities, the possibility of creating larger or smaller local power bases, and any number of ways of benefiting from the resources of the state and the stolen possessions of its victims.

Hitler's tolerance for rivalries and power struggles could go very far. It usually came to an end at the point at which an individual or agency threatened to achieve complete control over a particular function. Then he called a halt, often by postponing or

avoiding an ultimate decision or authorization, so that the balance of power created by multiplicity and overlapping responsibilities was maintained. As long as the party existed in a dual world of Reich and state governments, true centralization and lack of duplication would have required a different, far more fundamental institutional reconstruction than Hitler attempted and seems to have wished. A clear link connects his system of governing with his maneuvers as party leader before 1933, the principles of which an old party member summarized as: "Power struggles on the lower level best prevent the formation of a common, united front against the party leadership. Consequently they are beneficial rather than damaging, and should be left to run their course. Under some circumstances they should even be secretly encouraged. In the rare case when that is not possible, the stronger party should be supported, without worrying about legal rights and wrongs."5 Less fragmentation would have reduced opportunities for the advancement of ambitious party members and limited the means of controlling them by playing off one against the other in a dynamic web of authority and influence, segments of which even senior party leaders found impenetrable.

In 1933 Hitler had to decide how best to reform the arts, how to divide responsibilities for them among his senior assistants, and how to integrate the new institutions into a structure of government that was rapidly changing but retained much that was inherited from the republic and beyond that from the empire. In the Weimar Republic, governmental responsibility for the arts rested primarily with the Ministries of the Interior and of Culture of the Reich and of the particular states. Other ministries, such as the Ministry for Foreign Affairs, also had sections concerned with the arts. A Reich custodian for the fine arts, the Reichskunstwart, had a hand in the aesthetics of official ceremonials, oversaw the

design of coins and stamps, and possessed some patronage. Partly official, partly self-governing institutions exerted influence on exhibitions, purchases for the public collections, and fellowships – an example being the Prussian Academy of Arts, with sections for literature, music, and the fine arts, its activities largely financed by the Prussian government, and its appointments and policies requiring confirmation by the Prussian minister of the interior. Below the national and state levels lay a dense network of municipal agencies, some of which were extensions of the state, others having a high degree of autonomy. Many were linked institutionally and politically to the foundations, schools, and galleries that formed the private component of the country's cultural matrix.

Rosenberg's disappointment that Hitler would not place him in charge of this world did not stop him from attempting to take command of the accelerating attack on modernism. Inspired by fanciful readings of the Germanic past, he and his followers in the League for German Culture applied the strictest ideological standards to contemporary art. In April 1933, one of his associates, the neo-romantic painter and new director of the Karlsruhe art academy, Hans Adolf Bühler, organized the earliest ancestor of the great degenerate art exhibition of 1937: *Government Art from 1918 to 1933* – a title that once again firmly associated art and politics. Throughout the country, members of the League and of other nationalist cultural groups engaged in guerrilla actions against museums, the press, and individual artists, which added to the atmosphere of insecurity and illegality that now enveloped Germany. The state of anarchy continued even after a new and eventually decisive player intervened in the relationship between government and culture: the Ministry for Public Enlightenment and Propaganda under Goebbels that was established in March 1933. The mission of the new department, to advance the German

public's understanding and acceptance of National Socialist prin-
ciples and policies, did not refer to the fine arts specifically. But
from the outset culture and art were included in its areas of re-
sponsibility, as important if slippery forces that could positively
and negatively affect the German people's ideological soundness.

It was apparent to Goebbels that his appointment was merely a
first step toward gaining control over the arts. He needed to carry
the fight to his rivals, among whom Rosenberg and his allies were
the noisiest if politically not the most threatening, while defining
his ministry's relationship with other parts of the government, and
filling the institutional shell with new agencies and programs. In
negotiations with his peers he achieved the transfer of a number
of art and cultural sections. Other pockets of art policy, how-
ever, remained in different hands throughout the Reich and state
governments. Hermann Goering, as Prussian minister-president,
and Bernhard Rust, the Prussian minister of culture and soon also
Reich minister of science and education, retained authority over
the Prussian museums. A compromise with Robert Ley, head of
the Labor Front, eliminated him as a competitor, but Goebbels
had to share authority with Ley over staff appointments for the
cultural section in the strength-through-joy program of workers'
leisure-time activities. Another path to control lay in the societal
restructuring of culture with the new ministry as its core. Over the
next months Goebbels, in consultation with Hitler, formulated a
series of far-reaching changes that were institutionalized in a new
body within his ministry: the Reichskulturkammer – the Reich
Chamber of Culture – which began operating in September.

To the opening ceremony on 15 November, with Hitler in at-
tendance, Goebbels invited a number of well-known modernist
artists: Emil Nolde, Karl Schmidt-Rottluff, Erich Heckel, and
Barlach – who did not accept. In his address to the assembled

representatives of the party, of government, and of the arts, Goebbels reasserted the regime's intention to expand the political revolution to all other areas, including those of the economy, science, culture, and the arts, and distinguished between the liberty of the individual and the mass, which was truly free under National Socialism. The artist was also free, as long as he retained his link to the German people. That link was represented by the state: "The new state has its own laws; everyone, from first to last, is subject to them. The artist, too, has the duty to recognize them, and to make them the guidelines of his creativity. Beyond that, he is free and unrestrained."[6] With his fanaticism, intelligence, and agility, Goebbels rather than Rosenberg was becoming the true theorist of National Socialism.

The Reich Chamber of Culture – its mission "to advance German culture and ensure its responsibility toward the German people and the Reich, [and] to regulate the economic and social activities of the cultural professions" – consisted of seven chambers or professional-economic corporations, each covering one broadly defined area: literature, the press, radio, theater, music, the fine arts, and film. The membership of the chambers was made up of "all culture-creating and culture-transmitting individuals." In the Chamber of the Fine Arts they ranged from artists to curators, art dealers, and framers, for a total of over forty-five thousand men and women by 1937. Each chamber combined the characteristics of a government agency with those of a state-run union that possessed an absolute monopoly over its area of activity. The chambers worked with and were responsible to parallel sections in the ministry, which formulated policy. The minister presided over the Reich Chamber of Culture and appointed the presidents and executive committees of the constituent chambers. Presidents might be notable figures, like Richard Strauss, who was president

of the Chamber of Music from 1933 to 1935, minor cultural rep-
resentatives of the nationalist-populist camp, or trusted National
Socialists. In 1937 a Reich cultural senate was added, partly to
forestall a similar scheme of Rosenberg. The new body had no
real functions, but it publicly asserted the propaganda ministry's
preeminence in the cultural field, and provided another title with
which to reward the deserving.

Despite clashes with government departments and agencies,
whose areas of responsibility the chambers repeatedly invaded,
the Reich Chamber of Culture soon functioned as an efficient
arm of the propaganda ministry. By 1937 it had a staff of over two
thousand; its members numbered in the hundreds of thousands.
As the chambers reshaped parts of German society, they placed
vast new powers and influence in Goebbels's hands. Leaving
questions of cultural policy aside and considering only the basic
matter of survival, since each chamber was to include everyone
active in its area, people not accepted as members or expelled from
membership were deprived of their livelihood. Writers could be
forbidden to publish, musicians to perform, artists to exhibit or
sell their work or – the ultimate prohibition, which, for instance,
was imposed on Emil Nolde in 1941 – be forbidden to paint.

Throughout 1933 Goebbels's opinions on the question of mod-
ern art remained opaque. He liked the Nolde watercolors that
Albert Speer hung in his Berlin apartment, and it was reported that
Barlach's sculpture *Man in Storm* stood in his office.[7] For a time
he seemed to search for a flexible policy that would allow a degree
of modernism to exist, and in his newspaper *Der Angriff* struck
out hard at rivals and critics – mostly left unnamed – to whom
anything but the most obvious realism in sentimental or heroic
versions went against the National Socialist spirit. But the paper's
venomous attacks reflected Goebbels's wish to destroy Rosenberg

with ridicule rather than a serious exposition of his own ideas.
Since his vision of the National Socialist state of the future was
among the most radical in the party – his search for extremes
further intensified by his implacable anti-Semitism – even at that
early stage some observers believed that Goebbels, notwithstand-
ing his taste or tolerance for the work of some modern artists,
regarded the arts as merely one more building block in construct-
ing the revolutionary police state. Whatever his own views, he
was careful not to irritate Hitler. His speech on the occasion of
the ceremonial book burnings in German universities on 10 May,
in which he gloated over reducing the works of a corrupt un-
German individualism to cinders and ashes, "throwing spiritual
filth into the flames," pointed in the direction that in the end he
invariably chose.

The bonfires, symbolic celebrations of the "black lists" of harm-
ful books drawn up by party cells and individual enthusiasts, which
quickly transmuted into systematic book censorship, were ini-
tially organized by the German Student Union and the National
Socialist German Student Alliance, before the propaganda min-
istry provided support and assumed control. Among the leaders in
Berlin were Fritz Hippler, head of the Brandenburg section of the
Student Alliance, and the painter Otto Andreas Schreiber, deputy
head of the section. Schreiber, an artist of some ability, had joined
the party at the age of twenty-four, and had gained prominence as
a party activist among his fellow art students. Two weeks after the
National Socialist assumption of power, he led a group into class-
rooms and studios of the state art-teacher academy in Berlin; they
threw out several professors who had been denounced as enemies
of the new regime and beat up students who tried to defend their
teachers. Schreiber represented a familiar type in the regime's
early stages: the university-educated humanist, whose ready use

of intimidation and even violence was motivated by intense ideological conviction but coexisted with a cultural idealism beyond the mental horizon of the party's rank-and-file bullies. Simpler and more opportunistic was his comrade Hippler, who, despite a bump or two along the way, came to enjoy a successful career in government and the party.

The book burnings were aimed at Jews, Marxists, and other enemies of the new Germany, but not at modern literature in all its forms. In the fine arts, too, Hippler and Schreiber wanted to draw the line between what they deemed false and genuine modern art. This brought them into opposition with Rosenberg's league, a conflict they welcomed rather than avoided. With their friend Hans Weidemann, now a propaganda ministry official and probably the man responsible for including two of Barlach's sculptures in the German works sent to the Chicago exhibition, they began to beat the drum for modern art in the National Socialist Student Alliance, drew up membership lists, including famous names as well as unknowns, for a new organization, "the Ring of German Artists," and under the alliance's sponsorship planned an exhibition of the Ring's work with the motto "Against French Aesthetics – For a Nativist German Art." Early in June they sent Barlach an account of their activities, and invited him to become president of the Ring.[8] Barlach reacted with caution. He did not know who had chosen the Ring's members and its executive committee, he wrote to the graphic artist Alfred Kubin, to whom he appealed for information. He added with perhaps purposeful naivete: "Nor do I know what the concept 'French aesthetics' signifies."[9] When Schreiber and a colleague repeated the invitation two weeks later, Barlach responded with a definitive refusal: He suffered from "exhibition fatigue," had nothing new to show, found this a difficult time in which to work, and believed he should

continue to wrestle with his art "in self-imposed isolation." The invitation seems to have included the flattering remark that Barlach was ahead of his time, at least Barlach concluded his answer with the words: "Whether as an artist I am in advance of my time or can barely keep pace with it, I dare not decide."[10]

Even as he turned down the invitation, Barlach must have found some reassurance in having been approached by men who evidently held positions of authority in the National Socialist movement and yet stood up for his work. But with his letter he considered the matter closed. Schreiber and Weidemann, however, continued their agitation for modern art, backed by Hippler and the Student Alliance. On 29 June they convened a meeting, under the slogans "Witness of Youth for Art" and "Youth Fights for German Art," in the main auditorium of the University of Berlin, a location Hippler had already used for other National Socialist and anti-Semitic convocations. Before a large and appreciative audience of students and others interested in art, including the director of the national gallery, Carl Justi, they declared their faith in German modernism and announced that they would not accept the imposition of antiquated concepts on the art of the present.[11]

The meeting attracted attention in the public and the press, not only because of the speakers' challenging words but also because one of the organizers worked in the propaganda ministry, which suggested that the meeting represented Goebbels's views, or at least was being used by Goebbels to test how far disagreements on cultural issues were still permissible. Like Goebbels, whom Rosenberg in the 1920s had accused of harboring "pro-bolshevik tendencies," the organizers were veteran National Socialists whose sympathies tended in the direction of the movement's antibourgeois, social-reformist wing; their support of expressionism was in part attributable to their disdain for conventional,

middle-class standards. They now attempted to create a zone of acceptance for expressionism and some of its derivative movements within the body of National Socialist ideology. They believed in the mythic power of German blood, in the essential bond between the German people and the German artist who served the race, whose work expressed in spirit, if not necessarily in form or thematically, the Nordic, Aryan values that had sustained Germans through centuries of delusions and betrayals and that were now infused with political power and given new life by Hitler. Inevitably, anti-Semitism formed the negative side of the organizers' Aryan ideal, and the elimination of Jews in the arts and in the cultural institutions of state and society was one pragmatic expression of this idealism.

But anti-Semitism could also help to identify positive forces in the arts. In a daring reinterpretation of the historical record, Schreiber sought to mobilize anti-Semitism for the cause of expressionism. Jews had introduced impressionism to Germany, he declared with only slight exaggeration. But impressionism was superficial, it lacked soul. Between impressionism's international, non-German style and the even more destructive force of abstract art, Schreiber positioned expressionism as it progressed by way of a Nordic modernism to the goal of a more politically informed German art, an art that reflected not only the National Socialist spirit but also the new, technology-oriented way of life of the modern German: "With their credo of inwardness as the sharpest rejection of surface-superficial art," such expressionist and truly German artists as "Barlach, Nolde, Heckel, Schmidt-Rottluff, Marc, and Rohlfs...led a total war against impressionism." Inevitably these artists and their vision were betrayed by Weimar: "The Jewish republic, sensing that they were its enemies, completely and *intentionally* [emphasis in the original] denied the

significant meaning that the founders of expressionism had for the German soul." Schreiber's praise of expressionism reached a cultural-political climax with the reassuring assertion of faith: "Our blood instinctively rejects the Jewish people and its art."[12] In his excitement Schreiber overlooked the fact that Franz Marc, one of his champions of German inwardness, had a Jewish grand-father, that the art dealer Paul Cassirer, whom he excoriated as a Jewish trader, was Barlach's friend and most important supporter, and that Kandinsky, whose abstract art Schreiber hated and whom he classed among Jewish artists, not only was not Jewish but was himself said not to be free of anti-Semitism.

It was against the backdrop of such steamy fantasies of blood and soil that Schreiber and Hippler proclaimed the freedom of modern German art. Following their lead, the meeting on 29 June passed a resolution declaring that "the principal threat to the birth of a new art lies in the narrow-minded exclusion of valuable German artists from this collaborative effort [to regenerate the nation and its culture] for reasons not related to their personalities or work; and, on the other hand, in the preference shown to men, who, though worthy enough, confuse the academy of the Wilhelmine Reich with national art."[13] No one doubted that the worthy men referred to were the members of the League for German Culture and the academic painters they championed, and that Schreiber was calling for liberation from Rosenberg's tutelage. But not satisfied with delivering this clear message, he went further and announced the dissolution of the league sections in the Berlin art academies – a challenge that could only strengthen the response that was sure to come from Rosenberg.

The "Witness of Youth for Art" was organized less than six months after Hitler took power, following on the first wave of major National Socialist initiatives, when many uncertainties

remained, countless details awaited resolution, and people still tested the regime's intentions and determination. The National Socialist leadership was also beginning to grow concerned over the unauthorized actions of many party members, which at least at the edges interfered with centralized control. The students' meeting of 29 June and their planned exhibition could be seen in this light. In the course of the next days a number of important decisions were announced, not in direct reaction to the "Witness of Youth for Art," but all emphasizing the authority of the central leadership. On 30 June, Hitler issued a decree further defining the duties of the new Ministry of Propaganda, which, it has been said, "gave it all the responsibilities of a Reich Ministry of Culture, aside from the fields of science and education."[14] The following day, Justi was suspended from the directorship of the national gallery – the museum's retention of works of expressionism as the core of the most visible collection of modernism in the capital of the Reich being one of the republican ruins still dotting the cultural landscape, which National Socialism was now leveling. At the same time Hitler declared that the National Socialist revolution had reached the stage of consolidation – the real or pretended fear of a "second revolution" serving to discipline the party, until the bloody denouement of June 1934 made further warnings unnecessary.

On 7 July, Rosenberg, recently appointed one of seventeen party "leaders of the Reich," a title that gave him a boost in status if no additional power, reacted publicly to the meeting at the university. He published an article in the *Völkischer Beobachter* in which he denounced the students' praise of expressionism as a political error, even a disloyal act, and played on Hitler's theme of the revolution concluded by pointing out that although the Third Reich had entered a phase of consolidation, the organizers of the meeting continued to refer to themselves as revolutionaries. For

their spiritual leaders they had chosen Nolde and Barlach; in Rosenberg's emotionally charged phrase, they had "raised them onto the shield," which returned the issue to the historical period dearest to him, the age of Germanic tribes before the coming of Christianity, when warriors proclaimed their king by lifting him on a shield. But, Rosenberg continued, these artists demeaned their considerable ability and – in Barlach's case – technical mastery to create false visions. As an example, Rosenberg pointed to the Magdeburg memorial, which, as we know, he had denounced as a corrupt work for its disregard of race and heroism in the nation's service. He conceded that true National Socialists might follow different paths toward a new art; but no one had the right to cross the political boundaries that defined the new Germany. In a second article Rosenberg went so far as to compare Schreiber to Otto Strasser, the leader of a left-wing National Socialist splinter group, who had left the party in 1930 and fled Germany after Hitler became chancellor.[15] Rosenberg also let it be known in the party that Schreiber's behavior was unacceptable, and on 14 July Schreiber publicly apologized for his statements.

Despite these danger signals, Schreiber and his associates did not give up on their planned Ring exhibition, which opened on 22 July under the title *Thirty German Artists* in the Ferdinand Moeller Gallery in Berlin. Actually the exhibition showed the work of thirty-three artists, among them Barlach. The organizers – a small irony – borrowed two of his carvings from the gallery of the Jewish art dealer Alfred Flechtheim. Other sculptors represented were Kolbe, generally accepted in the party despite his modernist background; Lehmbruck, whose towering figures – by now twentieth-century classics – were particularly offensive to National Socialist taste, and Gerhard Marcks. In 1937 works of both men were shown in the degenerate art exhibition.

Painters included such notable expressionists as Heckel, Macke, and Schmidt-Rottluff, as well as Nolde. Despite having been a member of the National Socialist party in north Schleswig in the early 1920s, Nolde was unacceptable to Hitler because of his interest in Old Testament themes and the violent distortions and colors in his work. Weidemann and Schreiber were two of the newcomers. Even protagonists of modernism, who approved of the show's political message, found it disappointing. Fusing large numbers of disparate works into a convincing modernist whole was evidently beyond the capacity of the organizers and the gallery. But a few newspapers not yet fully emasculated by the party welcomed the show as a sign that works of quality from an earlier age continued to play a role in the culture of the new. After three days, Frick, who two years earlier in Thuringia had given the country a preview of the nature of National Socialist cultural policy, and was now the Reich minister of the interior, closed the exhibition. It reopened the following week without the imprimatur of the National Socialist German Student Alliance, and after Nolde's and Barlach's works had been removed. A few days later, Schreiber and Hippler were forced out of the alliance. It is not known whether Rosenberg had them expelled or they were allowed to resign.

The revolution to establish a Nordic modernism, so-to-speak by acclamation within the party, had failed. That Hitler had not openly intervened to bring the failure about is not its least telling aspect. As was his practice, he allowed his lieutenants to fight over issues and resolve them within the limits he set. On their part, it demanded a sensitivity to his probable intentions, as well as to the power relationships and to prevailing trends in the party and government. In this case they were with Rosenberg, to the extent that the party leadership took art itself – as apart from its importance to the Führer – seriously at all.

Nevertheless, even within the party some efforts to salvage parts of the artistic heritage of modernism handed down from the empire and the republic continued, as they did, more openly, in the country at large. Some museums and private galleries still showed works of art in contention, a few newspapers and art journals published positive articles, and museum directors everywhere tried to defend their collections against confiscation. But mostly these were separate initiatives, not connected and coordinated, and organized demonstrations such as the meeting of 29 June did not recur. Increasingly, the defenders of modernism fought rearguard actions against opponents whose strength was rapidly expanding. The issue of modernism in its various forms remained unresolved. Aside from a few pregnant comments, Hitler had not yet enunciated his position with unambiguous clarity, but the direction in which policy was headed was becoming apparent.

The fate of the three leaders of the failed revolution in art was indicative of this trend. That despite their very public defeat at the hands of Rosenberg they managed to survive comfortably also illustrates the intermingling of modernism in National Socialist thought and attitudes that is a ubiquitous and characteristically convoluted part of the history of the Third Reich. That each man had joined the party before the great flood of newcomers arrived in January 1933, and that at least Weidemann and Hippler possessed the party emblem in gold – the mark of membership in the party when it was still a struggling band of radicals – went far in determining his future. Hippler's path now diverged from that of the others. In a steep trajectory, helped by his membership in the SS, he rose to be head of the film section in the propaganda ministry and became one of the men who under Goebbels's close supervision determined the character of German film production. He combined his administrative duties with work on a number of

films. In 1940, as the solution of the "Jewish question" was about to enter its ultimate phase, Hippler helped plan and directed the film *The Eternal Jew*, one of the most vicious specimens of the anti-Semitic propaganda with which the regime thought it advisable to inundate the German public, notwithstanding the already existing feeling against the Jews, to help justify whatever was beginning to be done to them in the East.

In the course of the summer Goebbels decided on the staff of the new segment of his ministry, the Reich Chamber of Culture, and appointed Weidemann to the executive committee of the Chamber of the Fine Arts. In November, shortly after the chamber began to function, Weidemann had the nerve and poor judgment to propose Nolde for its presidency, and on Hitler's orders he was dismissed from his post. It was only prudent for Goebbels to remove Weidemann from the ministry for the time being, but he found a place for him as chief of the cultural section in Ley's strength-through-joy program. Weidemann, in turn, arranged for his friend Schreiber to head the section's program of art shows for workers, in which capacity Schreiber began to organize exhibitions that included modern art. This again roused Rosenberg to action, and he was now in a somewhat stronger position to impose his views. In January 1934, Hitler had finally responded to Rosenberg's repeated requests for an appointment related to cultural policy by designating him deputy of the Führer "for the supervision of the entire intellectual and ideological schooling and education of the party and of its coordinated associations." Once again Hitler had granted one of his followers authority or seeming authority that duplicated, overlapped, or conflicted with the responsibilities of other senior officials, without having clearly defined the mission of the new appointment or regulated the relationship between the relevant offices. He did not even discuss

the matter with Goebbels and others who were most closely concerned.[16]

Rosenberg's new title was, in fact, not linked to a government position, nor was he given specific authority over the arts; nevertheless he now had some official justification for intervening in the party's cultural activities. In March he protested to Ley that Weidemann and Schreiber represented a cultural direction diametrically opposed "to the ideals for which the party had fought for fourteen years."[17] In consequence Weidemann was transferred back to the propaganda ministry, where he eventually became deputy head of the film chamber in the Reich Chamber of Culture. Goebbels could not, however, prevent Ley from replacing Weidemann with one of his own men. Schreiber stayed. With Goebbels's silent approval he founded a journal as a voice for those interested in modernist National Socialist art, with the assertive title *Kunst der Nation*, but was soon forced to resign the editorship. The journal continued to appear until Goebbels withdrew his protection in 1936, having come to realize that Hitler would allow no deviation – however small and controlled – from the narrow line of officially approved German art, and that Nordic modernism had no future in the Third Reich. Two years later, one of Schreiber's woodcuts was included in the degenerate art exhibition. Nevertheless, he was able to retain his position in the cultural section of the strength-through-joy program. Until well into the war he mounted dozens of shows for workers and employees in factories, canteens, and meeting halls, which included paintings and sculptures of artists whose work could no longer be shown elsewhere in Germany.[18]

Hildegard Brenner, one of the pioneers of the study of National Socialist cultural policy, has commented that it is not clear why an opposition movement – even one that stressed its own ideological

purity – developed in the fine arts rather than in music, literature, or architecture, and furthermore succeeded in reaching a broader public.[19] A few brief references to the state of the arts in 1933 may throw some light on the issues raised in the first part of her observation, even if they cannot provide a complete answer. That in the first year of the regime an act of organized defense of modernism took place in the fine arts while elsewhere only individual actions occurred, such as Wilhelm Furtwängler's attempts to protect Jewish musicians, and his and Erich Kleiber's defense of Alban Berg and Paul Hindemith, is presumably attributable to the different course of development of the various media, to their stylistic dissimilarities, perhaps also to an uneven distribution of talent and achievement. In painting and sculpture few, if any, major figures still worked in relatively conventional styles – the sculptors Fritz Klimsch and Georg Kolbe, neither well known outside Germany, were probably the most notable. Significant achievement was limited to modernism. That was not true in literature. Of the more important German writers, some were Jews, who, whatever the character of their work, could not contribute to a modernist literature viable in the Third Reich. But among non-Jewish writers a relatively large number with stronger-than-average talent were accepted by the regime – Gerhart Hauptmann, Agnes Miegel, Ernst Jünger, and Hans Carossa come to mind. Some of them had not moved far beyond the late achievements of naturalism. Others – notably Gottfried Benn – worked within the broad current of European modernism. Nevertheless, in literature the conventional still claimed some vitality, and the educated public did not, in general, draw the dividing line as sharply between the traditional and the modern in literature as in the fine arts.

Nor did modernism have the same hold on the musical public that it claimed in painting and sculpture. Atonality did not

possess the same presence as expressionism. Some major com-
posers, no longer at the forefront but still writing music that in-
terested the sophisticated listener, accommodated themselves to
the regime. Richard Strauss, no admirer of Hitler, could live in any
environment that did not seriously interfere with his work. Hans
Pfitzner hoped for more than the new masters were willing to
give, but his work was performed, and he received a modest share
of honors and titles. Younger composers, like Werner Egk and
Carl Orff, salvaged enough dissonance and syncopation to per-
suade their audiences that they were keeping up with the times.
Many distinguished conductors and performing artists enjoyed
successful careers in the Third Reich. In architecture, a not in-
considerable number of modern architects, even from the Bauhaus
circle, made their peace with the regime. If the representational/
symbolic structures now built – ministries, sports arenas, memo-
rial temples recalling the party's struggle for power, schools for
the party elite – were almost without exception historicist in spirit,
many bridges and stretches of the *Autobahn* were shaped in con-
temporary terms; and in industrial design – the streamlining of
automobiles, for instance – as well as in furniture, dishes, cooking
utensils, wallpaper, and other items of interior design, modernism
retained a strong voice. In short, the break between the conven-
tional and the avant-garde was harsher in painting and sculpture
than in the other arts – at least so it appeared to many who were
not artists in one or the other medium, but who made up the inter-
ested public on whose potential sympathy revolutionaries depend,
in the arts as in any other field.

The answer to Hildegard Brenner's question – why did the
opposition movement in the fine arts reach the broader public? –
must lie in the nature of the regime. Under National Socialist
control and terror, openly voiced opposition on a larger scale was

conceivable only with at least partial institutional protection by the churches or the armed forces, or from within the system. Criticism was certainly expressed throughout the arts, but it was scattered and sought safety in caution and obscurity. Had the Third Reich lasted longer than its twelve years, criticism may possibly have become more assertive over time and coalesced to have a significant impact. But the evidence is clear that in the six years before the outbreak of the Second World War, and during the war itself, major changes in cultural policy could have been brought about only by people with a measure of authority in party and government, officials of one kind or another, who could organize assemblies, demonstrations, and even more far-reaching public actions – the book burnings in May 1933, for instance – under cover of an organization such as the National Socialist German Student Alliance.

The "Witness of Youth for Art" movement was launched by leaders of the Student Alliance with connections to the propaganda ministry. It was brought down largely by Rosenberg, who in this instance managed to align his idiosyncratic ideas with the more general concerns of the party leadership. His success must have irritated Goebbels, to whom in other respects the failure of Schreiber and his associates could have meant no more than a small disappointment, and – more significantly – an indication of the strength and weakness of the modernist position.

In the rivalry between Goebbels and Rosenberg over political power, the meeting on 29 June and the following art exhibition *Witness of Youth for Art* marked a skirmish that Rosenberg won even as he was losing the war. The build-up of the propaganda ministry and the Reich Chamber of Culture continued unimpeded. Goebbels's implementation of national cultural policy, even if he did not control its wellsprings, and his economic

and social authority over every individual active in the creation and dissemination of culture overwhelmed Rosenberg. The grandiose ideological schemes of the Führer's deputy for the supervision of the party's ideological purity were reduced to interfering with, and sometimes terrorizing, individuals who had strayed too far from cover. Until the defeat of France in 1940, when an assignment to confiscate books and documents owned by Jews led to the formation of "Office Rosenberg," which soon made its mark with gigantic robbery raids on art and art objects across occupied Europe, Rosenberg remained a political power of the second or even third rank in the party hierarchy. But in his ability and eagerness to feed the most extreme attitudes in party and society, he possessed an importance that went beyond organizational charts and political maneuvering. Any fanatic in the areas of cultural politics, of ideological refinement in searching out Jewish influence and eliminating its source, could count on his inspiration and support. Hitler ridiculed Rosenberg, left him largely impotent, repeatedly prevented him from imposing his absurd reconstructions of old-Germanic lore on German daily life; but in the most basic sense of judging every social phenomenon according to the racial concept of Aryanism, and of mechanically but with deep satisfaction destroying whatever did not fit, the Führer and his most loyal shield-bearer were as one.

4

The Hounding of Barlach

"**I**f, as petitioned, my memorial is removed from the Magdeburg cathedral," Barlach had written in the spring of 1933, "others will follow."[1] In concept and detail his monument rejected the message of patriotic struggle and triumph that was sweeping the country, and denying the party's rhetoric now meant opposing the state. Before 1933, war veterans' associations and their ladies' auxiliaries might feel insulted by Barlach's unheroic way of remembering the war dead. The new leaders, if taken at their word, could be expected to brand his work an insult to the national community, and deal with it appropriately. Objections to the monument intensified. By May demands for its removal had reached the office of the regional art and monument conservator; in the following months the proposal was discussed at high levels in the church, government, and party, until in August 1934 it was announced that the memorial would be transferred to the national gallery. After renewed protests by Rosenberg, the museum rescinded the plan to install the sculpture in one of its galleries.

Instead it was placed in storage.[2] That more than a year and a half passed before the monument was finally removed, despite all Rosenberg and his allies could do, characterizes the early, unresolved state of the relationship of National Socialism to art. A degree of tolerance for modern art persisted, provided it was not abstract or the work of Jews; at least people remained uncertain about the direction of official cultural policy, and church and government officials could still feel free to say that despite everything Barlach was an important German sculptor. But as the argument over the monument moved back and forth, the general ideological and political issues narrowed to concentrate on the person of the artist. The processes of National Socializing the country were fed by the search for those who rejected the new values. They were hunted and imprisoned or destroyed, or hounded until survival became their main occupation and they were pressed into silence.

As his professional world shrank, Barlach remained outwardly calm. Rumors that he was a communist propagandist or that he had been arrested and was now in a concentration camp were easier to bear than anonymous attacks; he expressed his rage over unexplained cancellations of exhibitions and performances only to Marga Böhmer and to a few friends and acquaintances.[3] Another kind of attack had to be confronted openly. The accusation, occasionally raised since the 1920s, that Barlach was a Jew, now became ubiquitous. In July, Alois Schardt, the provisional director of the national gallery after Justi was relieved – himself, despite his Germanic mysticism, soon to be replaced and arrested – asked Barlach for assurances of his Aryan ancestry, without which his graphics could not be included in an exhibition. Barlach responded with some "genealogical fragments," adding that although the assertion that he was Jewish had caused him serious harm, he did not want to issue a public correction, especially at this time, nor did

he feel insulted by the gossip. But he recognized it as an attempt to influence public opinion against his work.[4] This private clarification was insufficient. Friedrich Dross, an admirer and friend of the artist, and later editor of his correspondence, wrote after the war that "the assertions on the part of National Socialists that E. B. was a Jew were tantamount to a sentence of death."[5] Matters had not gone that far in 1933, but if Barlach still hoped to exhibit and sell his works in the new Germany, the record had to be set straight, and with Barlach's assistance Dross found documentary proof that on his father's as well as on his mother's side Barlach descended from gentile families that for generations had lived in the shifting border area of Schleswig and Denmark.

To give these facts wider circulation, Dross published them in the guise of an anecdotal article in a regional journal. At the end of the year Barlach wrote to a friend that for a Christmas present he had received an

almighty family tree, which others assembled for me by the sweat of their brow. Seeing it fills my heart – which is, in any case, occasionally sorrowful – with sadness. To think that such a thing is necessary, and almost imperative! . . . And what is one to do with the 'federation pin' of the Reich Headquarters of the Reich Federation of German Writers, for which I am supposed to pay one mark? My membership number is 5865. Until now I was a free man, who handled pen or chisel as he wished. Now I am regulated, catalogued, enrolled, and favored with a pin. Does one have to wear the thing? Quick, let's change the subject![6]

A few weeks later he read that the National Socialist party newspaper in Mecklenburg had condemned the publication of his family background as "an act of willful opposition."[7]

On one occasion he allowed himself to strike back. In October he received a questionnaire from the north-German section of an association of German artists, the "Reich Cartel of the Fine Arts," a temporary umbrella organization for existing art associations,

which was soon incorporated into the propaganda ministry's new Reich Chamber of Culture. In a covering letter, an obscure sculptor who had risen to a position of authority in the organization threatened Barlach with "artistic and economic consequences" if he failed to answer the questions or did not answer them truthfully.[8] Barlach responded that the assumption that he might lie was an impudence (*Dummdreistigkeit*), and he did not return the questionnaire.[9] The exchange was typical of the clashes occurring throughout the country between traditional civility and a new order based on threats and worse. In this instance, the new order was represented by a weakling. The sculptor-functionary was not heard of again, and Barlach enjoyed a brief sense of relief.

A more serious encounter, this with a high-ranking party leader, occurred several months later. In February 1934, Friedrich Hildebrandt, head of the party in Mecklenburg, as well as the state's governor and thus the Reich's senior regional representative, gave the keynote address at the tenth annual meeting of the party in Lübeck. A passage in his speech was directed against Barlach. Hildebrandt had begun his political life as a twenty-one year old in a free corps after the First World War, waging guerrilla or terror campaigns against Poles in Silesia and the new Baltic states. For a short time he served in the police, but was dismissed for brutality. In 1923 he became a National Socialist, rising quickly through the ranks. A disagreement with Hitler, whom he criticized for associating with industrialists and allowing the party to drift from its original revolutionary fervor, was soon healed. But Hildebrandt, secure in his provincial redoubt, always retained a good deal of independence. After becoming chancellor, Hitler felt compelled to ask him not to appoint senior officials in the state without previous consultation; Goebbels called him the little king of Mecklenburg.[10] He reached the equivalent rank of four-star

general in the SS during the Second World War, at the end of which he was arrested, tried for war crimes, and condemned to death by an American court. He was executed in 1948.[11] To an "Old Fighter," who early on had made Mecklenburg one of the stronger bases of National Socialism in Germany, and who had no patience with the cultural and political ambiguities that pre-occupied his peers and superiors in Berlin, it was not acceptable that Mecklenburg's most famous artist would not fit the National Socialist pattern. "Ernst Barlach may be an artist," he instructed his party comrades, "but German nature is alien to him." He continued with a term that revealed his corporative view not only of society but also of art: "The artists' guild [*Künstlerstand*] has the duty to comprehend the German in his simple honesty, as God created him." Aside from Barlach's memorials it was his vision of the German peasant and worker as Everyman, caught between external forces and the equally mysterious forces of his self, that offended the governor: The German worker of the land is not lazy or dreamy, but a "hard, self-assured man, with the will to overcome all difficulties, making his way with brutal fist, sword in hand."[12]

Barlach responded with a polite letter. He expressed regret over Hildebrandt's criticism and declared that his art had been inspired by the north-German people among whom he lived; but he did not attempt to change Hildebrandt's mind. He merely asked to be informed of his rights as an artist and a citizen when faced with unexplained prohibitions and censorship. Should he plan his future with the expectation that these conditions would continue? Hildebrandt's lengthy answer did not mention rights, and it was apparent that in Mecklenburg at least Barlach would no longer be given the opportunity to present his work to the public.[13]

A week later the attack on Barlach spread from Mecklenburg to the whole of Germany. Several newspapers and journals that

still retained remnants of independent judgment favorably re-
viewed an exhibition by the Union of Jury-Free Artists in Berlin,
which included works by Barlach. Rosenberg reacted immedi-
ately. On the front page of the party's national newspaper, the
Völkischer Beobachter, he warned once again that the achievements
of National Socialism were threatened by Jews and by "a very con-
siderable number of [gentile] associates of Jews, who only on the
surface have adjusted to the new conditions [*bloss äusserlich gleich-
geschalteter Judengenossen*]." He named Barlach, Klee, and Nolde
among those whom "they try to pass off as artists of *our* time,"
and he declared that although "from a purely technical point of
view, Barlach is undoubtedly superior to the others," one needed
only to visit the jury-free exhibition "to experience the gaping
horror of anti-artists alienated from nature." The article con-
cluded with the barely literate statement, "that . . . his admirers
confuse the half-idiotic expressions [of Barlach's figures] with
passion and devotion is the barrier that separates us from his
defenders."[14] A second article followed a few days later, this one
by Robert Scholz, the paper's art critic. Scholz grouped Barlach
with Nolde and Lyonel Feininger as representatives of a "thor-
oughly senile [*vergreiste*] and outdated concept of art," who are
used by others "as battering rams against the National Socialist
Weltanschauung."[15]

In these days, the modernist threat more than usually alarmed
Rosenberg and Scholz. Less than two weeks later, their suspi-
cions were confirmed by a loan exhibition from Italy of futurist
Aeropittura in the Hamburg Kunstverein. It evoked Scholz's bitter
criticism. The Italian scholar, Ruggero Vasari, who had written
the introduction to the catalogue, protested that Scholz misinter-
preted both the exhibition and his text, and cited Mussolini to the
effect that one could not live on the art of the past but needed an

art of one's own age. He added that the Italian organizers of the exhibition had no intention of influencing German "art political conditions." Scholz rejected Vasari's explanation in a second article, "For and against Futurism," in which he complained that such foreign exhibitions of "extreme 'modernistic' directions" were exploited by "German supporters of international art fashions [*internationalen Kunstmoderichtungen*]." To make Vasari's defeat complete, Scholz cited the most prominent modern Italian painter, Giorgio de Chirico, as condemning futurism for its "neglect and distortions of the human form."[16] Nevertheless, the exhibition moved to Berlin, although Goering and Goebbels, who were listed among the honorary members of the sponsoring committee, did not attend the opening, thinking, perhaps, that after the articles in the *Völkischer Beobachter* prudence was advisable.[17] Scholz had the last word. In a further article he declared that the exhibition demonstrated that futurism was a dead end.[18] Coming so soon after Barlach's inclusion in the exhibition of the Union of Jury-Free Artists, the show of Italian painters sounded an alarm that blocked out even Rosenberg's and Scholz's admiration of fascism.

The two prosecutors of false art made an interesting pair: the deeply troubled autodidactic party theorist, whose criminal tendencies meshed with a sincere belief in National Socialism; and the opportunistic art-academy student, who before 1933 had developed his tepid expressionism under a Jewish teacher, but who wasted no time in changing sides when the revolution came. Actually, the amoral ideologue and the amoral careerist represented familiar types in the leadership cadres of the Third Reich. "The *Völkischer Beobachter* has wildly vomited on me," was Barlach's reaction to their diatribes against him; but he felt in part responsible for the prohibition against further exhibitions

with which the jury-free union paid for the courage to include his work. Even so, the ring of official disapproval had not yet fully closed. At the end of March, a provincial theater near Hamburg, safely beyond Hildebrandt's reach, put on Barlach's tragicomedy *Der blaue Boll*. It ran for twelve performances, which the author welcomed as "a ray of light in gloomy times."[19]

From the first days of the new regime, Barlach had a clear sense of its criminal character, and he did not keep his dismay and disgust at the changes occurring in Germany to himself. In May 1934, in a characteristic mixture of bluntness and irony, he wrote a friend that it was time for "heads to roll" – the heads of people who complained about the new conditions: "The question is only, how do we find the many executioners that are needed? Not every unemployed man can be quickly trained to become a good, productive hangman."[20] Nevertheless he did not yet give up hope. He may have placed too much weight on his own situation, but any sign that his work found supporters in the party and the bureaucracy rekindled his belief that despite everything a return to decency and justice remained possible. Might it not indicate a shift in policy that a Berlin radio station had broadcast excerpts of an account of country life from his diary? And how was he to interpret a small notice that appeared in the *Völkischer Beobachter*, in the same weeks as the articles by Rosenberg and Scholz, which announced without the customary insults that Barlach had changed publishers for his dramatic works, and continued, "This German poet and graphic artist will celebrate his 65th birthday [on 2 January 1935] in the coming theater season."[21] But a minor relapse into the neutral businesslike tone of a former age did not indicate that the regime might shift course toward legality and order, merely that the National Socialist mobilization of the country was not yet seamless.

Barlach's uncertain, intermittent hopes, which he shared with many others at the time, were fed by a trait in his personality that now became very apparent. Despite massive evidence to the contrary, to which he responded not passively but with outrage and protest, he found it difficult to accept the reality of the aggressively unjust state. Whatever the psychological and cultural sources of this difficulty – and growing up in a family of the educated middle class in the halcyon days of the Wilhelmine empire could imbue one with a profound faith in law and order – he continued to argue with party officials and the secret police over what were and what were not inalienable rights. As late as 1937 he could write a short essay, addressed to himself, in which he demonstrated logically that he was being treated unjustly, and yet stated that his "ultimate trust in the function of justice remains unshaken."[22]

Linked with these lapses of realism in an otherwise combatively realistic individual was the fact that despite the right wing's attacks on him before 1933, it was not until 1936, when repression of his work entered a new phase, that Barlach understood with finality that in the Third Reich he would be judged on ideological grounds alone. By intent he was an apolitical artist, even if the impact of his sculptures could be highly political. But the sense he had of himself and of his art made it difficult for him to meet political attacks on his work except by insisting on its apolitical character and, beyond that, by declaring that the artist was owed the absolute right of self-expression.

Friends and even some sympathizers in the party advised him not to call attention to himself "until things had settled down." Barlach did his best to comply. "Hostilities and suspicions of all kinds have battered me to such an extent," he wrote to an admirer who feared that National Socialism would destroy Barlach's work, "that the only thing I can think of doing is to isolate

myself as much as possible."[23] To avoid giving further offense
he turned down invitations to exhibit. Periodically he tried to
exercise greater discretion in his correspondence. Occasionally
he gave letters to friends to deliver rather than risk having the
Gestapo read them, and he burned papers that the authorities
might find incriminating. He believed that in his absence his house
had been searched. On one occasion strangers insulted him in the
street, which led to what he later called a state of panic.[24] His
mood wavered between accepting the inevitable with dignity, and
telling himself and others that he was a "mean old monkey," who
could bite if driven too far.[25] That, like his brother Hans, his son
was "caught up in the anti-Semitic craze" was a further concern.
When both became ill, a physician "with a Jewish-sounding name"
helped them, which, he noted grimly, "seems rather a pity."[26]
Economic worries added to the strain. For much of 1933 he had
little or no income. A loan from his brother and two grants from
foundations, administered by the Prussian Academy of Arts, to
which he still belonged, tided him over until he was able to sell
a few small pieces. Under the circumstances, he found it amaz-
ing that "some people, among them National Socialists, have
the courage to buy a bronze or even commission a small wood
figure."[27]

His work was affected by the difficulties of his life. His energy
and creativity declined, for which not only his intermittent chest
pains but also the continuing disappearance of opportunities must
have been responsible. Above all, the collapse of the republic
brought an immediate halt to two projects to which he had given
much of his time. In 1929 the Lübeck museum director, Carl
Georg Heise, invited him to sculpt a number of glazed brick
figures for the facade of the medieval church of St. Catherine.
Three of the larger than life-sized figures of *The Community of*

Holy Ones were completed by 1933 [Fig. 26]. Then Heise was dismissed from his post for his support of Nolde and Barlach, and the project was terminated.

The sculptures embody major motifs in Barlach's work. In the central niche, as they are placed in the church front today, a beggar balances on crutches, his head lifted in supplication and devotion. On his left, a young chorister, the personification of calm and unselfconscious beauty, sings words and music from a sheet he holds in his hands. On the other side, the tragic figure of a woman, her face expressive of knowledge and suffering, stands still in the wind, which blows her cloak in long folds across her body. Barlach often depicted men and women in the wind as metaphors of the human condition; together the three figures may be seen as a concise statement, not in a formal but in a psychological sense, of his reading of humanity.

In the late 1920s, Barlach had developed another, similarly serial concept, *The Frieze of Listeners*, eventually nine wood figures, each over three and a half feet high, which a collector agreed to buy with periodic payments. Here, too, the project was interrupted after Barlach had completed three figures. In the economic crisis of 1931 the buyer's firm failed, and he was unable to continue the payments; after Hitler gained power Barlach could not risk investing further time in a group that would take much longer to finish and especially in the new conditions would be more difficult to sell than a single figure. He concentrated on what he regarded as less important and less challenging pieces, but felt, as he said, "driven by a mean recklessness" toward ever more radical conceptions.[28]

In August, a year and a half after Hitler's appointment as chancellor, and in the same days in which the decision to dismantle the Magdeburg monument was announced, Barlach took what was to be the one misstep in his encounter with National Socialism. On

2 August, Hindenburg, still the formal head of the German gov-
ernment, died, and Hitler proceeded to combine the functions of
president and chancellor in his person. To add the mark of public
approval to this further concentration of authority, a plebiscite
was to be held on the 19th, and the propaganda ministry drafted
supporting statements signed by prominent individuals for pub-
lication before the vote. On being asked to sign the "appeal of
the culturally productive," Barlach declined. When telephoned a
second time by an official in the ministry who admired his work,
and who read him the names of the other signatories, he assented,
so that, as he explained to his brother, he could put a stop to the
charge of cultural bolshevism against him – "until they are dragged
out of the box again."[29]

Formulated in Goebbels's fulsome German, the "Declaration
for Adolf Hitler!" avoided all specifics. After glorifying the "young
Führer," who had "offered speech and life to restore our people,"
and proclaiming the nation's "confidence in his mission, which
demands dedication beyond all carping intellectualism [*krittelnden
Vernünftelei*]," the statement ended: "The Führer has again asked
us to stand with him in confidence and loyalty. None of us will
remain apart when the time comes to be counted."[30] Thirty-seven
names followed, arranged alphabetically, except that "Barlach"
appeared second, behind "Werner Beumelburg," a popular au-
thor of novels glorifying war and patriotic sacrifice. Evidently the
ministry wanted to avoid the embarrassment of heading the list
with someone whose National Socialist sentiments had been re-
peatedly called into question. Among other signatories were the
presidents of the Reich Chambers of Literature and the Fine Arts,
as well as any number of now forgotten writers, artists, architects,
and academics; but also included were the architect Mies van der
Rohe; the painters Emil Nolde and Erich Heckel; the sculptors

Georg Kolbe and, one of Hitler's favorites, Joseph Thorak; the writers Rudolf Binding and Agnes Miegel, neither of whom was a National Socialist; and, among musicians, Richard Strauss, Hans Pfitzner, and Wilhelm Furtwängler.

That Barlach's name appeared on such a document distressed both National Socialist ideologues and their opponents. Rosenberg complained that it was degrading to beg signatures "from those against whom we have waged a total cultural-political war for years."[31] To a Jewish admirer of Barlach's work who was about to emigrate and now wrote the artist to express his amazement and disappointment, Barlach responded with Pilate's "What I have written I have written."[32] But although no more than a symbolic gesture given under duress, signing the appeal marred his record of detachment from National Socialism, and his rejection of it, and was a mistake even from the perspective of immediate self-interest, for it did nothing to bring the attacks on him to a halt.

The frustrations and insults Barlach suffered at this time might be compared in war to receiving exploratory fire from patrols fanning out into unknown territory, while to the rear armies are preparing for a major offensive. A reconnaissance in force was signaled by Hitler on 5 September 1934 in his speech on culture at the annual Reich party rally in Nürnberg. Once again Hitler disappointed followers who expected a clear-cut statement of policy. After outlining the fusion that turned various "racial cores" into the German people, parallel to which a new culture would be fused, and calling for respect for the cultural achievements of earlier generations without necessarily agreeing with all of their values, he identified two dangers that faced German culture after the National Socialist revolution. One danger was posed by cultural bolsheviks: "As though nothing has happened, these cultural

assistants of political destruction attempt, in their innate, naive nonchalance, to enrich the new state with their stone-age culture" – this a reference to the "primitivism" of modern art. The second danger consisted in "those backward-looking individuals, who believe they must transmit a 'Teutonic' art, created out of the confused world of their romantic imagination, to the National Socialist revolution as a duty-bound inheritance for the future."[33] In their familiar combination of prohibitions and ambiguities, Hitler's words narrowed the scope for acceptable modernism on the one hand, but rejected antiquarianism and the carryover of nineteenth-century bourgeois traditions on the other. Without yet becoming specific, Hitler demanded an art that expressed the values and possibilities of the present, as defined by National Socialism.

For the time being, artists and cultural officials were left to feel their way between forbidden alternatives. Rosenberg and his allies were shaken. A number of veteran cultural warriors, like Paul Schultze-Naumburg, who had ridden high in 1930 when schools and museums in Thuringia were purified of internationalism – whether that of Jews or of their gentile minions like Barlach – and who was still sufficiently well known to appear as a signatory of the "appeal of the culturally productive," now left the field and faded into obscurity. At the same time Schultze-Naumburg and others like him were reassured that even those modernist artists to whom Goebbels tentatively and intermittently lent some cover, in case Hitler might yet approve a more accommodating cultural policy, were unlikely to face a promising future.

From an external perspective, the development of National Socialism's cultural policy and the development of its policy toward the Jews show a number of similarities. Common to both was the thesis that the corrupt elements of modern culture, from

which National Socialism had saved Germany, expressed Jewish rootlessness and consequent lack of idealism, and Jewish intent to capture Germany for capitalist or Marxist internationalism. After January 1933 both policies began with powerful terroristic acts – arrests, dismissals, boycotts – after which they settled into repressive courses that at times might appear to move in a more conciliatory direction. Despite restrictions and losses, Jewish life in the professions and in business and culture persisted, just as most of the artists now officially out of favor could still find a gallery or an exhibition for their work. As time passed, the possibility faded of coexistence with the majority on terms that might be unfavorable but were at least stable, that is, Jews isolated in German society but with their own social and cultural institutions; a supervised, but tolerated, minority. Instead, the impending end of the Jews, first in Germany, then in the camps to which they had been shipped, became apparent. Among the differences between the two policies was the degree to which their goals were subject to change. In 1933 the extermination of the Jews was not yet policy, but their elimination from German life was always intended. In contrast, the party leadership long remained uncertain about the place that some of the many varieties of modernism might retain in the Third Reich.

The contradictory messages that continued to emanate from various party and state offices influenced one of two opportunities that came to Barlach in the summer of 1934. Reinhard Piper, an important publisher in the fields of the fine arts, literature, and philosophy, an acquaintance and then a friend since the turn of the century, offered to bring out a volume of Barlach's drawings. That two books on Barlach published before 1933 were still sold in bookshops may have contributed to Piper's optimistic sense that a new work on the artist would not encounter serious obstacles.

Barlach, too, seems to have felt or hoped that the climate of opinion was improving, and in Piper he could count on an understanding collaborator. A few weeks before he signed the "appeal," he decided to end his self-imposed isolation and appear before the public with a new publication.

An early indication that matters might not be as favorable as Barlach and his publisher expected was the difficulty in finding an author for the introduction. A National Socialist art historian who in 1933 had defended modernism now rejected Piper's invitation on the ground that associating with the artist carried the risk of defamation – "a sign of the times!" that shocked Barlach.[34] Piper nevertheless would not renounce the project, and work on the book continued with author and publisher in close cooperation, although inevitably their particular perspectives led to differences. Barlach more than Piper worried about the appropriate kind of paper for the reproductions and about the radical reduction in size of the images that the book's format required. The choice of subjects caused open disagreements. Piper preferred innocuous themes. For Barlach it was a matter of principle that after the attacks he had suffered the volume should avoid any hint of compromise and include examples of his most disturbing work – a drawing of "animal people" among others. In November 1935 the book – fifty-six charcoal drawings with an introduction by the editor and critic Paul Fechter – appeared in an edition of five thousand copies.[35]

The summer of 1934 presented Barlach with a second opportunity when the Hamburg cigarette manufacturer Hermann Reemtsma, who had recently become acquainted with Barlach's work, visited the artist in Güstrow and bought the figure *The Praying Man*. Meeting Barlach, and seeing his studio crowded with sculptures, casts, and studies, made a strong impression on

Reemtsma, who during the next months decided to buy the three figures of the *Frieze of the Listeners* and also commissioned Barlach to make the remaining six that would complete the group. Barlach responded to the offer with gratitude and renewed energy. Work on the frieze made him cheerful and calm, he wrote when he had completed it in November of the following year, within days of the publication of the volume of his drawings.[36]

The Frieze of Listeners, a row of freestanding figures on rectangular blocks of wood placed within a few inches of each other, was Barlach's largest work in the last years of his life. Perhaps it is not his most successful, despite the strength of the individual figures. Once more Barlach created men and women alone in the world, encased in the shell of their personalities and emotions: *The Dreamer* [Fig. 28], *The Blind Man*, *The Expectant One*. Many appear to fend off the outside; only the ecstasy of *The Believer*, the certain faith of *The Pilgrim*, and the suspicion of *The Sensitive One* clearly reach out. Together they make a powerful statement. Barlach's wisdom and sense of the tragic – which in *The Believer* and *The Pilgrim* blend into irony – seem to speak through the figures without overwhelming their individuality and autonomy. But possibly one or the other figure would make an even stronger impact on its own – indeed, Barlach removed one of the "Listeners," the *Meditating* or *Reflecting Man*, and carved the figure in the round, as a separate work. The figures' nearness to each other and their interaction come at a price. A comparison with the three glazed brick figures in the Gothic facade of St. Catherine's church suggests that had he been able to complete *The Community of Holy Ones*, Barlach would have achieved a stronger solution for the problem of the individual in the mass than he did in *The Frieze of Listeners*. The pointed niches in which the saintly figures are placed, and the patterned surface of the ancient brick between

each of them, emphasize each figure without detracting from the
extended front with which they face us.[37]

To move from the work of art to the world in which it was cre-
ated: Barlach's solitary, ruminating individuals, introspective even
in a group, contradicted every National Socialist ideal of German
men and women, who find themselves by serving country and
Führer. The conflict of concepts was self-evident; by 1935 it had
become acute, and an effort was made to bridge it – at least in
the mind of the public, and also to quiet doubts of Reemtsma,
the prospective buyer of the frieze. Barlach's former assistant,
Bernhard Böhmer, now an art dealer with connections to influen-
tial party members, induced an official in the propaganda ministry
to issue a statement that suggested that the ministry approved of
the frieze. But such maneuvers had no lasting effect, and by the
end of 1935 the cultural atmosphere had changed, both in general
and in relation to Barlach.

In June, Governor Hildebrandt had reopened his campaign
against Barlach in a major address on conditions in Mecklenburg.
In unequivocal if syntactically doubtful formulations, he branded
Barlach as culturally alien and an enemy of the German people:

Our mission, Germany's rebirth out of blood and soil, seems to have found its
greatest resonance in Mecklenburg. Our land breathes easier, and the principal
carrier of our blood and heritage [Blutträger], our farm worker, joins the cause
with joy and enthusiasm, and wants to do his duty. We have put a stop to the
liberalistic carryings on of a Mecklenburg artist, who created war memorials
in the worst, twisted bolshevik manner. And I hope that the last traces of his
terrible works are soon removed from the places they still occupy, as has already
been done in Magdeburg. He is alien to our nature [Er ist uns innerlich fremd],
and therefore we cannot exist with him in the same spiritual and thus cultural
community.[38]

Hildebrandt's charge was repeated three weeks later in the
national newspaper of the SS, Das Schwarze Korps. The primary

target was the Worpswede sculptor Bernhard Hoetger, whom Barlach rightly dismissed as a derivative minor talent, but whose interest in primitive art and beliefs displeased "The Black Corps." Linking Hoetger's "case" with the "highly controversial case of Barlach," the paper concluded that "both men, now at the height of their powers, are creating a succession of works that we all feel are of alien blood."[39]

As Barlach predicted, the removal of the Magdeburg memorial encouraged campaigns to dismantle his other monuments. Competing jurisdictions of church and state, bureaucratic inertia, and even some opposition slowed the efforts, but eventually they succeeded. In 1937 the floating figure was melted down, and *The Fighter of the Spirit* was dismantled – on Hitler's birthday, Barlach noted, one of the few references to Hitler in his letters.[40] As it was not a war memorial, the lack of patriotic symbolism was not the cause. The sculpture's guilt lay solely in its paternity. Shortly before the invasion of Poland, the image of the mother and child were broken out of the Hamburg stele – it and the Güstrow angel survive today in casts taken from models. Only the tablet in the Nicolai Church in Kiel was deemed too unobtrusive to bother with; it was destroyed in an air raid in 1943.

Already in the summer of 1935, Hildebrandt confiscated Barlach's sculpture *The Reunion* from the Mecklenburg state museum in Schwerin. It was to surface again in the exhibition of degenerate art. In September, Hitler delivered a further speech on culture and art in the new Germany, and the antimodernist tone of his address was no longer diluted by attacks on other stylistic directions. Since Hildebrandt took Barlach's presence in Mecklenburg as an affront to National Socialism, it is not surprising that when the volume of Barlach's drawings was published in November, and a number of positive notices appeared

in the press, editors of Mecklenburg newspapers declined to review the book. To Piper's renewed request, the editor of one paper replied: "We beg you ... to understand the special difficulties a large Mecklenburg daily faces in this delicate matter." Another feared a demonstration by the Hitler Youth if his paper carried a review.[41] The project of a tombstone for a friend of Barlach, the writer Theodor Däubler, which required approval from cemetery and planning offices, was turned down. When asked to intervene, the incoming president of the Reich Chamber of Literature, Hanns Johst, refused "on political grounds," and for good measure referred to the animosity Hitler felt toward the artist, an allusion that despite its potentially great significance Johst did not explain further, and that has not been documented.[42] A few days before Christmas, Barlach, looking back on the previous twelve months, found that despite the completion of *The Frieze of Listeners* and the publication of his book, 1935 had been a murderous year, a phrase to which he reverted when the time came for his next annual review. On 24 March 1936, finally, the Bavarian Political Police forbade the further sale of the volume of Barlach's drawings and confiscated the 3,419 bound and unbound copies in the publisher's warehouse, on the grounds that the work's "content is likely to endanger public safety and order."[43]

The publication of the book, which, more than the completion of his frieze for a private collector or even the inclusion of his work in exhibitions, was intended to mark Barlach's return to a wider public, proved a mistake. That an artist who experienced a new surge of energy would not hide from his critics forever and would decide to reenter the public sphere, however antagonistic it might be, cannot be a surprise. Without grandiose fantasies about his work, Barlach believed in it, and he allowed his belief to overcome

the disgust he felt at developments in Germany. In moments of optimism he still could not fully grasp how irreversible they now were. He ignored the risks that lay in publication and may not have realized that his enemies would interpret the book's appearance as a challenge. Nor did his publisher, despite his business acumen, see matters more clearly. How badly both men misread the situation is further revealed by their efforts over the next months to save the book.

On 31 March, a week after Piper had been notified of the confiscation, he responded with a petition appealing the order and requesting return of the impounded copies. He asked why a "serious work of art . . . having nothing to do with politics" would be confiscated. Its contents were largely innocuous. "Admittedly the artist also depicts the darker aspects of life"; but, Piper added with a salute to Germanic seriousness, "that has always been part of German art, in contrast, for instance, to the art of Italy . . . Whoever knows the artist, is also aware of his deep links with Nordic Sagas, myths, and fairy tales, and thus witches, furies, and monsters also appear in his work . . . If the artist occasionally draws beggars and the cold and hungry, it is explained by his 'empathy with the poor and weak,' a sentiment already mentioned in the introduction." That Barlach's pure Aryan descent was a matter of documented record seemed worth emphasizing as well.[44] Since Piper was a member of the Reich Chamber of Culture he also sent a letter to its head office. Eventually he received an acknowledgment, together with the information that his letter had been forwarded to Gestapo headquarters in Berlin. This suggested that the confiscation was not a decision of the Bavarian Political Police, but that because the Piper firm, based in Munich, was located in its area of responsibility, the police had been acting for another office or agency.

Probably in connection with his letter to the Reich chamber, Piper also wrote to the propaganda ministry, of which the chamber was a part. On 22 April, Goebbels through his deputy, State Secretary Walter Funk, sent a crushing one-sentence reply: "I see no cause to question the confiscation of the *Drawings* by Ernst Barlach." Piper at once forwarded a copy to Barlach, to whom the reason for the book's confiscation, and what it implied for himself and for other German artists, now became clear.[45]

The publisher, on the contrary, was still reluctant to acknowledge the irreversible character of the ban, and searched for particulars that had given offense or for a misunderstanding that could be removed to resolve the matter. "If the selection [of the contents] had been a trifle more reserved," he wrote on the 25th, "we would probably have spared ourselves much excitement and damage" – a reproach Barlach angrily rejected: "Subject matter has nothing to do with it; only the manner of expression [Von Stoff ist schon garnicht die Rede, nur vom Ausdruck]." Goebbels's refusal to intervene confirmed Barlach's earlier suspicions: "Not some or all of the 56 drawings caused the political police to intervene, but the constantly stronger current against certain phenomena [in the arts] in general. Friends in National Socialist offices are powerless; no one dares to express his honest outrage. Everyone cowers and evidently knows that the sentence has long been handed down."[46] Whatever uncertainties still remained disappeared a few days later when Piper relayed the information that the confiscation order had originated in the propaganda ministry's section for the supervision of artistic design. That explains much, Barlach wrote on 2 May. Once overall policy changed, even officials in the ministry like Hans Weidemann, a leader of the Nordic modernism movement in 1933, who earlier had submitted a positive evaluation of *Drawings* to Goebbels, would no longer

support him: "Either Goebbels is covering for the section . . .; or, and this seems more likely, *he instructed the section to act* [emphasis in the original]."[47] Barlach's former assistant, Böhmer, sounding out contacts in the ministry, confirmed that the prohibition of the book had been issued by the Reich deputy for artistic design, the Reichsbeauftragter für Formgebung, Hans Schweitzer. Böhmer further learned that Rosenberg wanted it known that the order did not originate with him. Since Rosenberg considered Barlach a threat to German art, his effort to distance himself from the confiscation of Barlach's work may seem strange. But his competition with Goebbels gave him sufficient reason to oppose the propaganda ministry whenever possible.

Schweitzer, who was to reappear in Barlach's life, was a radical National Socialist, who hated modern art as a fraud and took pleasure in treating a once honored Weimar artist as an enemy. In his youth Schweitzer attended the Berlin art academy, rebelled against his middle-class background, and joined social revolutionary factions of the far right. After Goebbels was given charge of the party in Berlin, Schweitzer became a close assistant, and under the pseudonym "Mjölnir" – the hammer of the Norse God Thor – one of the party's most effective cartoonists and poster designers. He created the hard-faced, heroic storm trooper, known as the "Mjölnir type," whose opposite image, the bloated, leering Jew, he adapted from nineteenth-century models and invested with a new viciousness. Both Hitler and Goebbels valued his relentless aggression against the republic. When war came, his violence transferred easily to the external enemy, and his posters, distributed in tens of thousands of copies, formed an inescapable element in the visual environment of wartime Germany. After the defeat, in his trial before a German court – which would finally let him go with a slap on the wrist – he praised National Socialism for

opposing modern art that "depart[s] from nature," defended the reduction of "excessive Jewish influence" in German art and society, and minimized concentration camps as necessary emergency measures against spies and other internal enemies.[48]

Schweitzer's position in the propaganda ministry gave him a supervisory and at times an active role in the design of emblems, stamps, banknotes, and uniforms; gradually he was also assigned duties related to the fine arts. He had no true authority in this area, but his tendency toward extremes, which also made him a difficult subordinate, affected the way he carried out orders. He was not sufficiently senior to ban Barlach's book on his own account. The order had to come from one of his superiors either in consultation with Goebbels or – as was the case here – from Goebbels himself. Sometime before 24 March, Goebbels must have instructed Schweitzer to ask the police to set the process in motion. The order of confiscation seems not to have been put in final bureaucratic form until 3 April. In his diary entry for that day, Goebbels wrote: "Have banned a crazy book by Barlach. It isn't art. It is destructive, incompetent nonsense. Disgusting! This poison must not enter our people."[49] Goebbels's curt reply to Piper on the 22nd merely confirmed the ban, without revealing that, as the diary shows, it had originated with him nearly three weeks earlier.

Barlach was left in no doubt that he had been severely damaged. But his letters during the following weeks were almost lighthearted in their open and ironic comments on the confiscation and on cultural conditions in general. He and Piper continued to ask for specific reasons for the ban, and when the Bavarian Political Police at last informed Piper that the book was prohibited "because the contents cannot be reconciled with the National Socialist concept of art," Barlach reacted merely with a joke or two. Böhmer's report that Johst, now president of the Reich Chamber

of Literature, was placing the book on the index of forbidden publications, which added to the difficulty of reversing the ban, seems to have been taken as a matter of course. A follow-up letter from Gestapo headquarters in Berlin did, however, elicit Barlach's "sharpest protest" against the characterization of the book's contents as "art-bolshevik expressions of a destructive concept of art not appropriate to our age."[50] He had been drafting a letter to Goebbels, and after revising the text to shorten it and make it less emotional, he mailed it at the end of May. Two months later Goebbels had not answered, and Barlach drafted a second letter. Recognizing perhaps that the effort was pointless, he seems not to have sent it. Piper still tried to save the book by appealing to Schweitzer, who found excuses not to see him.

Barlach's first letter to Goebbels opens with the transparent ploy of attributing the order of confiscation to the Bavarian police and requesting that the minister review it. He feels certain, the letter continues, that the objections were to a few drawings, not to the entire work – a possibility he denied when Piper had raised it earlier. He backs his belief that his drawings in general could not be condemned with the strange argument that since his sculptures had only recently been praised by distinguished museum directors, "one can hardly assume that an artist wins approval in one area of his work, and is subjected to a diametrically opposed judgment in another." If he were informed which few drawings were regarded as too "unusual or even crass," he would gladly replace them. These labored and unconvincing arguments are presented in exquisitely polite formulations, a style that is maintained in the closing paragraphs, although a different tone is now sounded: "By the way, everything that I here carelessly label as crass – in the eyes of the untaught viewer – has sprung from my search for the uncompromising image, from

striving for the definitive. The artistic value or lack of value of my works is not covered by the decisions the political police make [steht ausserhalb der von der politischen Polizei zu treffenden Entscheidungen]" – or the decisions the police are authorized to make, as the wording also suggests. Barlach cannot believe that he will be denied the right to defend himself against such serious and unspecified attacks, and he ends by assuring Goebbels that he trusts in the minister's readiness to acknowledge the reasonableness of his expectations.[51]

The short draft of the second letter declares once more that failure to respond to his request for specific objections to his work makes it impossible for Barlach to defend himself. He points out the gravity of the accusations against him – he has been "pilloried as a parasite in today's cultural life." The draft concludes: "I beg you to spare me the threatened bitterness of being disappointed in my confidence that I will receive the minimal degree of justice that I have claimed."[52]

The draft seems more to the point. It is less labored than the letter, in which Barlach flails about for supporting arguments until pride and outrage break through his attempts to find a sensible manner of communicating with a man holding extraordinary power over him. It is not surprising that he received no answer. Goebbels was not in the habit of justifying his measures either to subordinates or to victims, and he would have shrugged off Barlach's complaint that it was unjust to prevent him from defending himself against vague accusations. That Barlach might present a more ambiguous case than other artists under attack, if only because Goebbels himself had earlier expressed admiration for his work, could be a further reason for not allowing the prohibition of the book to become a starting point for possibly awkward exchanges.

What was it about Barlach's fifty-six drawings that Goebbels found "destructive, incompetent nonsense"? And why did he ban the book? – which is not the same question. In choosing and arranging the drawings, Barlach and Piper had not aimed at an overall theme; rather their intention was to present a selection of the artist's work over the preceding quarter century. Barlach's graphics cannot always be dated accurately, but the great majority of the drawings in the book came from the 1920s, and over half were made by 1924, the year Goebbels had admired Barlach's *Berserker* in Cologne. It would have been beyond the ability of National Socialist art historians to identify a change in Barlach's graphic style in the years since. Both before and after 1924 Barlach worked in strong, smooth lines that created forms of a simplified realism, alternating with violently conceived and executed fantasy figures, like the *Animal People* of 1920 that had worried Piper. This charcoal drawing depicts two long-haired, bearded men with gaping mouths, one lying on the ground, the other crawling on all fours [Fig. 15]. Actually, in its realistic rendering of the men's features and bodies, the sketch is rather subdued. A number of other plates that show figures with oversized grimacing heads and elongated limbs extending into twisted hands and feet certainly offended against the National Socialist canon of nearness to physical realism and reserve in the expression of emotion – other than the rage of battle. And National Socialist sensitivity in these matters could be great. A not unsympathetic observer pointed out that Barlach's design for the book's jacket, based on an earlier drawing [Fig. 8], of a stocky man blowing a horn, whose left arm – the upper arm in slight perspective – might appear too long, revealed just that "disregard of physical relationships" that the party fought against. Certainly Barlach emphasized the point of the drawing by linking the man's arm and horn into a great

curve, which swoops out of the page, and transforms the notes of the horn from sound to image. But a good-natured propaganda ministry official, taking account of the stylistic character of the work overall, could have dismissed these irregularities as studies, or as the artist's brief excursion into the grotesque. At most he might have suggested replacing them with less disturbing images. Other "unusual or even crass" subjects were furies, witches, a cursing woman. Erotic themes, in any case very rare in Barlach's oeuvre, were absent. One drawing from 1912 shows a man floating beatifically through the air [Fig. 9]; another, a man swinging two large bells, which, in turn, seem to swing the swinger to unheard music [Fig. 10]. A series of seven drawings from 1922 and 1923 illustrates violent episodes of the *Nibelungen Lied*, a subject dear to Goebbels, who in April 1945 still called on Germans to demonstrate "Nibelungen faithfulness" and fight on. But specific subject matter was no more the issue here than were interpretations that under different circumstances might have been forgiven as occasional stylistic derailments.

Far more difficult for National Socialism to accept, once the matter was seriously considered, was the book as a whole. Together, the fifty-six drawings express an intense, unbroken interest in the individual, whose image is not mediated by larger groups – soldiers, inspired crowds, the people – let alone by such organized abstractions as the nation or state. Barlach's men and women, singly or alone, express their emotions or struggle with them, try to stay alive or face an ultimate crisis, not as Germans but as human beings. Only the figures in the *Nibelungen Lied* and Faust wandering with Mephistopheles through the Walpurgis Night [Fig. 17] are identified by ethnic and historical origin. The robed man raising a goblet to the choral movement of Beethoven's Ninth Symphony is a citizen of the world. Certainly, in conception and

execution Barlach gives an unmistakably German air to almost every one of these figures. But this is not the result of the artist's intended or unaware nationalism; it simply reflects the vital diversity of European culture. The book documents and calls on the reader to join in the artist's deep involvement with the unorganized individual. In sending this message, *Drawings* resembles *The Community of Holy Ones* and *The Frieze of Listeners*. Still, exhibited or reproduced individually or in small numbers, the drawings might have evoked few protests beyond the circle of fanatics around Rosenberg. But collected, widely distributed, and calling attention to themselves, they were recognized as subversive. That recognition could have come at any time; it became more likely with the growing radicalization of domestic policy from 1935 on, and after Hitler's speeches on art and culture narrowed the alternatives that for a time had still been permitted or that had benefitted from being ignored.

Goebbels was influenced by the shifting trends in cultural policy, and also helped bring them about. He pursued his own aims and was capable of independent judgment; but for deeply personal as well as political reasons, he took care not only to be in compliance with the Führer's wishes but to appear in fullest agreement with them. He was "working toward the Führer." That Hitler still did not relinquish Rosenberg altogether, who continued to intervene in the policing of culture, made it even more important for Goebbels not to be accused of supporting modernism. But his changing attitudes toward the arts also resulted from his tenure at the propaganda ministry and the Reich Chamber of Culture. Since the beginning of 1933 he had been determined to teach the "creators of culture" their duty both to spread the values of National Socialism throughout German society by means of their work and to support the government's day-to-day measures and

long-range policies. Instruction and control worked together. It was obvious to Goebbels, as, for instance, it was not to Rosenberg, that a minimum of carefully apportioned flexibility could increase the effectiveness of a narrowly defined and firmly controlled image of German art at home and in Germany's dealings with other countries. But the ministry meetings and discussions in which he hammered out his policies, and the encounters with Hitler and with other ministers in which they were defended, adjusted, and coordinated, made the difficulties of allowing exceptions increasingly apparent. The spread of ideological uniformity through every layer of culture was too strong to resist even for the greater National Socialist good. Goebbels's aggressive anti-Semitism contributed to the process. In 1935, even before the Nürnberg Laws were issued, he had begun to remove Jews from every aspect of cultural activity in Germany by expelling them from the chambers of culture. At the beginning of March of the following year, he issued more restrictive guidelines, eliminating from the chambers every member with even one Jewish grandparent, as well as non-Jewish members who were married to partners who were Jews or who had three Jewish grandparents. As he both advanced and was pushed toward the ideological and racial absolute, Goebbels was no longer willing to defend the deviation or privileged exception of a Barlach or a Nolde, whose situation at this time also took a turn for the worse.

In the encounter of Barlach and National Socialism, the banning of *Drawings* was another step in the process that had begun with denunciations of the artist's war memorials, and proceeded with closures of his plays, cancellations of exhibitions, and criticism of particular works, followed in some cases by their confiscation, such as Hildebrandt's removal of *The Reunion* from the museum in Schwerin. The war memorials conveyed Barlach's

reactions to the highly charged experience of the First World War, which lay at one of the roots of National Socialism; the collection of drawings expressed his general view of life. Even if the book had not appeared, the efforts to silence Barlach would have continued. Its confiscation again marked him as someone whose solidarity with the community was denied by its leaders, and opened him to further attacks. That he continued to struggle intensified the measures against him. The book's banning, with its sparse ideological justification, was also a signal, one among a growing number in the spring and summer of 1936, that the time for ambiguities in the relationship of the fine arts and National Socialism was coming to an end.

5

German and Un-German Art

A continuing issue in the study of the Third Reich is the extent to which its character and policies were determined by Hitler the individual on the one hand and, on the other, by social and political forces that originated in industrialization, nationalism, and the cultural conflicts of modern Germany – all intensified by the First World War. The two opposing interpretations, each encompassing a range of perspectives and emphases, have been grouped under various labels: "Hitler-centrist" and "functionalist," for instance. They are the results of research, but also guide it; individually and through debates between supporters of the opposing sides they have advanced scholarship on a broad front.

Except in their most extreme versions, which tend to express ideological positions, these interpretations are not absolute and thus are not mutually exclusive. In the area of art policy it is evident that Hitler's views on the racial origins of art, and his belief in art as a measurement of racial and political health, derived from the nationalist and pseudo-scientific populist literature of the late

nineteenth century, itself a product of large shifts in German and European society and culture. It is equally apparent that his fascination with aspects of music and architecture was not the inevitable by-product of a particular class and time, even if it cannot surprise that an offspring of the marginal bureaucratic bourgeoisie of the Austrian empire developed such interests. But they were linked to the unique emotional and intellectual maturation of this particular individual, and they affected his behavior. Hitler without an interest in the arts is entirely conceivable; as perhaps also is a Führer who liked Wagner operas, disliked abstract paintings, but would not have been sufficiently engaged with either to include the arts in his political thinking and actions before and after January 1933.

The real Hitler rejected these options. His relationship with some of the arts was strong, if ambivalent. He was genuinely offended by paintings and sculptures that rather than idealizing life, or calling on society and the individual to fight for nation and race, imposed the flaws of human existence on the viewer. Modernist art that adapted the forms and techniques of African and Polynesian masks and figures, and, as he thought, returned to primitive stages of humanity, enraged him. Their aggressive distortion of the human face and body, which he interpreted as glorifications of illness, made him anxious and angry. But conversely, these works gave him deep satisfaction, especially after he became politically active. They laid bare the self-doubts and conflicts of the individual in the bourgeois world and could be used as levers to help pry open this world and destroy it. He needed targets and victims to become himself; and in the arts as elsewhere he chose them with foresight.

The history of repressive regimes in modern times, especially those that take their ideology seriously, or claim to, indicates that

they will not grant extensive stylistic and thematic freedom to the arts, whether or not the arts are of interest to the people at the top. But repression need not be total: In Italy, futurism and fascist varieties of social realism coexisted. In Germany, too, despite the powerful nativist strains in the party, some National Socialists believed that forms of modernism were acceptable. A man of Goebbels's stature could think that widening the regime's perspective on the arts was possible and beneficial. Because he grew tired of the interminable conflicts with Rosenberg, who on this point expressed a basic tendency of the movement, but above all in obedience to Hitler, Goebbels eventually changed his position. Hitler also paid some attention to populist sentiments in the party, the more so since they matched his own hatred of international modernism, and in part derived from the traditions in which he had grown up. The "functionalist" interpretation would argue that here was another case in which Hitler represented more general forces: It would have been surprising had he supported modernism in the arts, just as it would have been unusual had he grown up free of anti-Semitism. But Austrian anti-Semitism of the 1890s was very different from what Hitler was to make of it. His suspicion of modernism came naturally; nevertheless it was selective – at the turn of the century, after all, Wagner could hardly be considered a traditional composer, and in the years before the First World War modernism in music cannot be imagined without him. Hitler's sense of what the arts were and what they should be combined personal and general elements. From ideas he encountered he took those that interested him, adapting them to suit and reinforce his politics. The result was uninformed and crude, but shrewdly put together, and dynamic. A personal element is also suggested by the unusual viciousness and brutality with which he expressed his views on art and culture.

National Socialism penetrated every area of German life, but some areas more rapidly or more completely than others. The degree to which domination was achieved, the extent of relative freedom and of evasive possibilities that remained, could differ. One example is an area of activity not without similarities to the fine arts: historical teaching and scholarship. Both historians and artists are specialists, who address segments of the public. The regime quickly integrated the institutional structure of historical scholarship: Universities, research institutes, and publication programs were brought under close control; Jews, and gentiles with Jewish spouses, were excluded from the professoriate; and new research institutes and publication series were established to underpin National Socialist ideology. But despite the massive perversion and corruption that defiled the historical profession, some historians continued to work on a high intellectual and ethical level, and could publish their results, especially if their subjects were of little concern to the regime. Friedrich Meinecke, the doyen of German historians of ideas, was deprived of the editorship of the *Historische Zeitschrift*, the profession's most representative periodical; but in 1936 he was able to bring out his seminal study on the origins of historicism. In the same year, Gerhard Ritter, a conservative, nationalist scholar, who in 1944 was to be imprisoned by the Gestapo for his links to the conservative resistance movement around Carl Goerdeler and Helmuth von Moltke, treaded on more dangerous ground with his biography of Frederick the Great. But even though Ritter's interpretation implicitly warned against the dangers of autocratic, expansionist rule, it was allowed to appear. To be sure, a work of art may be seen by many more people than would read a scholarly text. Nevertheless, judging solely on the basis of creative distinction, publishing a book by Meinecke in 1936 was not too different from exhibiting a landscape or portrait

by Lovis Corinth. But by 1936 works of Corinth in German museums were on the list of ideologically unacceptable art, and in the following year seven of his paintings were included in the exhibition of degenerate art. That Hitler's personal engagement was less in evidence in the drive to purify history than in cleansing the temple of art may have made the difference, which Himmler's and Rosenberg's interest in National Socialist historical scholarship could not outweigh – especially since a principal motive of their interest was the elevation of the old Germanic tribes into models for today, an idea Hitler ridiculed more than once.

Documentation of the steps leading to Hitler's policies on the arts is uneven. But his speeches on the subject at cultural events and at the annual party rallies are revealing. Even when they cannot be taken as firm decisions – when he made promises or threats without implementing them at once or eventually – they are more than empty rhetoric. They influenced public opinion, framed peoples' thinking on the issues, and provided the necessary formulations for self-definition and for the identification and analysis of internal and external opponents of the National Socialist concept of culture, which reflected society, yet gave it standards to live by, and which above all served the state. In turn, party leaders and officials of all ranks repeated Hitler's ideas in their own speeches and based their decisions on them. Hitler's speeches express a firm view on German art, its role in the country's past and future, and the dangers it still confronts. At all times, the art he attacks stands for the perversions of the Weimar Republic that National Socialism has destroyed. But that the art still exists also indicates that the fight against the values of Weimar must go on. Despite their tactical obfuscations, the speeches work toward the elimination of certain kinds of art and the intimidation of artists who refused to desist from making art in their way rather than in his.[1] On

a murderous level, the brutal anti-Semitic statements in his addresses at party rallies from 1934 on similarly functioned to lay the groundwork for the future policy toward Jews, whether or not the policy's goals had already been decided on, and before its methods were developed in detail.

Hitler's speeches on art and culture, and his frequent references to these matters in other talks, continue his discussion of them before 1933. In his proclamation opening the *Reichsparteitag* – the party's annual national rally – in 1933, he referred to the "always existing link between political and cultural focal points," as the source of the riches of German art.[2] A major address on culture followed, the first of Hitler's *Kulturreden*, which from then on regularly appeared on the annual program. He began by declaring that before 1933 National Socialism fought for more than control of the government. The external revolution – the acquisition of total power – was completed. But the aim of National Socialism is to impose principles, ideals, a world view that all Germans should make their own. The internal revolution and with it the regeneration of the arts continues. Germans can achieve much in the arts. But their achievement depends on political and cultural leaders who understand that race is the source of any *Weltanschauung*, and who represent the values of the nation and of the race.[3] Modernism is antithetical to the German spirit. "The slogan that [art] above all is international is hollow and stupid."[4] The essence of art rests in the race and in its ideals. Once again, Hitler insisted that art is not a marginal concern: Culture and art are essential to a healthy race, people, and state.[5] The political victory of National Socialism provided the foundation on which a healthy culture could be built: "Whether fate will bring us the men who can give an equivalent cultural form to the political will of our time and its achievements, we do not know. But one thing we do know, under

no circumstance may the representatives of the decline that lies behind us suddenly become the standard-bearers of the future."[6] This last was directed at artists who disowned or minimized the role they had played in the republic, and now joined the party or in other ways associated themselves with the National Socialist revolution in expectation of patronage and honors, or at least tolerance.

These were the same points Rosenberg was making, and continued to make: Just as every trace of Weimar politics had been eradicated in National Socialist Germany, so the aesthetics of the Third Reich, as they gradually unfolded, must not be diluted by the concepts and practices of Weimar culture. The assumption of political power should usher in change in every area of public and private life. Prominent artists who before 1933 had diverged from the true path of German art should not be granted an easy return. Hitler did not mention names, but Rosenberg eagerly gave examples – Nolde and Barlach among them. Except for artists who had committed merely minor infractions, they remained enemies of the regime, targets of the Reich's cultural policies until substantial new work done in the correct spirit proved the genuineness of their conversion. To accuse them of seeking acceptance, and of wanting to be "leaders" and "standard-bearers" of art in the new Germany – whatever that might mean specifically – gave Hitler and Rosenberg yet another way of striking at modernism in general. A positive corollary was the founding of a new museum, "The House of German Art," in Munich, as a future rallying point for the art to be created in the Third Reich.[7] The question remained whether the new art was to be insulated from every variety of modernism that had spread across the world, or whether some directions and tendencies of modernism could be adapted to enrich the demonstrative realism that the regime demanded.

Goebbels praised Hitler's 1933 speech on culture for its "totally new ideas," and noted the "sharp attacks on Dadaists and opportunists."[8] In fact, Hitler said little that he had not said before, the difference being that he no longer spoke as one politician among many, but as chancellor of the Reich. In contrast, the cultural address at the party meeting the following year – the *"Reichsparteitag* of Honor" – was more substantial. Hildegard Brenner even gives her discussion of Hitler's speech of 5 September 1934 the title "The Decision."[9] That may imply more than actually occurred. The meeting was held during a politically sensitive period. Two months earlier Hitler had ordered the execution of Röhm and other SA leaders on the pretext that they had plotted against him, an act that eliminated the SA as a serious element in the power relationships of the state. But even if it was no longer necessary to pay attention to the views of the remaining SA leaders, the organization's rank and file needed to be reassured. At the same time, the conflict between Goebbels and Rosenberg continued unabated, and one of its issues – the place of modern art in the Third Reich – touched on matters in which Hitler took a strong interest. As we know, he resolved the controversy by turning against both sides: against modernism in the arts, which sent Goebbels a clear message; and against the Teutonic antiquarianism that Rosenberg persisted in advocating. This was a decision of sorts, but it still left a large sphere of uncertainty in such practical matters as patronage, exhibitions, and publications. Nor was Rosenberg permanently silenced, although his lack of influence had been made more evident.[10]

In his cultural address at the next annual party rally – the 1935 *"Reichsparteitag* of Freedom" – in which he dealt primarily with painting and architecture, Hitler added no specifics on the nature of National Socialist art, or on its relationship to contemporary

art of other societies. But he repeated his earlier rejection of artists who traded on their former prominence to claim a place in the art world of the Third Reich, and he continued to denounce them not only as bad artists but as ideological enemies. Possibly because artists had visibility and their work might turn into symbols, but also because they generally lacked political influence, the regime made greater difficulties for the modernists among them than it did for the many men in business and people in the professions who had kept their distance from National Socialism before 1933 but now were accepted, or at least not persecuted.

The rally was held in a year in which the regime scored important political successes abroad. In January, a plebiscite in the Saar resulted in a large majority for the territory's reunification with the Reich. Two months later Hitler repudiated the arms limitation clauses of the Versailles Treaty, an action with which he achieved one of the oldest goals of National Socialism, and laid the basis for the remilitarization of the Rhineland that followed in March 1936. Rearmament deeply affected society and the economy, and facilitated further radicalization at home. A major step was announced at the party meeting: the Nürnberg Laws, which deprived Jews of the protections of German citizenship, defined intermediary legal categories of Germans according to the number of their Jewish parents and grandparents, and gave the regime another means for controlling the individual.

Quite apart from its content, Hitler's *Kulturrede* on 11 September 1935 repays attention for certain characteristics that are present in many of his longer statements on culture and the arts. Despite their often uncertain syntax, and whatever the truth or falsehood of their assertions, the speeches tend to be clearly structured, until the line of argument suddenly becomes entangled with new themes, begun but not carried forward, and with details that

are only vaguely related to the issues at hand. Listeners must have found these shifts from clarity to a clotted, shapeless text difficult to follow, unless the flood of words blocked out every response but that of unquestioned, numb admiration.[11]

Hitler opened the cultural address of the *Reichsparteitag* of Freedom with a dramatic image of a year and a half earlier, when National Socialism had gained power. He compared the Reichstag fire to a torch that "illuminated the magnitude of the historical turning point."[12] The party's fight

was a truly wild struggle with all the elements and phenomena of Germany's internal decadence, and with her interested and hopeful enemies in the outside world. Future generations will note with surprise that at this very same time, while National Socialism and its leaders fought a heroic life-and-death war for existence, *German art received the first impulse for its revival and regeneration* [emphasis in the original]. . . . In short, a revolution sweeps over a state, and at the same time concerns itself with the first seeds of a new high culture. And truly not in a negative sense! For whatever account we had to settle with our cultural criminals, we really wasted little time in holding these spoilers of our art responsible. They were either fools or crooks. Yes, we always felt that most of what the leaders of these cultural arsonists did was criminal. Therefore any confrontation with them would necessarily land them in jail or in an insane asylum . . .[13]

Hitler's epic reconstruction of the party's struggle for power once more reminded his listeners that modern art was not only bad art but an invidious political danger. He continued by positing that well-meaning people who nevertheless lacked faith in National Socialism could raise two objections to the party's concern for culture at that critical period. They might ask: "In view of the gigantic political and economic tasks we face, is this the time to occupy ourselves with cultural and artistic problems, which may be important under different circumstances or even in earlier centuries, but which today are neither necessary nor urgent?"[14] Their second objection might be, how could National

Socialism afford to make sacrifices for art when "we are still sur-
rounded by great poverty, want, misery, and despair? Isn't art,
after all, only a luxury for the few, rather than the bread necessary
for all?"[15]

To the first objection, Hitler responded that art cannot be
switched on and off. Artists, public, and art itself require con-
tinued care and training. No age can dare to be relieved from
the obligation to nurture the arts. Such neglect would be partic-
ularly serious in a time that demands "the strengthening of the
nation's backbone and morale."[16] He continued with a disqui-
sition on the vital social and political role of the arts, ending
with the pronouncement that *"no people outlives the documents of
its culture!* [emphasis in the original]."[17] The more critical the po-
litical and economic conditions, the greater the need for culture,
which teaches a people that the "human and political suffering of
the moment is *temporary* [emphasis in the original] in comparison
with the eternal creative energies, and thus with the greatness and
importance of the nation."[18]

Hitler then refuted the second objection: The argument that the
arts interest only a minority of the population carries no weight,
because that would also apply to every other cultural activity. No
one would claim that the mass of the population is directly in-
volved in the great achievements of chemistry, of physics, "and
of all the other highest expressions of life. *I am convinced, on the
contrary, that the arts, because they are the least corrupted, most imme-
diate reflections of the spiritual life of a people, unconsciously exert the
greatest imaginable direct influence on the mass of peoples and nations*
[emphasis in the original; presumably Hitler meant that peoples
and nations are unconsciously influenced by the arts], always pro-
vided that they draw a true picture of a people's spiritual life and
its innate capabilities, and not a distortion."[19]

This close link between art and the psyche of the people, Hitler concluded, affords

a very exact clue to the value or lack of value of art. Perhaps the most damaging condemnation of the whole dadaist art enterprise of the past decades may be found precisely in the fact that the overwhelming majority of people not only turned away from it but at last no longer expressed any interest whatever in this kind of Jewish-bolshevik derision of culture. In the end, the only people who still paid any attention to these idiocies were their producers. In such circumstances, admittedly, the number of people interested in the arts is very small, for they include only the feebleminded – that is, degenerates – who, thank the Lord, are still in the minority, as well as those who are interested in destroying the nation.[20]

Hitler interrupted his response to the second objection by once more emphasizing the cultural duty of National Socialism: If it really has brought about a revolution, the movement must justify it with creative cultural achievements. "*If you want to educate a people to be proud you must also give it visible cause for pride* [emphasis in the original]," a statement that led to a brief disquisition on architecture, and to the Parthenon, "the pride of Greece."[21] He dismissed the objection that in times of great poverty money should not be spent on the arts, by pointing out that poverty has always existed, even in times of the highest cultural achievement. But although art beautifies life, it is not therefore "the expression of a 'capitalistic' tendency! . . . Ages of religious inwardness that are most detached from the materialistic point of view, can demonstrate supreme cultural achievements. Whereas, on the contrary, Judaism, thoroughly infected with capitalism and acting in accord with its values, never had, and never will have, its own art."[22]

If art is to justify its economic cost, however, and benefit society, it must be "*a messenger for the sublime and the beautiful, and thus be a force for all that is natural and healthy* [emphasis in the original]."[23] A denunciation of primitivism followed, as well as of

those who defend "our Dadaists, Cubists, and Futurists or imagined Impressionists" for experimenting with primitive styles. "It is not the task of art to remind man of his degenerative manifestations, but rather *to counter the appearances of degeneration by pointing to what is eternally healthy and beautiful* [emphasis in the original]. If these art spoilers dare to express 'the primitive' in a people's feelings, then our people has long, for some thousands of years, *grown beyond* the primitiveness of these art barbarians. It not only rejects this nonsense, it regards their producers as either swindlers or insane."[24]

By now, the main line of argument – that art matters, and that the two objections to supporting it in times of political and economic crisis are not valid – has almost collapsed under the weight of extraneous material, a burden that in the last third of the speech increases in bulk and variety. Further attacks on modernism alternate with explanations of the special significance of architecture, and the need to combine eternal beauty with modern practicality. To demonstrate that this is possible, Hitler chose an amazingly out-of-the-way example: that Prussia's great classicist architect Karl Friedrich Schinkel would certainly have included "modern lavatory system[s]" in his palaces and museums if the hygienic conditions of the Napoleonic era had been those of today.[25] Hitler concludes his long talk – over fourteen pages in its printed version – with an extended peroration on "the eternal language of great art," and on German achievements in the arts over the past two thousand years. The art that National Socialism furthers will fulfill "the wishes and hopes of today, in the spirit of a thousand-year-old legacy of the past."[26]

The address was marked by Hitler's customary dogmatic assertions, his preference for categories rather than specifics, for repetition and increasingly violent expressions, alternating with

the calm tones of the statesman and philosopher. Here and there, straightforward formulations that are memorable and effective act like tent poles that keep the sagging canvas of the argument aloft: "No people outlives the documents of its culture"; "Nothing is better suited to silence petty faultfinders [*Nörgler*] than the eternal language of great art"[27] – the seeming simplicity of the statements masking their ambiguities. As in many of his speeches, parts of the argument are structured in the form of a fictitious dialogue between the speaker and unnamed interlocutors.

What were the messages of Hitler's 1935 cultural address? He announced no specific policy; instead he outlined a new cultural attitude. National Socialism integrates idealism and practical concerns. His proclamation that the arts are not reserved for the educated and well-to-do but are shared by every German expresses the socialist side of National Socialism; it also includes an implicit defense against internal criticism. For a year, complaints about the high prices of such staples as milk and fat had been reported from all parts of the country. Real wages were falling, which stimulated criticism of the regime's pomp and luxury, ranging from its Germano-Greek official architecture to the gold-encrusted uniforms of party greats, who in popular parlance were beginning to be called "gold pheasants." The arts, Hitler now insisted, are not a marginal luxury, but a general national concern. Economic difficulties should not preclude their being supported. A further message is the imperative of not tolerating art based on international rather than national values. National Socialist efforts to foster a new art are opposed by the racial and ideological enemies of the country. Modernism is not just bad art; it is fraudulent, an insufficiently recognized weapon directed against the National Socialist regeneration of Germany – which explains the increasingly harsh campaign waged against it by party and state. In the

areas of art and culture, the speech expounds the general maxim that conflict [*Kampf*] is the basic element of National Socialism.

These points, structured around the two "objections" and their refutation, were made clearly and effectively enough by Hitler in the first half of his address. In the confused and wordy second part he added little of substance, and it is difficult to imagine what it conveyed to his listeners, except perhaps the speaker's intense vision of the seamlessly political-cultural nature of German art, his determination to purify and protect it, and to lay out its future course.

In a speech devoted to painting and architecture Hitler mentioned only one artist by name – Schinkel, who had died in 1841. Another architect – Paul Ludwig Troost, the designer of the House of German Art, who had died in 1934 – was alluded to, but left in anonymity. This, too, was characteristic. Hitler's speeches on culture rarely identify a particular artist, even as an example of a style or movement. Instead he employed categories – "Dada," "Cubism," "Impressionism" – they could mean anything, and their foreign names could be made to sound ridiculous and vaguely threatening to a German audience. Twice in his *Kulturrede* of 1935 he included "Futurists" in his gallery of horrors. He could feel certain that at a time when Italy needed German support for its war against Ethiopia, Mussolini would disregard criticism of a few unnamed Italian painters as a minor peculiarity of cultural policy north of the Alps, and he evidently wanted to signal that even abstract art accepted by Italian fascism was no longer tolerated in the Third Reich.

The *Kulturrede* of the following year made it still clearer that the limits of acceptable art were now very narrowly drawn, even if Hitler again scorned the "undefinable Nordic phrases" of Rosenberg and his followers.[28] Two points stood out: Unity was

as essential in culture as in politics; and the Jews were the principal agents of cultural corruption, with all the political dangers this implied: "An indissoluble connection exists between the destructive activities of the Jews in economics and their no less destructive activities in all areas of culture."[29] They were "overbred, parasitic world-intellectuals, who required an alien race on which to feed."[30] Hitler continued to denounce art that claimed to be detached from politics, and art that did not employ the vocabulary of realism to express a political and ultimately racial attitude. But his association of culture and politics now carried a pronounced personal identification: *At all times culture can be imagined only as the expression of the mentality and character of the people's political leadership* [emphasis in the original]."[31] The National Socialist age could accept only National Socialist art: "Let the creators of the cultural life of our people understand . . . that just as the development of human society is conceivable only if *we overcome individual permissiveness* [emphasis in the original], so . . . in culture, too, a general line must be adopted, which fills the individual's creations with a greater idea that deprives them of unbridled arbitrariness, and instead gives them the features of a common world view."[32]

Despite the violence that marked the speech, its rhetoric was tired. Much, probably all, Hitler had said before, if not often with the same degree of vehemence against Jews and against artists who would not fall in step with the National Socialist battle hymn of art. His continued, emphatic insistence on stylistic uniformity – an idealized realism in the nation's service – merely made it even more apparent that Schreiber and the National Socialist German Student Alliance had hoped in vain for the inclusion of a Germanic modernism in National Socialist culture. What Hitler now needed was to render the corrupt art of the past more tangible, and to confront it with an art that National Socialism could accept. The

small "shame" exhibitions and "chambers of horror" of decadent art held since 1933 suggested a model for the former; the completion of the House of German Art in Munich provided a venue for the latter.

One consequence of the radicalization of the regime, of which these ideas and plans were a part, was a more stringent separation between acceptable and unacceptable works. This process found an easy victim in Barlach, who was already badly exposed by the publication of his book of drawings and its prohibition in March 1936. By order of the Prussian minister of culture, his sculptures, "phenomena of the past period," were removed from an exhibition of the Prussian Academy of Arts, of which he was still a member.[33] It was a sensible but useless precautionary measure for friends to withdraw a planned article on Barlach's work: "At this time it would certainly be a mistake to place Barlach noticeably in the public eye."[34] The following year Barlach was forced to resign from the academy, and an exhibition in a private gallery in Berlin, which included three of his figures as well as graphics, was closed by order of his nemesis, Schweitzer, the Reich deputy for artistic design, who as Goebbels's agent had instructed the Bavarian police to prohibit the sale of Barlach's volume of drawings. Barlach was informed that the president of the Reich Chamber of the Fine Arts forbade the showing of the sculptures and graphics elsewhere, and he and his friends feared that he was being threatened with a general prohibition to work as an artist. To the question, "What is Barlach to do in that case?" Schweitzer replied, "He can always emigrate."[35]

Schweitzer's intervention did not come about by chance. The House of German Art was scheduled to open in June 1937 with an exhibition of new German art, and in the previous November artists throughout Germany were invited to submit their work. At

about the same time, the idea of a contrasting exhibition of diseased modernism took hold. Nevertheless Goebbels waited until late spring or early summer before appointing a commission of five to inspect museums and collections and select German works of hybrid, degenerate art since 1910 for the exhibition.[36] In May he also appointed a jury to screen the entries for the exhibition of German art, after which Hitler would make the final selection. The two groups were chaired by the president of the Reich Chamber of the Fine Arts, Adolf Ziegler. Schweitzer, whose radicalism recommended him to Goebbels, was a member of the jury as well as of the commission seeking out works of degenerate art. Two other members of the commission were Scholz, the art critic of the *Völkischer Beobachter*, and the painter Wolfgang Willrich, whose recently published pamphlet, *Säuberung des Kunsttempels* (*Purification of the temple of art*), both helped guide the confiscations and provided many of the slogans with which the exhibition explained the pernicious nature of the objects shown.

Schweitzer's initiative to close the show that included Barlach's sculptures and drawings, was actually taken two or three days before 30 June, the day Ziegler and his commission received Hitler's official authorization to weed out decadent art. But the prospective members of the commission would have been informed in advance, and Schweitzer, secure in the knowledge that he and his colleagues were about to be entrusted with special powers by the Führer, would not have hesitated to terrorize a small private gallery and its politically undesirable exhibitors. Ziegler and his team now worked under extreme time pressure. The original June date of the opening of the House of German Art was delayed until the third week of July, but even so the commission and the curatorial staff in Munich had less than three weeks to assemble and hang the exhibition of decadent art. Goebbels expressed the hope

that it could be done: A simultaneous opening of the two shows of German and anti-German art would create a sensation.[37] Despite some difficulties the schedule was kept. The new House of German Art in Munich and its first exhibition of art of the Third Reich were opened with three days of party pageantry, from 16 to 18 July, including speeches by Hitler, Goebbels, and others. One day later, Adolf Ziegler opened the exhibition of degenerate art in the rooms of the plaster cast collection of the nearby Bavarian Archaeological Institute.

In assembling the two exhibitions, it proved more difficult to identify suitable German art than to choose works of the decadent and corrupt past. After the jury of the Great German Art Exhibition reduced the fifteen thousand entries to nine hundred, Hitler and Goebbels flew to Munich to inspect the results. "With sculpture everything is all right," Goebbels noted in his diary the following day, "but with painting much is absolutely catastrophic. Works are being shown here that make one literally sick.... The Führer is wild with rage."[38] Reportedly Hitler excluded some eighty works; his statement, "I will not tolerate unfinished paintings," indicating the grounds for his objections. He blamed Schweitzer for the poor choices – unfairly, Goebbels thought – but also criticized other members of the jury, threatened to postpone the exhibition for a year, and finally transferred authority for the exhibition to his personal photographer and advisor on art matters, Heinrich Hoffmann.[39]

In the early stages of planning, Adolf Wagner, head of the party in Bavaria and one of the patrons of the exhibition, was asked whether he could imagine that works by Nolde and Barlach might be included in the show. Wagner's response – "Absolutely. Everyone who does good work must be admitted; we exclude no names, only poor work" – was at the least very naive.[40] Before

Barlach was forced to resign from the Prussian Academy of Arts, he was routinely invited, as a member of the academy, to submit his "best" works to Munich. But he neither wanted to take part nor believed that if he did his entries would be accepted.[41] In the end it was as well that his works and Nolde's were not included; they would have pulverized the massed mediocrity that was assembled in the House of German Art. With few exceptions, Mario-Andreas von Lüttichau writes, "The show presented a decently craftsmanlike, rather conservative way of painting."[42] The monumental naturalism of the landscapes, industrial subjects, and portraits reminded him of nineteenth-century academic art. The stamp of the academy also lay heavily on various updated specimens of eroticism, among them paintings by Ziegler, who had the additional bad taste to exploit his influence by having five of his works shown while most exhibitors were limited to one or two. Some sculptures achieved a higher level of quality – notably a female and a male nude by the former Secessionists Klimsch and Kolbe, the latter contributing one of his idealizations of combative masculinity, *The Young Fighter*.

In his opening speech, Hitler claimed no more for the exhibition than that it marked "the beginning of the end of German art-foolishness, and thus the end of the destruction of our people's culture."[43] He spent more time denouncing the iniquities of modern art, which was practiced by "art midgets," and the "Jewish discovery that art changes with time" – although "true art . . . is not subject to the laws of seasonal appraisal of the creations of the fashion salon." Toward the end of the speech he outdid himself with a torrent of threats:

From now on we will fight a merciless war against the last forces of the degeneration of our culture. Should anyone be among them who still believes he is called to higher things, he has had four years [since the National Socialist assumption

of power] to prove himself. But these four years have also been long enough for us to reach a final judgment. Now – and I assure you of this here – all the cliques of babblers, dilettantes, and art fakers, who support and maintain each other, will be caught and eliminated. So far as we are concerned, these prehistoric art-stutterers of a cultural stone age can return to their ancestral caves and cover the walls with their primitive international scribbling.[44]

In a speech the following year he went so far as to acknowledge that at one point he had been tempted to cancel the exhibition.[45] Once again, the basic weakness of Hitler's cultural policy was revealed. National Socialism had little of substance to put in place of work that it rejected as ideologically dangerous, removed from sight or grouped in didactic exhibitions to demonstrate its incompetence and criminality, and sometimes destroyed.

In contrast to these disappointments, the preparations for the degenerate art exhibition proceeded quickly and relatively smoothly, so far as its National Socialist agents were concerned. The museum directors and curators, who were forced to give up major objects of their collections, took a different view. Some hid endangered works from the traveling inquisitors. The director of the modern section of the Berlin National Gallery refused to co-operate with the commission and secreted a few paintings before it arrived. One of his curators, Paul Ortwin Rave, drew up a report of the visitation, which served as the basis of the account he published after the war: After the museum was closed to the public, Ziegler and his colleagues appeared. "The true driving forces were two quasi-artists [*Halbkünstler*], filled with a burning eagerness finally to tear down what they had hated so long." One was Willrich, the other Schweitzer. The output of some artists had been judged and condemned in advance. Without looking at their works, and without discussion, the commission demanded their confiscation. The works of other artists were subjected to close analysis of the degree

and kind of their degeneracy.[46] "Barlach was treated as a tragic case; his sculptures were 'spared'; only one of his drawings was chosen, so that his name, too, would be represented."[47] Perhaps even Ziegler found it problematic to associate Barlach with such uncompromising expressionists as Kokoschka, Schmidt-Rottluff, or Kirchner. On this first visit – for the commission returned – sixty-eight paintings, seven sculptures, and thirty-three graphics were confiscated.

Out of the many objects sent to Munich from throughout Germany, about four hundred – paintings, sculptures, watercolors, graphics in portfolios and singly, books, posters, and photographs – were chosen for the exhibition. They were displayed in a space too small for them, crowded on walls and around doorways, some overlapped or hung at an angle to signal that they were trash and not art that deserved respect. Slogans defined and reinforced the exhibition's message: "Madness Becomes Method," "The German Woman Defiled," "Revelation of the Jewish Racial Soul," "This Is How Sick Minds Saw Nature." The purchase price of many works was listed, often in the highly inflated currency of the early 1920s, together with such notations as "Paid out of the tax pennies of the working German people." Although much was made of the Jewish threat, only a small percentage of the artists whose work was shown were Jews. That Max Liebermann, the most prominent German-Jewish artist of the period, who had died recently, was not included – even with some of the highly "unfinished" landscapes of his last years – remains one of the puzzles of the exhibition. Possibly, the organizers recognized that his cool, aristocratic images were not conducive to their concept of Jewish-bolshevik decadence.

Works of Barlach shown in the exhibition were a bronze cast of *The Reunion* and a copy of his prohibited book of drawings, which was displayed with other forbidden publications, jointly labeled "Defilers of Culture [*Kulturschänder*]. At least as mad as the monstrous products of incompetent, malignant, or diseased 'artists.' " Four charcoal sketches from 1922 and 1923, three of which were reproduced in the book, were placed nearby.[48] The organizers of the exhibition must have chosen the sketches as particularly reprehensible, but the choice revealed only their helplessness before Barlach's work. Three of the four sheets were devoted to furies and witches, a motif long dear to Barlach, which he had used for several sculptures and in his woodcut illustrations of *Faust*. They would hardly have known that he also regarded witches as symbols of injustice.[49] The witches are drawn in violent, hurried strokes, which, presumably, was a reason for selecting the sketches. But the fact that they represented figures of legend and fairy tales may have made their rather theatrical wildness more acceptable to the public. Only *The Waiting Man* of 1922, a study for the 1924 wood sculpture, served the cause of the exhibition as an example of the unnatural distortion that Hitler found so pernicious [Fig. 18]. The powerful figure is among Barlach's works that suggest a link to late-medieval German wood carvers and their views of humanity, stylized, yet full of life and character. The man's right arm, emerging out of the funnel-like sleeve of his cloak, is certainly elongated, and his head, towering over the massive body, is oversized and flattened. Yet in the vast, assertive chorus of abstraction, expressionism, and modernism of every type, the drawing's voice would scarcely have been heard.

The organizers had no time to prepare a catalogue. Its place was taken by an illustrated brochure, itself available only in the later

weeks of the show, which explained what the exhibition wanted to achieve:

At the start of a new age for the German people, *it wants* to give an insight, on the basis of original documents, into the gruesome final chapter of the cultural decay in the last decades before the great turning point... *It wants* to reveal the common roots of political and *cultural* anarchy... *It wants* to lay bare the ideological, political, racial, and moral goals and intentions that were pursued by the forces of decay... *It does not want* to prevent those of German blood among the exhibited, who did not follow their Jewish friends abroad, from honestly struggling and fighting to achieve the basis for a new, healthy creativity. But it *will* and *must* prevent the groups and cliques of such a grim past from foisting these men on to the new state and to its strong, forward-looking people, as the 'destined standard-bearers of the art of the Third Reich'

– a statement, directed at Barlach and other modernists, and their many supporters, even in the party, which suggests that despite the firestorm that raged against international modernism since 1933, the fear of a National Socialist, Nordic expressionism persisted.[50]

After the Second World War, the Munich exhibition of degenerate art became a universal symbol of the National Socialist perversion of culture. At the time, despite its vicious absurdities, the exhibition seems to have been a success. It attracted many more visitors than did the Great German Art Exhibition. Some people used the opportunity to see a concentration of modern art that elsewhere could no longer be shown. But most of the visitors, drawn to the exhibition by newspaper articles, radio talks, and leaflets distributed by party members and Hitler Youth, were less interested in art than in seeing the objects that they had heard denounced since the beginnings of the Third Reich, and earlier, as symbols of Germany's international enemy. Many must have been disturbed or even repelled by some of the works. The same paintings, sculptures, and graphics exhibited in the United States in

the 1930s might have encountered a similar degree of incompre-
hension and dislike among the general public. Only the political
message would have met with a different reception. Barlach's com-
ment when he saw a list of the artists in the exhibition, that the
exhibition would recoil on its organizers, was a forlorn hope.[51]

That Barlach was among those whose work was included only
worsened his troubles. In September his name was removed from
the roster of the Reich Chamber of Literature. Since he was a
member of the Chamber of Literature as well as of the Cham-
ber of the Fine Arts, this may have been a measure to eliminate
duplicate membership, but it could also have been preliminary to
his dismissal from the Chamber of the Fine Arts, in which case
he would no longer be able to show and sell his work, even in his
studio. The following month the version in wood of *The Reunion*,
which Hildebrandt had confiscated from the Mecklenburg mu-
seum, was included in an "antibolshevik" exhibition in Nürnberg.
Other pieces appeared in an "exhibition of degenerate art" in
Berlin. Eventually nearly four hundred of his works – sculptures
and graphics – were confiscated from museums and collections. To
a communication from the office of the Mecklenburg Chamber of
the Fine Arts, he responded in exasperation, asking why the cham-
ber would be interested in retaining a member officially labeled
a defiler of culture.[52] The continued hostility of the municipal
and church authorities in Güstrow, and insults and threats from
people in the street, led him to vague plans to move elsewhere.
An anonymous denunciation accusing him of a criminal offense
that can no longer be identified was investigated by the authorities
and found groundless, but the experience added to his nervous-
ness. He could see no end to National Socialist rule. The worst, he
thought, was yet to come. When he heard the radio broadcast of
Hitler's *Kulturrede* at the 1937 party rally, in which Hitler poured

crude insults on modern art and its makers, he could respond only with a grim joke about its eternal message.[53] Throughout the year he found it difficult to work. "I can't deny that my productivity is paralyzed," he wrote in September to a young writer, who was unable to publish his poems because he had a Jewish wife. "When day after day one has to expect the threatened, deadly blow, work stops by itself. I resemble someone driven into a corner, the pack at his heels. You don't become tame in such a situation; but neither do you hate" – a comment he immediately withdrew: "You long for some standard on the part of the enemy, so that everything, hatred, etc., would make sense. But what standard! A kingdom for a decent enemy! Love your enemies? Certainly, certainly, but they need to be worthy of it!"[54]

Not only National Socialism weighed on him, but also his poor health. His old heart complaint was growing worse. Chest pains sometimes interfered with his sculpting and carving. His physician advised rest, but spending several months away from Güstrow, in the milder climate of Silesia and the Harz Mountains, proved of little value. His sense that he had not long to live merged with anguish over his inability to work – as he put it with some exaggeration – and with anger and bitterness over the removal or demolition of his monuments. He complained of being "an immigrant in my own country," although he repeatedly told himself and others that nothing about his situation was exceptional.[55] In a letter typical of many he wrote at this time, he thanked an old acquaintance who had expressed regret at his troubles, but added: "I can't be helped, and I no longer want to talk about it and around it . . . After all I am only one of thousands, and in the end each of us deals with these things in his own way . . . In the face of the ultimate reality, all this nonsense becomes meaningless; why then make oneself important and pretend that it matters. Forget it!"[56]

Barlach's complaints that he could not work expressed his de-
spair at a lessening of productivity, but in the course of 1937 he did
complete several figures. The clay statue of a sorrowing woman,
standing upright, a scarf wrapped around her arms and hands, to
which some friends gave the name *The Bad Year 1937*, was actually
finished in 1936, as was *Man Reading in the Wind* [Fig. 35], a figure
of calm and concentrated introspection, the most broadly popular
work of his late period. But the following year he carved a version
in teak wood of the 1931 figure *The Doubter*, made a portrait bust
of the artist Leo von König, and made the three sculptures that
were shown in the Berlin gallery before Schweitzer closed it: the
Sitting Girl, in rosewood, based on a porcelain figure of 1908, and
two related figures, *Freezing Crone* [Fig. 36] and *Laughing Crone*
[Fig. 37], both of which were first modeled in clay, then cast in
bronze, and finally, much enlarged, carved in wood. As was the
case with many of Barlach's sculptures, these works took up for-
mal elements that had occupied him years, even decades, earlier.

The figures of the two old women – Barlach referred to them
jokingly as "the old thunderstorm woman" and "the witch pepper-
tongue," and told a visitor, "I wouldn't want to get caught in their
traps" – are far apart in style, if not in emotion.[57] The *Freezing* or
Shivering Crone is a squatting, compact, uncompromisingly ugly
creature, seemingly out of one of the Grimm brothers' darker fairy
tales, silently waiting out bad weather. The *Laughing Crone* reverts
to a sketch of three witches Barlach had drawn in 1908. Her body,
like that of the *Blind Beggar* of 1906 among others, leans far back,
her head thrown back even further, but the elegantly sweeping
lines of her arms and trunk are suddenly interfered with by the
grotesque, cartoon-like laughing mouth. In his "Notes to the Bar-
lach Exhibition [of 1952]," Bertold Brecht commented that "her
gaiety is irresistible . . . Goebbels and Rosenberg would not have

had much pleasure in seeing her laughter, I think. It is said that Barlach made his *Laughing Crone* when he heard that many of his sculptures taken from museums as 'degenerate' were being sold in Switzerland, to garner foreign currency for the manufacture of cannon."[58] Brecht was misinformed. The sale of confiscated art did not take place until 1938, after the *Laughing Crone* had been exhibited in Berlin, was confiscated by Schweitzer, and was eventually returned to Barlach with his other pieces in the exhibition. Who, in any case, can say what stimulated Barlach to choose just this motif at this time, and what the old woman's grin meant to him when he carved it? Only one thing is certain. That Barlach made two such radical sculptures in 1937, and chose to show them rather than figures less abhorrent to National Socialist eyes, exemplifies two traits of his personality that had now marked his art for decades: the inability to compromise in his work; and the refusal to accept criticism or condemnation based on fashion, politics, or an unwillingness to depart from the customary. A regime that had condemned his book of drawings as a threat to public order would inevitably see the two crones as the outrageous fantasies of a sculptor bent on insulting the ideals of the new Germany and the aesthetic principles of its leader. The two figures were the strongest protest he could make against National Socialism. In turn, the regime struck back with two of its favorite weapons – prohibition and confiscation. Barlach's stubbornness certainly included an element of arrogance. He believed that he was the best judge – not of the quality of his work, but of the issues he set himself to solve and the manner of solving them. Inevitably these attitudes brought him into conflict with the Third Reich; they also enabled him to maintain his independence at a time "of purest amorality," as he called it.[59]

After 1937, Barlach's illness and a now frequent depression made his fear of not being able to work a reality. A commission – a great rarity since 1933 – gave him encouragement. But the project, a baptismal font for a Westphalian town, did not progress beyond many sketches and two clay models, one showing on its massive base the cloven-footed embodiments of evil repelled by the forces of good. Increasing ill health compelled him to enter a clinic in Rostock at the end of September, where he died of a heart attack on 24 October 1938, in his sixty-ninth year.

6

After the Fact

On 26 October, the official conducting the propaganda ministry's daily press briefing issued directives on the permissible manner of reporting Barlach's death. The event "could be announced, but should be treated with reserve, since his work was not approved of. In addition, some space might be devoted to an evaluation of his personality."[1] The writers of the obituaries, which appeared in a number of newspapers and periodicals, took care to observe the warnings that accompanied the permission to write about Barlach at all; but the note of "yes . . . but" that persistently crept into their texts hinted at an unexplained element in the relationship of the artist and the new Germany.

The Berlin mass-circulation daily *B.Z. am Mittag* printed an appreciation by Carl Dietrich Carls, who in 1931 had written a monograph on Barlach, which two years later was prohibited by the new regime. Carls declared that Barlach's sculptures and dramas expressed the contrast between the burdens of life and its affirmative yearnings. An age that was renewing the classical ideal

of beauty in sculpture would not value this approach.[2] A similar point was made by Ernst Sander in the *Hamburger Fremdenblatt*: "It goes without saying that National Socialism, which seeks a clear, bright, classical German ideal of art, rejected Barlach's oppressive and brooding heaviness.... Barlach and his work are exceptions. The individual element is stronger in him than the typical and the native, and an age in which native values count above all, inevitably must reject this individuality." In his work, the times have recognized "a discord, perhaps even a false note. But they will not be able to deny the deceased their respect for the seriousness of his intentions."[3] Two newspapers that still retained traces of their liberal traditions and were given some leeway because they were frequently quoted in the foreign press went further. A day after briefly announcing Barlach's death, the *Frankfurter Zeitung* printed a sober appreciation of the man and his work: His art did not derive from expressionism, but "from the silent, withdrawn character of his native environment [*Lebenskreises*]." It was driven by "the force of a heavy, solid, even speechless nature, secure in the knowledge that once set in motion, it would imperturbably advance."[4] The *Deutsche Allgemeine Zeitung* printed a sympathetic account of the funeral ceremony in Barlach's studio, noting the many people who expressed their respect for the deceased by attending a ceremony "that in its plain dignity reflected Ernst Barlach's nature."[5]

Subsequent articles included the comments that it was Barlach's fate to be out of step with the times; that his isolation did not mean that he was lost, but became a path toward inner freedom; and that "the honest 'yes' of his friends was opposed on the other side by an equally honest 'no.' "[6] These and similar statements, which treated Barlach with some dignity and even sympathy, caught the attention of the intelligence service of the SS. Its

annual report on conditions in Germany, an analysis from a gener-
ally radical perspective that was distributed only to the most senior
men in party and government, declared that "wider circles of the
population were taken aback by isolated obituaries that honored
art-bolshevik artists [*kunstbolschewistische Künstler*] like Munch or
Barlach."[7]

Ideologically the most telling memorial, an appraisal of
Barlach's work rather than an obituary, was a full-page article in
Das Schwarze Korps, the organ of the SS, illustrated with reproduc-
tions of a Barlach self-portrait and of four of his sculptures, includ-
ing the Güstrow angel and one of the figures of the Magdeburg
monument. The noticeably ambivalent note with which the
anonymous author began continued throughout:

Barlach's death has taken one of the most striking art personalities from the ranks
of those who shaped the face of art in Germany in the first third of our century.
Undoubtedly he also belonged to those who inevitably were the most contro-
versial, because although his work is nearly always gripping and unforgettable,
it is usually also unsatisfying and only too often repulsive. . . .

Certainly the name 'cultural bolshevik' is even less appropriate for Barlach than
for Käthe Kollwitz, whose nature is so closely related to his. Even if Barlach
had been, like Kollwitz, emotionally on the left, he is as detached from 'art
bolshevism' proper as she is, by the genuine, profound seriousness and lack of
rhetoric of his art, and by its unity, solidity, and formal maturity.

Up to this point the author's comments – whether one agrees
with them or not – are couched in rational terms. Then the text
shifts to a new mode of reasoning, in which differences or antag-
onisms between an individual and National Socialism are neces-
sarily based on race. That Barlach's gentile descent on his father's
side and his mother's was documented for generations did not pre-
vent the SS critic from branding him "un-German." In the end,
he could explain Barlach's failure to accept National Socialism,

and be accepted by it, only as the result of an immutable racial difference that separated Barlach from the true German, or of his having been corrupted by members of another race. Although the claim that Barlach was Jewish had been publicly disproved, he could at least be pronounced infected by the eastern-Russian virus. The racial accusation is introduced with the general statement that Barlach, the individual, and his art belong to a world alien to Germans. "One need not be a racial scholar to recognize that this man would have had to be untrue to himself had he wanted to create images according to a different ideal. . . ."

"By race, Barlach is anything but German. He is spiritually unbalanced, possessed by the demon of the Eastern-Slavic world, the sudden change from boundless excitement to deep depression . . ." This duality also characterizes his sculptures. "Faced with these Barlach figures one has the feeling of being in the company of neurotic, intellectually limited, unstable creatures."

Although Barlach did not think of himself as a believing Christian, regarding every faith as a valid attempt to understand the world and humanity's place in it, the SS writer used the link between Barlach's work and Romanesque and Gothic churches and statuary to open another avenue of attack. Accusing him of devout religiosity would carry weight with radical members of the SS: "Barlach was so deeply Christian, that even had he left the Church, he would not have become free. He reveals the same ignorance of the godly and the human as [did] some medieval sculptors, who created terrifying scenes of crucifixion, and, renouncing 'the base world,' quaked and stumbled toward the Last Judgment. Within this unheroic conception of the world, Barlach achieved great things."

By way of Christianity, the Middle Ages, and mysticism, the author had reached what was always the crux of the matter

for the National Socialist critique of Barlach's work – Barlach's interpretations of the First World War. Ill-defined racial accusations now take the place of explanations:

> Unbearably alien . . . is the effect of those of Barlach's works that should have been felt and conceived heroically if they were to fulfill their purpose, for instance, the memorials. For that reason the feelings of the German people were outraged at Barlach's war memorials – and rightly so. Heroism and honoring the hero – those are matters of race. . . .
>
> Race is fate, and he, too, had to obey this law. Barlach could only carve, paint, or write as he did; otherwise he would have become untrue to himself and would have betrayed his artistic ideals. Had he done so, he might have become a cultural bolshevik. Barlach was not a cultural bolshevik, but his world is not our world. . . . And that is why we had to reject Barlach, not as a human being, not even as an artist as such, but as the messenger of an attitude and an ideology that are alien to us, and that at the same time represent a danger to the single, clear line that we are seeking.[8]

After the war, the critic and editor Karl Scheffler, who nearly forty years earlier had been one of the first to find promise in Barlach's work, called the patronizing judgment in the SS article – that, despite everything, Barlach was not a cultural bolshevik – arrogant and impertinent.[9] It was that, but between the lines we can sense the SS author's interest in modern art – reminiscent of the attempt by young National Socialist intellectuals in the first months of the Third Reich to gain acceptance for a National Socialist modernism – and his effort to come to terms with work that resists easy categorization, even if the attempt fails in a muddle of racial and ideological fantasies. A striking response to the convoluted redefinition in this article of what was and what was not German came in a Swiss obituary, which, without emphasizing the irony it found in Barlach's being attacked by champions of Germanic uniqueness and superiority, observed simply that "if anyone in Germany, by reason of descent, tradition, and attitude

fulfilled the racial demand of the innate link between blood and soil [*Blut und Boden*], it was he."[10]

Each in its own way, these articles and notices raised the issue of the German qualities of Barlach and, more importantly, of his art. The German writers found themselves in a quandary, created by an ideology they were forced to accept, whether or not they believed in it. Actually, if not clouded by mythic attributes, the national characteristics of Barlach's work are readily established by scholarly methods and connoisseurship, which identify the kind and degree of affinity of an artist's work with one or the other among the multitude of traditions, influences, and styles in Western culture. Comparing Barlach's sculptures with his own, Aristide Maillol had no difficulty in telling him, "Tu es Nordique – moi je suis Mediterrané."[11] For National Socialists, however, the question became one of ideological significance. It bore on their definition of who and what was German, and on their relationship to the values they defined and imposed.

In their eyes an artist was German who before 1933 did not reject realism, who interpreted the individual as part of the national community, not as autonomous, and who from 1933 on accepted the National Socialist message, or – if the person was too hidebound – at least remained apolitical and behaved with circumspection. Barlach could not easily be squeezed into these categories. Nevertheless, he might have been tolerated, as were other artists, writers, and musicians, had it not been for his images of the First World War, his unwillingness to obey the state's cultural policies without argument, and for the urge of National Socialism to control and impose uniformity in the arts as in every other area, a propensity that Hitler's hatred of modernism intensified.

Barlach himself was in no doubt about the national identity of his work. In his 1936 essay "When I Was Threatened with the

Prohibition to Work in My Profession," he defined himself as "an artist of German birth and roots," and continued: "I know that I belong nowhere else than in the place in which I have worked until now. And because I am accused of being an alien, I want to claim a better, stronger, far deeper association with the land of my birth – a belonging, yes, even enslavement, more fully developed in me by history and experience than in any of those who now deny me these attributes."[12]

What was in question was not where he belonged, but the nature of what he belonged to. His Germany was not Hitler's. Unencumbered by nationalistic ideology, he did not think of Germany or German culture as something undivided, a unitary entity, deviating from which was forbidden. He could even view with detachment and scepticism what he considered his own specifically German traits. Among other critical and self-critical statements, a letter of 1932 recalled that Paul Cassirer, the art dealer who had represented Barlach for twenty-five years, "cared very little for my overly 'German' nature, specifically its north- and low-German characteristics. Nevertheless we remained friends. He tolerated much in me, as I in him."[13] Barlach recognized some of the limits as well as the strength of his native culture. As we have already noted, despite his compositional daring and his readiness to experiment, in a few of his works Barlach approaches the parochial or regional *Heimatskunst*, the same unchallenging repetition of homey German themes that he condemned as unthinking and sentimental in others. The reading couple in the fireplace frieze of 1916 [Fig. 14]; *The Jolly Peg-Leg* of 1934, a three-dimensional caricature, reminiscent, as already noted, of Wilhelm Busch's cartoons [Figs. 32 and 33]; even the frowning, pained face of *The Fettered Witch* of 1926 [Fig. 20] are among lapses into the obvious. They illustrate rather than interpret, and even the artist's

compositional power and technical finesse cannot fully salvage them. They make up no more than a minor element in his total work, but they cannot be overlooked. To the later observer they provide an interesting baseline that indicates the length of the journey that led to Barlach's strongest sculptures. At the time, this part of his work appealed to the longing of some National Socialist critics for the homegrown and thus added a nativist tinge to Barlach's ambiguous status in the Third Reich.

The ambiguity of his work is actually far greater than was generally recognized at the time. Much of it is in tune with German themes and German approaches to them. To varying degree, often with great success, Barlach turns the specifically German into a representation of common humanity. In some sculptures he goes still farther, to range far beyond the limits of Germany, or of central- and northern-European art. Major pieces like *The Lonely Man* [Fig. 6] or *Man Drawing Sword*, also of 1911 [Fig. 7], are figures of great thematic and stylistic independence. They seem to belong not to a national or even an international world, but to a world that is non-national.

The very fact that obituaries of Barlach appeared at all made it clear that although branded a despoiler of German culture, he was still not wholly excluded from the German community. By the time he died, it would have been out of the question for a Jewish artist, modernist or not, to be discussed in the press with a similar degree of respect. Despite the many measures taken against him, Barlach remained a dissident whose death deserved notice. By descent he should have been in the National Socialist camp, an affiliation also borne out by much of his subject matter, the common German man and woman, and by the affinities of some of his work with the art of the German Middle Ages – the first Reich in Hitler's messianic triad, which the third was to restore

and lead to new triumphs. That Barlach and the Third Reich had, nevertheless, been in open conflict could raise questions, if not about National Socialist values then certainly about their implementation. That may also have been in Hitler's mind when he is reported to have said, on hearing of the artist's death, that he had not known, and regretted, that Goebbels, in an excess of zeal, had "ostracized" Barlach.[14]

Barlach's refusal to be a passive victim was one reason for the relentless attacks on him. He continued to carve and draw as he pleased, exhibit and publish works that he knew were too radical to be accepted, and express his outrage to the police and to senior officials at what he persisted in calling unjust treatment. His self-assertive protests had no effect, and he continued to be harried and isolated. But he might have been treated far worse. Unlike Käthe Kollwitz, who was questioned by the Gestapo after she gave an interview to a Russian reporter and warned that she was in danger of being sent to a concentration camp, the police left him alone.[15] Although other artists were formally forbidden to work – the eighty-eight-year-old Christian Rohlfs in 1937, for instance, or Emil Nolde and Karl Schmidt-Rottluff in 1941 – Barlach was merely threatened with the prohibition; the order was never issued. It has been suggested that his art was so popular that the cultural functionaries of the Third Reich hesitated to treat him too severely; but there is no evidence for the premise, and the conclusion seems overly fanciful, the Third Reich not being in the habit of responding to popular pressures.[16] It would be more realistic to assume that the National Socialists' own ambivalence acted as a brake to the most severe measures. Had Barlach lived long enough to experience the regime's continued radicalization during the Second World War, as its future was becoming increasingly doubtful, he, too, would have been forbidden to work.

If the claim that in the late 1930s Barlach was a broadly pop-
ular artist is inconclusive at best, there were enough admirers of
his work to make possible the appearance soon after his death
of a number of privately printed books and pamphlets on the
man and his art. The first, in 1939, was a brochure of brief state-
ments and recollections by his friends. The same year, Friedrich
Schult, an artist and teacher in Güstrow who helped preserve many
of Barlach's papers, edited a twelve-page collection of Barlach's
statements and comments, *Barlach im Gespräch*, which he printed
in 350 copies and distributed privately. In 1940 he reprinted the
pamphlet, 200 copies of the new edition going to a bookshop in
Güstrow, where they were sold under the counter. Also in 1940,
Schult, the driving force behind this somewhat ghostly posthu-
mous literary revival, edited a volume of illustrations to Heinrich
von Kleist's novel *Michael Kohlhaas*, which Barlach had drawn in
1910. Because the novel – the account of a man who became a
criminal out of an insulted sense of justice – was a classic work by
the greatest Prussian writer of the Napoleonic era the Gestapo
apparently set aside concerns about its illustrator and allowed the
book to appear in a bibliophile edition of 1,000 numbered copies.
In the same year, however, a new edition of Barlach's diary of
his Russian journey in 1906 was confiscated before it reached
the bookshops, although the periodical *Deutsche Rundschau* had
already printed excerpts. As late as 1944, two anonymous publi-
cations of Barlach texts appeared.

In a letter thanking Schult for sending her a copy of *Barlach im
Gespräch*, Käthe Kollwitz wrote how clearly she recognized the
artist in his statement: "At no time did I possess what is called
talent." She added, "That is absolutely right. I, too, would deny
him any talent [das Talent ganz absprechen]. Barlach's work comes
from a different direction."[17] She drew a difference between the

technical and formal proficiency that Barlach shared with others, and the emotional and intellectual weight of his view of life, to which he was able to give unique aesthetic expression.

The relationship between Käthe Kollwitz and Barlach casts further light on Barlach's place in German art and on the National Socialist interpretation of his work. He and Käthe Kollwitz first met in the years before the First World War, at exhibitions and meetings of the Berlin Secession. They saw each other only infrequently, then and later, but developed a sense of kinship and stayed aware of what the other was doing, with Käthe Kollwitz repeatedly finding her work inferior to his. Characteristic is her comment in her diary after she had attended a performance of one of his plays. She experienced "a deep sense of envy that Barlach is so much stronger and deeper than I am."[18] She recognized his more expansive formal and thematic range, but perhaps she did not realize that both her style and her subject matter – especially her variations on the themes of mother and child, and of the power of love, and of its helplessness in protecting the loved one against the forces of poverty and war – made her work more accessible to a broader public. Barlach's engagement with her art was not as strong; but it speaks to the value that he placed in her person and in the seriousness of her effort that unconsciously, as he said, he chose her face as a model, or as one of the models, for the floating figure in the Güstrow dome. With the coming of National Socialism the trust the two artists had in each other could only deepen. As already noted, the cultural critics of the Third Reich sensed their affinities – the link between artist and the drama of human existence, unscreened by the interjection of the state and its ideological and physical demands – but also their differences: Barlach was not "emotionally on the left." When Barlach died, Käthe Kollwitz attended his funeral; she made a sketch of the

corpse, which she did not want published, and soon began work on a small bronze relief, *Lamentation on Barlach's Death*, or simply *Lament*, the most notable of the immediate reactions to his life and art [Fig. 38].

A precursor for the work in theme and form was the relief for her own grave, on which she had worked in 1935 and 1936 – a woman's face, eyes shut, enveloped by two powerful arms and hands that are taking her away. Now she modeled an asymmetrical rectangle filled by the face of a woman – perhaps herself – with eyes shut, her face partly covered by her two hands, which try to contain her grief. Like Barlach's monuments to the dead, the relief expresses nothing but sadness. Ignored is the issue that by conviction or under compulsion had preoccupied the writers of the obituaries: Was the man who was being mourned or recollected a German artist? Nor did her work openly address a second question that some readers of the obituaries certainly asked themselves: Could the achievements of German artists since the early Middle Ages, the traditions in which and against which they had worked, and the ideas they expressed, be reconciled with the demands that the new rulers and their agents were imposing on art, and on the society and culture in which it was created? But the very existence of Käthe Kollwitz's relief gave a sufficient answer. That her relief itself betrayed French and Belgian influences – Constantin Meunier, Paul Gauguin, and Georges Minne have been suggested – would have been a matter of little concern to the artist.

With his work, and with his rejection of the state's authority to judge it, Barlach insisted on the native character of his art and on its betrayal by the Third Reich. His experiences from 1933 on raise a further general issue: that of the artist functioning in a dictatorship, and of the artist's resistance to it. Barlach protested the injustice of his treatment to party leaders and functionaries, to the

police, and to others; but his opposition to the regime was mainly expressed through his work. The events of 1933 and afterward did not put a stop to the exploration of themes and formal problems that had occupied him for decades. That was only one of several responses of German artists to the new conditions. In 1933 some artists shifted easily out of styles that had suddenly become unacceptable. What they produced is at most of historical interest today. A few others made the relatively minor adjustments that were necessary to fit their previous manner into the heroic, neoclassical mode or the prettified realism that the regime valued, and continued their work on an acceptable level of craftsmanship and imagination. Barlach, like almost every artist whose work still matters, refused to adapt. But unlike many, he did not manage to remain in obscurity. Otto Dix, whose paintings and graphics of the First World War and its impact on German society National Socialists if anything hated more than Barlach's memorials, found refuge in a small town by Lake Constance, where, in the lasur manner of 1500, he painted fantastic combinations of modernism and the German Renaissance. Emil Nolde, his life-long anti-Semitism and mythic Germanness no protection against the fury that the violence of his shapes and colors aroused in National Socialist aesthetes, isolated himself in his studio near the Danish border, and, being forbidden to paint, surreptitiously produced some thirteen hundred watercolors – his "unpainted pictures." Barlach, the least public figure imaginable, continued to call attention to himself by his insulted sense of justice, his defiance, and a stubborn wish, despite his own reservations, to publish and exhibit his work.

The obstacles that Barlach encountered in the Third Reich were faced by every artist. The state dealt harshly with some, less harshly with others; but the potential for sudden and extreme intervention in one's life was present for everyone. Even Adolf

Ziegler, president of the Reich Chamber of the Fine Arts and one
of the organizers of the exhibition of degenerate art, eventually
found himself in a concentration camp. Repression, threats, and
injustice were also part of the common experience, potentially
or actually, of millions of other Germans. From 1933 on, men
and women in every field of activity faced a political and social
revolution and soon a police state, which went to great lengths
to advertise and propagandize its ideology, but in the end always
relied on intimidation and violence. Barlach's experiences in the
Third Reich are not only those of an artist; they should also be
seen in this general light. He dealt with the same difficulties and
dangers everyone faced; but as an artist, who of necessity addresses
the public, he was more exposed than many.

The relationship between the artist and an uncomprehending
public is one of the themes out of which we construct our sense of
society. Despite the romantic exaggeration often associated with
it, the theme defines an aspect of modern social reality: How the
outsider is treated indicates and measures the values of the com-
munity, its political institutions, and its coercive practices. The
further intensification of this idea, which turns the artist into a
rebel – whether or not the image truly reflects a particular artist's
position – may also express a personal identification: The artist's
conflicts and frustrations then stand for our own, so that the artist
turns into a metaphor for the individual in society. The relation-
ship between the two rises to a high level of menace when the
artist confronts not general indifference or lack of understanding,
but a repressive political system. For the Third Reich the tension
between the individual and society was inadmissible. It could be
understood only as betrayal or as the inevitable workings of racial
antagonism. Nor did National Socialism allow the artist to be an
outsider, let alone a rebel. On the contrary, the artist's mission

was to be a voice that in the vocabulary of its particular medium retold the National Socialist interpretation of the German race, in the past and especially in the present. Those who refused to accept this role could expect difficulties. Like every other activity and occupation in German society, the fine arts had their own mechanisms of control and punishment; but the intentions behind them and the spirit and manner in which they were implemented in each area were the same throughout. In that sense, Barlach's experiences in the Third Reich were commonplace. Exceptional only was that out of this ordinary existence came works of art that surmounted repression, and that he alone could have made. Compared to the world-historical importance of the regime under which Barlach lived his last years, the significance of his art is minuscule, a sliver. But he and his work bear witness to these years, and unlike the Third Reich, his art has lasted.

A Note on the Literature

The principal collection of documents on Barlach's life and work is held in the archive of the Ernst Barlach Foundation in Güstrow. From 1933 on, Barlach burned many of the letters he received, to protect his correspondents and himself. Consequently documentation for his last years is uneven. Still, the archive contains material on this period that is sometimes important and always interesting.

Basic to any study of Barlach's life, writings, and art is the three-volume *catalogue raisonné* edited by Friedrich Schult, *Werkverzeichnis*, 1, 2, and 3, Hamburg, 1958, 1960, and 1971, for Barlach's prints, sculptures, and drawings respectively. The catalogues are of high quality, but over time additional works, especially drawings, have become known, and they are now somewhat out of date. Revised editions of the volumes on sculptures and prints are being prepared by the Ernst Barlach Foundation. Friedrich Dross and Klaus Lazarowicz edited Barlach's plays, *Die Dramen*, Munich-Zurich, 1968; and Friedrich Dross edited

Barlach's prose writings in two volumes, *Die Prosa*, Munich-Zurich, 1959, reprinted 1973 and 1976. Dross also brought out Barlach's correspondence in two volumes, *Die Briefe*, Munich-Zurich, 1968, 1969, with concise, informative notes. The edition contains 1,507 letters. For unstated reasons another 84 were not included ("Vorwort," *Die Briefe*, 1, p. 8). Barlach's handwriting is sometimes difficult to read, but comparisons with the originals in the Güstrow archive indicate that the printed text is highly accurate. New letters by Barlach continue to appear now and then. See, for instance, Wolfgang Tarnowski, "Ein unbekannter Brief Barlachs aus dem Jahre 1934," *Ernst Barlach Gesellschaft: Mitteilungen*, 1988. Tarnowski also edited the correspondence between Barlach and the publisher Reinhard Piper, who collaborated with the artist in the unfortunately timed publication of a volume of his drawings in 1935, which further intensified the National Socialist persecution of Barlach: *Ernst Barlach – Reinhard Piper. Briefwechsel, 1900–1938*, Munich-Zurich, 1997. The work is supplemented by the catalogue of an exhibition at the Ernst Barlach Foundation, *Reinhard Piper – Ernst Barlach. Stationen einer Freundschaft, 1900–1938*, ed. Volker Probst and Helga Thieme, Güstrow, 1999. Elmar Jansen edited an expanded version of Friedrich Schult's *Barlach im Gespräch*, Leipzig, 1985, a record of conversations with Barlach, which Schult originally published privately for Barlach's friends in 1939. After the war the work was repeatedly enlarged.

Barlach wrote an account of his first forty years, *Ein selbsterzähltes Leben*, Berlin, 1928, in which he takes a steady, somewhat detached view of his slow development as an artist. It has been reprinted several times, most recently in an annotated edition by Ulrich Bubrowski, Leipzig, 1997. The extensive diary Barlach kept during the First World War, "Güstrower Tagebuch,"

is included in the second volume of *Die Prosa*. Perhaps the difficulties of dealing both with Barlach the artist and Barlach the dramatist and writer have until now precluded a comprehensive biography that meets high standards of documentation and interpretation. A good, brief study, combining biography and analyses of the work, is Naomi Jackson Grove's very knowledgeable *Ernst Barlach: Life in Work*, Königstein in Taunus, 1972. Paul Schurek, who as a young man knew Barlach, published a "pictorial biography," *Barlach*, Munich, 1961, which does not lay claim to detailed scholarship but is interesting for the author's understanding of the atmosphere of the 1930s and for the good selection of photographs that give some insight into Barlach's physical and social environment. Schurek has also written a small volume of recollections, *Begegnungen mit Barlach*, Gütersloh, 1954.

Two collections of published sources on Barlach's life are Elmar Jansen, *Ernst Barlach: Werk and Wirkung*, Frankfurt a. M., 1972, a compendium of contemporary articles, reviews, and letters; and Ernst Piper, *Nationalsozialistische Kunstpolitik*, Munich, 1983, a collection of letters and documents with the subtitle "Ernst Barlach and 'Degenerate Art.'" Neither author aims at completeness, and neither hesitates to publish excerpts and partial texts; but they provide invaluable guides.

A number of major exhibitions and their catalogues in recent years give evidence of the energy of scholarship on Barlach, and they are stimulating further work. Among those of particular value for this study are the three-volume catalogue *Ernst Barlach*, Berlin, 1980, of the 1981 East Berlin exhibition, and the catalogue *Ernst Barlach: Werke Meinungen*, Vienna, 1984, of the 1984–1985 exhibition in Vienna; both were edited by Elmar Jansen, and are notable for Jansen's introductory essays and his wide-ranging commentaries on specific works. The Ernst Barlach Foundation

has published a number of excellent catalogues based on its exhibitions and associated conferences. Examples are *Ernst Barlach. Das Güstrower Ehrenmal*, ed. Volker Probst, Güstrow, 1998; and *Ernst Barlach: Artist of the North*, ed. Jürgen Doppelstein, Volker Probst, and Heike Stockhaus, Hamburg-Güstrow, 1998, with especially suggestive essays by Heike Stockhaus, "Das Nordische, das Germanische, das Gotische," and Anita Beloubek-Hammer, "Ernst Barlach und die Avantgarde." The latter has also written an interesting essay on the influence of German modernist sculptors on sculpture and its reception in the German Democratic Republic, "Die 'entarteten' deutschen Bildhauer und ihr Erbe in der DDR," in *Deutsche Bildhauer 1900–1945 Entartet*, ed. Christian Tümpel, Zwolle, 1992. *Ernst Barlach – Theodor Däubler*, ed. Volker Probst and Helga Thieme, Güstrow, 2001, explores Barlach's friendship with the poet Theodor Däubler, and suggests new approaches to the complex relationship between Barlach's sculptural work and his writings. The most recent catalogue of an exhibition of the foundation, *Ernst Barlach im Kunstsalon und Verlag Paul Cassirer*, ed. Volker Probst and Helga Thieme, Güstrow, 2003, appeared while this book was in press.

The publications of the Paul Cassirer Verlag, which include the first editions of Barlach's dramas and of his autobiography, as well as numerous portfolios and single prints of his graphics, have recently been catalogued with a detailed commentary by Rahel E. Feilchenfeld and Markus Brandis, *Paul Cassirer Verlag*, Munich, 2002. Work on an edition of Cassirer's writings on art and culture is in progress.

Apart from the rich literature of exhibition catalogues, numerous monographs, essays, and memoirs address or touch on one or the other aspect of Barlach's life. Representative are Karl Scheffler's memoirs, *Die fetten und die mageren Jahre*,

Munich-Leipzig, 1948; and Elmar Jansen's *Ernst Barlach – Käthe Kollwitz*, Berlin, 1989, an inspired comparison of the two artists, which is supplemented by Käthe Kollwitz, *Die Tagebücher*, ed. Jutta Bohnke-Kollwitz, Berlin, 1989, one of the great human and cultural documents of the twentieth century. My essay, "Field Marshal and Beggar – Ernst Barlach in the First World War," in the collection of my essays, *German Encounters with Modernism, 1840–1945*, New York-Cambridge, 2001, treats a period of Barlach's life that helped determine his life under National Socialism. A chapter in the section "Inner Emigration" of Werner Haftmann's study of artists disliked by the regime, *Verfemte Kunst*, Cologne, 1986, is devoted to Barlach. The book, by an art historian, offers a good overview of the work and fate of a large number of artists, but seems to me somewhat celebratory. Also to be mentioned are Olaf Peters, *Neue Sachlichkeit und Nationalsozialismus*, Berlin, 1998, a more searching study on three artists under National Socialism, among them Otto Dix; and Wolfgang Tarnowski, *Ernst Barlach und der Nationalsozialismus*, Hamburg, 1989, an expanded version of a lecture by a very knowledgeable author. Using Barlach's fate in the Third Reich to warn against the recurrence of authoritarian ideologies in Germany is, however, a recipe for oversimplification. The author's didactic purpose seems to inhibit him from discussing Barlach's decision to sign the plebiscite manifesto supporting Hitler's determination to combine the offices of chancellor and head of state. In a later essay, "Kunst, heldischer Mensch und rassische Klärung, Ernst Barlach und der Nationalsozialismus," in *Ernst Barlach*, catalogue of the 1994–1995 exhibition in Antwerp, ed. Jürgen Doppelstein, Antwerp, 1995, the author makes some interesting observations on the Third Reich's rejection of Barlach, but again fails to mention that Barlach signed a manifesto drafted by Goebbels. Nor

is the fact referred to in the cited works by Haftmann, Jansen, and Piper. The incident, which is indicative of the pressures and confusions characteristic of life under Hitler, should be dealt with openly, and not only because it has been used to accuse Barlach of being a National Socialist.

The politicization of art in the Third Reich was not the work of Hitler alone, or even of those party members who opposed "international modernism." Nevertheless, an essential part of this process would be missed if one were to ignore the people who initiated the control and repression of the arts in 1933, and continued to energize it. My discussion of National Socialism as it affected Barlach is based, in the first instance, on statements and writings of the individuals responsible for developing the cultural policies of the Third Reich. The equally important and equally complex history of the institutions and bureaucracy of culture in the National Socialist state can be pieced together from a large number of documentary publications, general and specialized studies, and biographies. Hitler's early speeches are published in *Sämtliche Aufzeichnungen, 1905–1924*, ed. Eberhard Jaeckel and Alex Kuhn, Stuttgart, 1980. An overview of his speeches from January 1933 to April 1939, with extensive quotations, is given in *Die Reden des Führers nach der Machtübernahme*, Berlin, 1939. The party's principal newspaper, *Der Völkischer Beobachter*, printed the texts of nearly all of Hitler's speeches, although sometimes only in excerpts, as was the case with the cultural address at the 1938 party rally (issue of 7 September 1938). Hitler's speeches at the annual rallies were also published separately, and in the official reports of the *Reichsparteitage*, which also contained other speeches of relevance to cultural policy, by Alfred Rosenberg, for instance. The documentary sections of works by Berthold Hinz and Peter-Klaus Schuster, cited later in this section, give the texts of some of

Hitler's speeches on art. Hitler's rhetorical style has been analyzed by Hildegard von Kotze and Helmut Krausnick in *"Es spricht der Führer,"* Gütersloh, 1966. *Hitlers Tischgespräche im Führerhauptquartier*, ed. Henry Picker, Frankfurt a. M.-Berlin, 1993, which report a statement by Hitler on Barlach, are not the most reliable source, but it would be a mistake to ignore them.

The first volume of Ian Kershaw's good, pragmatic biography, *Hitler, 1889–1936*, New York, 2000, does not mention Barlach. Joachim Fest's earlier work, *Hitler. Eine Biographie*, Frankfurt a. M.-Berlin-Vienna, 1976, has been criticized for marginalizing long-term social and political trends; but it seems to me good on the subject of cultural influences. Eberhard Jaeckel, *Hitlers Weltanschauung*, originally published in Tübingen, 1969, and available in a good English version, *Hitler's World View*, Cambridge, Mass., 1981, remains a reliable guide, even if the author's exemplary analysis cannot always plumb Hitler's pathological deformation of ideas to its depths.

The diaries of Goebbels have been edited and published by Elke Fröhlich, *Die Tagebücher von Joseph Goebbels: Sämtliche Fragmente*, Munich, 1987. Part 1, volumes 1–3, covers the period of this study, as does the first volume of Helmut Heiber's edition of his speeches, *Goebbels-Reden*, Düsseldorf, 1971. Alfred Rosenberg's ideas on art and culture, and their place in Germany's national revival, can be found in *Der Mythus des 20. Jahrhunderts*, Munich, 1934; in his articles in the *Völkischer Beobachter*; and in such collections as *Blut and Ehre*, ed. Thilo von Trotha, Munich, 1934. His memoirs and observations in prison, *Letzte Aufzeichnungen*, Göttingen, 1955, once more reveal Rosenberg's unique mix of naivete and amorality.

Ralf Georg Reuth's *Goebbels*, Munich-Zurich, 1990, is now the best biography. His account of the history of the Reich Chamber

of Culture should be read together with Volker Dahm, "Anfänge and Ideologie der Reichs-Kulturkammer," *Vierteljahrshefte für Zeitgeschichte*, 34, no. 1, (1986); and Alan E. Steinweis, *Art, Ideology, and Economics in Nazi Germany: The Reich Chambers of Music, Theater, and the Visual Arts*, Chapel Hill, 1993, which includes a good chapter on the chambers' gradual expansion of power. My essay on Goebbels's subordinate Hans Schweitzer, who played a destructive role in Barlach's last years, "God's Hammer," has been reprinted in my previously mentioned volume, *German Encounters with Modernism*. Goebbels's early appreciation of Barlach's work is documented not only in a well-known entry of 1924 in his diary but also in Albert Speer, *Erinnerungen*, Frankfurt a. M., 1969; and in Heinrich Hoffmann, *Hitler wie ich ihn sah*, Munich-Berlin, 1974. Still useful on the institutional side of the National Socialist revolution, and on its invasion of the arts, is the comprehensive study by Karl Dietrich Bracher, Wolfgang Sauer, and Gerhard Schutz, *Die Nationalsozialistische Machtergreifung*, Cologne-Opladen, 1962. Karl Dietrich Bracher's *Die deutsche Diktatur*, Cologne-Berlin, 1969, remains an excellent introduction to the history and structure of National Socialism. Otto Thomae, *Die Propaganda-Maschinerie: Bildende Kunst und Öffentlichkeitsarbeit im Dritten Reich*, Berlin, 1978, contains a mine of information on government relations with the arts; Jürgen Hagemann studies Goebbels's control of the press, one of his major areas of responsibility, *Presselenkung im Dritten Reich*, Bonn, 1970. Reinhard Bollmus, *Das Amt Rosenberg und seine Gegner*, Stuttgart, 1970, is a particularly valuable account and interpretation of Rosenberg's position in the power structure of the regime.

The literature on National Socialist attitudes and policies on art and culture is extensive. Two early works stand out: Paul

Ortwin Rave, *Kunstdiktatur im Dritten Reich*, Hamburg, 1949; and Hildegard Brenner, *Die Kunstpolitik des Nationalsozialismus*, Reinbek bei Hamburg, 1963. Rave, in the 1930s a young art historian, witnessed the spoliation of German museums at first hand. From his personal perspective he draws a clear line, from the initial defamation of artists in 1933, to the confiscation and often destruction of their work. Hildegard Brenner wrote the first comprehensive history of National Socialist policies in the arts, admirably balancing the subject's institutional, political, and cultural elements. If she divides the stages of complex and often ambiguous processes too precisely, she imposes a clarity on the material that was invaluable at the time, and remains stimulating today.

A number of Brenner's statements, including the reference I cite on p. 175 n39 to "accurate" rumors that Hitler regretted the quarrel between Barlach and National Socialism, are based on interviews conducted with "participants who were directly or indirectly associated with the events, and deposited as interview protocols (Prot.) with the Institut für Zeitgeschichte in Munich and the Wiener Library in London" (Brenner, p. 250). Unfortunately it proved impossible to explore these statements further. To my inquiries the Institut für Zeitgeschichte responded that no record could be found that the protocols had been deposited there; nor was the Wiener Library able to locate them in its holdings.

Among the many works that followed Brenner's pioneering book, three take a similarly encompassing approach, but with less emphasis on the state than on artists – those supported as well as those opposed by the regime. Berthold Hinz, *Die Malerei im deutschen Faschismus*, Munich-Vienna, 1974, is a rather deterministic Marxist study. Less ideologically engaged are Reinhard Merker,

Die bildenden Künste im Nationalsozialismus, Cologne, 1983; and Klaus Backes, *Hitler und die bildenden Künstler*, Cologne, 1988. Much inferior is the thin study by Henry Grosshans, *Hitler and the Artists*, New York-London, 1983. Thomas Mathieu, *Kunstauffassungen und Kulturpolitik im Nationalsozialismus*, Saarbrücken, 1997, carefully if schematically reviews the sources and content of the ideas on art of Hitler, Goebbels, Rosenberg, and other National Socialist figures. Barlach makes only a marginal appearance in Jonathan Petropoulos's two books, *Art as Politics in the Third Reich*, Chapel Hill, 1996; and *The Faustian Bargain*, New York, 2000. The first work includes good discussions on the National Socialist elite's use of art as status symbols and on the regime's various forms of art theft in Germany and in the occupied countries. The second work delineates, on the basis of extensive documentation, five major groups in the German art world: artists, museum directors, dealers, scholars, and journalists – among them Robert Scholz, "the Third Reich's most prominent art critic," who repeatedly attacked Barlach. To illustrate the ambiguities of culture in the Third Reich, *The Faustian Bargain* (p. 10) cites Frank Whitford, who lists Barlach among modernists who had "fascist or nationalist leanings" because in 1934 he signed the public appeal in support of combining the offices of Reich president and chancellor. That modernism and National Socialism were often related is a point still worth making, but Whitford's inclusion of Barlach among National Socialist sympathizers could not be further from the facts.

A work that integrates elite and popular culture is Peter Reichel, *Der schöne Schein des Dritten Reiches*, Frankfurt a. M., 1996, an exploration by a political scientist of National Socialist aesthetics, ranging from cultural policy to public ceremonies and the media of radio and film. At the other extreme of Reichel's

wide-ranging integrative approach is Peter-Klaus Schuster, ed., *Die "Kunststadt" München 1937: Nationalsozialismus and "Entartete Kunst,"* rev. ed., Munich 1998, a remarkable reconstruction by a group of scholars of a key event in National Socialist art policy, the exhibition of degenerate art, its background and its consequences.

Finally, in a wide-ranging analysis that leads to important insights, "Hitler the Artist," *Critical Inquiry*, 23 (Winter 1997), O. K. Werckmeister traces the "ideological transposition of [Hitler's] artistic creativity into political practice."

Notes

Introduction

1. Confidential note from a reporter for the *Frankfurter Zeitung* to a colleague, 21 April 1939, in Jürgen Hagemann, *Presselenkung im Dritten Reich*, Bonn, 1970, pp. 313, 68.
2. Ernst Barlach, "Wider den Ungeist," *Die Prosa*, ed. Friedrich Dross, Munich-Zurich, 1976, 2, p. 402.

One. Hitler

1. Ernst Barlach to Hugo Sieker, 26 January 1933, Ernst Barlach, *Die Briefe*, ed. Friedrich Dross, Munich, 1968–1969, 2, pp. 347–48.
2. Adolf Hitler, "Warum sind wir Antisemiten?" 13 August 1920, *Sämtliche Aufzeichnungen, 1905–1924*, ed. Eberhard Jaeckel and Axel Kuhn, Stuttgart, 1980, p. 185. In an earlier work, *Hitlers Weltanschauung*, Tübingen, 1969, Jaeckel carefully analyzes the sources and the process of accretion of Hitler's ideas. The ideas on art and culture held by Hitler and other senior National Socialists are traced to their origins in Thomas Mathieu, *Kunstauffassungen und Kulturpolitik im Nationalsozialismus*, Saarbrücken, 1997.
3. Hitler, *Sämtliche Aufzeichnungen*, p. 190.
4. Ibid., p. 186. In his cultural address at the 1935 party congress, Hitler ridiculed the belief in the myth of Atlantis, the legendary island that vanished beneath the sea, home of warriors who established themselves and their culture throughout Europe and the Mediterranean world. His derision

was aimed at Rosenberg, who in *Der Mythus des 20. Jahrhunderts*, Munich, 1934, p. 24, thought that the reality of Atlantis "was not entirely out of the question," but that in any case "the existence of a prehistoric Nordic center of culture must be assumed." Hitler agreed on this point, which, whatever he said, brought him close to the central element of the Atlantis myth.

5. Hitler, *Sämtliche Aufzeichnungen*, p. 196.

6. Ibid., pp. 196–97.

7. I discuss Thode's attack on Liebermann as an un-German artist, and Liebermann's role in Weimar culture, in *The Berlin Secession*, Cambridge, Mass., 1980, pp. 170–82; and in " 'The Enemy Within' – Max Liebermann as President of the Prussian Academy of Arts," reprinted in the collection of my essays *German Encounters with Modernism, 1840–1945*, New York-Cambridge, 2001.

8. Adolf Hitler, "Positiver Antisemitismus der Bayerischen Volkspartei," 2 November 1922, *Sämtliche Aufzeichnungen*, p. 717.

9. Adolf Hitler, 14 October 1923, address at a National Socialist meeting, ibid., p. 1034.

10. Adolf Hitler, 3 January 1923, address at a National Socialist meeting, ibid., pp. 779–80.

11. The formulation is Christopher Browning's, in his *The Path to Genocide*, New York, 1992, p. 79.

12. See, for instance, the reminiscences of Albert Krebs, head of the Hamburg section of the party in the late 1920s, *Tendenzen und Gestalten der NSDAP: Erinnerungen an die Frühzeit der Partei*, Stuttgart, 1959, pp. 90, 148–49.

13. On Frick's ideas on the arts, which apparently were determined entirely by concepts of race and of social Darwinism, see Mathieu, *Kunstauffassungen*, pp. 282–85.

14. Joseph Goebbels, 29 August 1924, *Die Tagebücher von Joseph Goebbels: Sämtliche Fragmente*, ed. Elke Fröhlich, Munich, 1987, part 1, 1, p. 78.

15. Joseph Goebbels, 2 July 1933, ibid., part 1, 2, p. 441.

16. Paragraph 1 of the league's statutes, cited in Hildegard Brenner, *Die Kunstpolitik des Nationalsozialismus*, Reinbek bei Hamburg, 1963, p. 8.

17. Alfred Rosenberg, *Letzte Aufzeichnungen*, Göttingen, 1955, p. 167.

18. Joseph Goebbels, 8 January 1930, *Die Tagebücher*, part 1, 1, p. 480.

19. Oskar Schlemmer, *Briefe und Tagebücher*, ed. Tut Schlemmer, Munich, 1958, p. 276. See also Schlemmer's letter to Goebbels, 25 April 1933, *In letzter Stunde, 1933–1945*, ed. Diether Schmidt, Dresden, 1964, p. 49.

20. Ernst Barlach to Friedrich Düsel, 21 September 1895, *Die Briefe*, 1, p. 233. On the theme of the "German characteristics" of Barlach's art, see the good, brief essay by Heike Stockhaus, "Das Nordische, das Germanische, das Gotische: Ernst Barlach und der Geist seiner Zeit," in *Ernst Barlach: Artist of the North*, ed. Jürgen Doppelstein, Volker Probst, and Heike Stockhaus, Hamburg-Güstrow, 1998, pp. 24–27.

Two. Barlach

1. Ernst Barlach, "Künstler zur Zeit," *Die Prosa*, ed. Friedrich Dross, Munich-Zurich, 1976, 2, pp. 421, 422. Henry Grosshans's statement, in *Hitler and the Artists*, New York-London, 1983, p. 72, that Barlach "spoke of Hitler as 'the lurking destroyer of others' and described Nazism as 'the secret death of mankind,' " is not correct. Barlach used the words "secret death" several times in his talk to characterize the effects of dishonesty, but not in connection with "mankind," and referred to Hitler neither by name nor in any pseudonymous fashion.

2. Ernst Barlach to Max von Schillings, 23 February 1933, *Die Briefe*, 2, p. 354.

3. Ernst Barlach to his cousin Karl Barlach, 14 March 1933, ibid., 2, p. 359.

4. Hans-Ulrich Thamer, *Verführung und Gewalt: Deutschland, 1933–1945*, Berlin, 1986, pp. 212–13. In the Reichstag elections in November the party lost votes in Mecklenburg, as it did throughout most of Germany. It regained them in the Reichstag elections of March 1933, already held under official pressure and intimidation.

5. "Die hündische Feigheit dieser Zeit und Herrlichkeit, bringt es dazu, dass man bis über die Ohren rot wird bei dem Gedanken, dass man ein Deutscher ist." Ernst Barlach to his brother Hans Barlach, 2 May 1933, *Die Briefe*, 2, p. 374.

6. Peter Selz, *German Expressionist Painting*, Berkeley-Los Angeles, 1974, p. 64.

7. Marie-Laure Besnard-Bernadac and Günter Metken, eds., *Paris-Berlin, 1900–1933*, Paris, 1992, p. 616.

8. Friedrich Schult, *Barlach im Gespräch*, ed. Elmar Jansen, Leipzig, 1985, p. 77.

9. Anita Beloubek-Hammer, "Ernst Barlach und die Avantgarde," in *Ernst Barlach: Artist of the North*, ed. Jürgen Doppelstein, Volker Probst, Heike Stockhaus, Hamburg-Güstrow, 1998, p. 28.

10. Ernst Barlach, "Künstler zur Zeit," *Die Prosa*, 2, p. 418.

11. Alfred Rosenberg, *Der Mythus des 20. Jahrhunderts*, p. 302. Note also his discussion of the "racial chaos of the metropolis," ibid., p. 298.

12. Walter Hinderer, "Theory, Conception, and Interpretation of the Symbol," in *Perspectives in Literary Symbolism: Yearbook of Comparative Literature*, ed. J. Strelka, University Park-London, 1968, p. 121.

13. In the short essay, "Dichterglaube" (1930–1931), in Ernst Barlach, *Die Prosa*, 2, p. 408.

14. Schult, *Barlach im Gespräch*, p. 72.

15. Ernst Barlach in his autobiography, *Ein selbsterzähltes Leben*, Berlin, 1928, p. 63.

16. On the Berlin Secession and Paul Cassirer, see my study, *The Berlin Secession*; and the collection of my essays, *German Encounters with Modernism*.

17. Adolf Hitler, "Politik und Deutschtum," 26 June 1920, *Sämtliche Aufzeichnungen*, p. 153.

18. Barlach himself was treated to this designation in the 1930s. See Chapter 4 below.

19. "Der Fall Hoetger," *Das Schwarze Korps*, 26 June 1935.
20. In its conflicting concepts, the Stralsund monument is more than a witness to Germany in the 1930s; it reaches back in time to trace a longer historical development. The course of Kolbe's inspiration and intentions – originating in the classical tradition, adapted and sifted throughout the nineteenth century, and finally resulting in an iconic image of the new order – parallels and reflects the processes, events, and misjudgments that led from the Wilhelmine empire to the Third Reich.
21. On this period of Barlach's life, see my essay, "Field Marshal and Beggar: Ernst Barlach in the First World War," in *German Encounters with Modernism*, pp. 144–84.
22. Ernst Barlach to Reinhard Piper, 19 December 1918, *Die Briefe*, 1, pp. 532–33.
23. I discuss the journal in *The Berlin Secession*, pp. 240–47; and in *German Encounters with Modernism*, pp. 162–66.
24. The different German words for memorial allow variations of meaning. Barlach's tablet was commonly called *Ehrenmal* = a mark in honor of someone or something. He also referred to it with the more modest term *Denk-* or *Gedenktafel* = memorial tablet, and in disapproving quotation marks as *Kriegerehrung* = plaque honoring soldiers. *Mal* = mark, sign, combines not only with *Ehren* = honor, but also with other nouns or noun derivatives: most commonly with *Denk* = think, reflect, recall – *Denkmal* is the general term for monument or memorial; with *Gedenk* = commemorate; with *Mahn* = recall, often in an admonitory sense; with *Toten* = dead; and with *Gedächtnis* = memory. *Denkmal* can further combine with *Krieger* = warrior, and stand for both war monument and soldiers' monument; and with *Gefallenen* = monument to the fallen. The various terms, often applied to the same work, convey both the memorial's message and the artist's and viewer's desired interpretation. *Mahnmal*, in particular, has pacifist or religious connotations, which are absent from *Kriegerdenkmal*.
25. On the Güstrow memorial, see, above all, Barlach's letters and Volker Probst's excellent edition of essays by Ilona Laudan, Margrit Schimanke, Inge Tessenow, Helga Thieme, and himself, *Ernst Barlach. Das Güstrower Ehrenmal*, Güstrow, 1998.
26. Probst, *Das Güstrower Ehrenmal*, pp. 46, 76, 85 n 88.
27. Ernst Barlach to Friedrich Adolf von Moeller, 31 August 1928, *Die Briefe*, 2, p. 128.
28. Ernst Barlach to Willy Hahn, 25 November 1928, ibid., p. 138.
29. Ernst Barlach to Karl Barlach, 15 January 1929; and to Hans Barlach, 22 January 1929, ibid., pp. 145, 147.
30. Ernst Barlach to Hans Barlach, 4 March 1929, ibid., p. 156; and Notes, March 1929, cited in an editorial note to Barlach's combative essay, "Wider den Ungeist," in which he outlined the confusion and dishonesty of the right-wing opposition to his recent work (*Die Prosa*, 2, pp. 710–11). The essay remained unpublished until after the Second World War.

31. Ernst Barlach, "Wider den Ungeist," *Die Prosa*, 2, p. 400.
32. Ernst Barlach, "Über das Magdeburger Mal," ibid., p. 405. Note also Barlach's comment in a letter to Hermann Giesau, 14 August 1933, denying that the crucifix at the center was meant to cast a religious aura over the monument: "I believe[d] that I depicted an episode of combat in a cemetery or churchyard, in which the dead and the half-buried are hurled among the men still standing" (*Die Briefe*, 2, p. 395) – a statement of intent, which, when compared to the stillness of the figures he actually carved, offers an important entry into Barlach's creative process.
33. "Kleine, halbidiotisch dreinschauende Mixovariationen undefinierbarer Menschensorten mit Sowjethelmen." Alfred Rosenberg, "Revolution in der bildenden Kunst?" *Völkischer Beobachter*, 6 July 1933. The piece appeared in several other publications and was also included in the collection of Rosenberg's essays and articles, *Blut und Ehre*, ed. Thilo von Trotha, Munich, 1934, p. 250. By 1939 the volume had reached its 22nd edition. It may be noted that the terms with which Rosenberg characterized Barlach's work were not exceptionally violent for him. In his book *Der Mythus des 20. Jahrhunderts*, p. 299, he characterizes Kokoschka's self-portraits as "an art of idiots."
34. Albert Krebs, *Tendenzen und Gestalten*, p. 178.

Three. Nordic Modernism

1. Ernst Barlach to Karl Barlach, 5 July 1933, *Die Briefe*, 2, p. 384.
2. Ernst Barlach to Hugo Sieker, 10 June 1933, ibid., p. 379. Manifest des Deutschen Künstlerbundes 1933, reprinted in Uwe Fleckner, "Carl Einstein und einige seiner Leser," *Überbrückt*, ed. Eugen Blume and Dieter Scholz, Cologne, 1999. The quoted passage is on p. 139.
3. "I reject any thought of leaving, even if I could earn my bread in another country." Ernst Barlach to Leo Kestenberg, 13 November 1933, *Die Briefe*, 2, p. 414.
4. Wilhelm Girnus, review of a Barlach exhibition in *Neues Deutschland*, 4 January 1952, cited in Anita Beloubek-Hammer, "Die 'entarteten' deutschen Bildhauer und ihr Erbe in der DDR," *Deutsche Bildhauer 1900–1945 Entartet*, ed. Christian Tümpel, Zwolle, 1992, p. 26. Note also the essay by Bertold Brecht, "Notizen zur Barlach-Ausstellung," January 1952, reprinted in Elmar Jansen, *Ernst Barlach: Werk and Wirkung*, Frankfurt a. M., 1972, pp. 496–501. Brecht's evaluation was positive if somewhat inhibited by the political climate of the German Democratic Republic. He defends Barlach against ideological criticism, but regrets that the artist is not among those who create images of the self-reliant, combative common man: "All of these figures seem to me characterized by realism: they have much that is essential, and nothing that is superfluous. Nor can one deny [the artist's] love for mankind, his humanity. Admittedly, he does not give man much to hope for" (p. 500).

5. Albert Krebs, *Tendenzen und Gestalten*, p. 66.

6. Joseph Goebbels, speech of 15 November 1933, *Goebbels-Reden*, 1, 1932–1939, ed. Helmut Heiber, Düsseldorf, 1971, p. 139. On the beginnings the propaganda ministry and the Reich Chamber of Culture, see, among others, Volker Dahm, "Anfänge und Ideologie der Reichskulturkammer," *Vierteljahrshefte für Zeitgeschichte*, 34 no. 1, (1986); Ralf Georg Reuth, *Goebbels*: Munich-Zurich, 1990, pp. 269–306; and Alan E. Steinweis, *Art, Ideology, and Economics in Nazi Germany: The Reich Chambers of Music, Theater, and the Visual Arts*, Chapel Hill, 1993.

7. Albert Speer, *Erinnerungen*, Frankfurt a. M., 1969, pp. 40–41. In his self-serving recollections, Heinrich Hoffmann reports reminding Goebbels that he once kept a Barlach figure in his study (*Hitler wie ich ihn sah*, Munich-Berlin, 1974, p. 146). Barlach believed that Goebbels "owns two of my figures: bronze and china." Ernst Barlach to Karl Barlach, 11 January 1936, *Die Briefe*, 2, p. 605.

8. The covering letter seems not to have survived. Its contents can be learned from Barlach's letter cited in note 9 below.

9. Ernst Barlach to Alfred Kubin, 12 June 1933, *Die Briefe*, 2, p. 380.

10. Ernst Barlach to unknown, 25 June 1933, ibid., pp. 381–82.

11. A comprehensive account of the meeting of 29 June and its aftermath does not seem to exist. Many works mention the episode briefly, often with somewhat contradictory details, e.g., Paul Ortwin Rave, *Kunstdiktatur im Dritten Reich*, Hamburg, 1949, p. 33; Hildegard Brenner, *Die Kunstpolitik des Nationalsozialismus*, pp. 65–71; Reinhard Bollmus, *Das Amt Rosenberg und seine Gegner*, Stuttgart, 1970, pp. 45–46; Andreas Hüneke, "Der Versuch der Ehrenrettung des Expressionismus als 'deutsche Kunst' 1933," *Zwischen Anpassung und Widerstand. Kunst in Deutschland, 1933–1945*, catalogue of the exhibition in the Akademie der Künste, Berlin (East), 1978; Wolfgang Tarnowski, *Ernst Barlach und der Nationalsozialismus*, Hamburg, 1989, pp. 41–45; and Dieter Scholz, "Otto Andreas Schreiber, die *Kunst der Nation* und die Fabrikausstellungen," *Überbrückt*, ed. Eugen Blume and Dieter Scholz, Cologne, 1999, p. 94.

12. Otto Andreas Schreiber, "Worin zeigt sich das deutsche Wesen in der deutschen Kunst?" *Der Betrieb*, 15 January and 1 February 1934, cited in Scholz, pp. 97–98.

13. The resolution was printed in the *Beiblatt* of the university student publication, *Berliner Hochschulblatt*, nr. 6, 14 July 1933.

14. Brenner, *Die Kunstpolitik des Nationalsozialismus*, p. 42.

15. Alfred Rosenberg, "Revolution in der bildenden Kunst?" and "Revolutionäre an sich!" *Völkischer Beobachter*, 6 and 14 July 1933. The articles were reprinted several times.

16. The suggestion by Bollmus, *Das Amt Rosenberg*, p. 58, that Hitler's carelessness in making a decision that further confused the political structure is symptomatic of "the limited rationality in his actions," seems to go too far.

Hitler was often careless about drawing lines of authority, but only within the framework of a clearly understood concept of governance, of which the competition and conflicting responsibilities of his subordinates were a part.
17. Cited ibid., p. 65.
18. Scholz, "Otto Andreas Schreiber," pp. 96–104.
19. Brenner, *Die Kunstpolitik des Nationalsozialismus*, p. 65.

Four. The Hounding of Barlach

1. Ernst Barlach to Hans Barlach, 5 April 1933, *Die Briefe*, 2, p. 367. Note also his letter to Friedrich Schult, 28 March 1933, ibid., p. 365.
2. Alfred Rosenberg to Bernard Rust, 14 September 1934, printed in Ernst Piper, *Nationalsozialistische Kunstpolitik*, Frankfurt a. M., 1987, pp. 114–15.
3. E.g., Ernst Barlach to Johannes Schwartzkopff, 14 August 1933, *Die Briefe*, 2, p. 394.
4. Ernst Barlach to Alois Schardt, 23 July 1933, ibid., pp. 388–89.
5. Note to letter no. 1077, ibid., p. 841.
6. Ernst Barlach to Carl Albert Lange, 25 December 1933, ibid., p. 425.
7. Ernst Barlach to Hans Barlach, 20 January 1934, ibid., p. 438.
8. On the cartels and their role in the process of coordinating the arts into the structure of state and party, see Alan E. Steinweis, *Art, Ideology, and Economics*, p. 37.
9. Ernst Barlach to Hugo Sieker, 14 October 1933, *Die Briefe*, 2, p. 407.
10. Joseph Goebbels, 11 August 1935, *Die Tagebücher*, part 1, 2, p. 501.
11. On Hildebrandt, see Peter Hüttenberger, *Die Gauleiter*, Stuttgart, 1969, particularly p. 214.
12. Friedrich Hildebrandt, speech of 16 February 1934, *Lübecker General Anzeiger*, 18 February 1934. See also, Barlach, *Die Briefe*, 2, pp. 846–47, note to letter no. 1123.
13. Ernst Barlach to Friedrich Hildebrandt, 6 March 1934, *Die Briefe*, 2, pp. 448–49.
14. Alfred Rosenberg, "Warnende Zeichen," *Völkischer Beobachter*, North-German edition, 11/12 March 1934.
15. Robert Scholz, "Hausse in Verfallskunst," *Völkischer Beobachter*, North-German edition, 16 March 1934. On Scholz, note the informative discussion in Jonathan Petropoulos, *The Faustian Bargain*, New York, 2000.
16. Robert Scholz, "Für und gegen den Futurismus," *Völkischer Beobachter*, North-German edition, 28 March 1934.
17. The assumption is Hildegard Brenner's, in *Die Kunstpolitik des Nationalsozialismus*, p. 75.
18. Robert Scholz, "Futuristische Flugmalerei," *Völkischer Beobachter*, North German edition, 4 April 1934.

19. Ernst Barlach to Hans Barlach, 18 March 1934, *Die Briefe*, 2, p. 455; to Paul Schurek, 30 March 1934, ibid., p. 460; and to Hugo Sieker, 30 March 1934, ibid., p. 461. An untitled and undated newspaper review in the Ernst Barlach Stiftung, Güstrow, Nachlass Friedrich Schult A31, reads: "At first, the audience responded respectfully to the difficult work, but then fell more and more under its spell, and at the end thanked the director and the actors with applause that would not end." The theater produced a second play by Barlach, which was quickly forbidden.

20. Ernst Barlach to Reinhard Piper, 17 May 1934, *Die Briefe*, 2, p. 471.

21. "Ernst Barlach," *Völkischer Beobachter*, North-German edition, 9 March 1934.

22. Ernst Barlach, "Als ich von dem Verbot der Berufsausübung bedroht war," 29–30 July 1937, *Die Prosa*, 2, p. 431.

23. Ernst Barlach to Margarete Havemann, 16 March 1934, *Die Briefe*, 2, p. 452.

24. Ernst Barlach to Reinhard Piper, 18 July 1934, *Ernst Barlach – Reinhard Piper. Briefwechsel, 1900–1938*, ed. Wolfgang Tarnowski, Munich-Zurich, 1997, p. 324, and n 9, pp. 638–39.

25. Ernst Barlach to Leo von König, 22 August 1934, *Die Briefe*, 2, p. 489.

26. Ernst Barlach to Hugo Sieker, 25 May 1934, ibid., p. 475; and to Karl Barlach, 7 August 1935, ibid., p. 571.

27. Ernst Barlach to Karl Barlach, 4 May 1934, ibid., pp. 465–66. On Barlach's precarious economic situation, see also Wolfgang Tarnowski, "Ein unbekannter Brief Barlachs aus dem Jahre 1934," *Ernst Barlach Gesellschaft: Mitteilungen*, 1988.

28. Ernst Barlach to Friedrich Düsel, 18 June 1934, *Die Briefe*, 2, p. 479.

29. Ernst Barlach to Karl Barlach, 31 August 1934, ibid., p. 490.

30. "Bekenntnis zu Adolf Hitler! Ein Aufruf der Kulturschaffenden" 17 August 1934, *Völkischer Beobachter*, North-German edition, 18 August 1934. The declaration appeared in many newspapers, not always with the same headline.

31. Alfred Rosenberg to Joseph Goebbels, draft, 20 October 1934, in Piper, *Nationalsozialistische Kunstpolitik*, pp. 116–17; see also Ralf Georg Reuth, *Goebbels*, pp. 321–22.

32. Ernst Barlach to Willy Katz, 15 September 1934, *Die Briefe*, 2, p. 493. The recipient accepted Barlach's explanation. After the war he rejected efforts to turn the incident into proof that Barlach was a supporter of National Socialism. Willy Katz to Hans Harmsen, 14/15 February 1960. Ernst Barlach Stiftung, Güstrow, Nachlass Friedrich Schult, Korrespondenz Willy Katz.

33. Adolf Hitler, "Rede auf der Kulturtagung," *Der Kongress zu Nürnberg 1934*, Munich, 1934, pp. 95–97, 98, 102–4.

34. Ernst Barlach to Reinhard Piper, 6 August 1934, *Die Briefe*, 2, p. 485.

35. In his early work, *Der Expressionismus*, Munich, 1914, Paul Fechter interpreted expressionism as a new form of Gothic, and as a Germanic and Nordic intuition. Later he sympathized with National Socialism; even so, during the Second World War he himself experienced difficulties over his writings. He always admired Barlach's work.

36. Ernst Barlach to Karl Barlach, 12 December 1935, *Die Briefe*, 2, p. 595.

37. Barlach made *The Community of Holy Ones* for the niches in the church facade. Until the first completed figures could be installed, they were provisionally placed on the elevated choir inside the church, which led Barlach to believe, at least for a time, that the interior placement might be preferable. See, e.g., Ernst Barlach to Arthur Eloesser, 26 November 1933, ibid., p. 416.

38. Friedrich Hildebrandt ["the great speech of our Gauleiter"], *Niederdeutscher Beobachter*, 2 June 1935.

39. *Das Schwarze Korps*, 26 June 1935. Brenner, *Die Kunstpolitik des National-sozialismus*, p. 68, writes that at this time rumors, "which, incidentally, turned out to be accurate," circulated "that even Hitler regretted the quarrel with Barlach, and had already made approaches to reconcile him with the new regime." On p. 258, n 13, she adds that "Barlach rejected this offer of reconciliation." It is not clear what reconciliation could have meant in practice. An official reversal of the confiscation and prohibition of Barlach's work would have been difficult to explain and would certainly have offended Rosenberg and Hildebrandt. At most, the attacks on Barlach might have diminished. Probably the rumors were linked with the efforts of Schreiber and his associates to find a place for modernism in National Socialist art. To speculate further seems useless, because the documentation for Brenner's statement is, in effect, nonexistent. See my comment in A Note on the Literature.

40. Ernst Barlach to Reinhard Piper, 23 May 1937, *Die Briefe*, 2, p. 706.

41. Editor of the *Rostocker Anzeiger* to Reinhard Piper, 26 November 1935, Piper, *Nationalsozialistische Kunstpolitik*, p. 128; Ernst Barlach to Alfred Heuer, 17 December 1935, *Die Briefe*, 2, p. 598.

42. Ernst Barlach to Hermann Reemtsma, 2 December 1935, and undated letter December 1935, *Die Briefe*, 2, pp. 593, 604. Johst, a patriotic hack, long allied with Rosenberg, whose dedication to rid German literature of ideological impurities eventually gained him the honorary SS rank of lieutenant general, was convicted after the war of major complicity in the regime and sentenced to three and a half years in a labor camp.

43. Bavarian Political Police to R. Piper & Co., 24 March 1936, Piper, *Nationalsozialistische Kunstpolitik*, pp. 129–30. Only two weeks earlier, on 10 March, "Der Zeichner Barlach und die Zeit," Fritz Nemitz's relatively favorable review of the book, had appeared in the *Berliner Tageblatt*.

44. Reinhard Piper to Bavarian Political Police, 31 March 1936, Piper, *Nationalsozialistische Kulturpolitik*, pp. 130–33.

45. Ibid., p. 137.
46. Reinhard Piper to Ernst Barlach, 25 April 1936, ibid., p. 139; Ernst Barlach to Reinhard Piper, 27 April 1936, ibid., p. 142.
47. Ernst Barlach to Reinhard Piper, 2 May 1936, *Die Briefe*, 2, p. 630.
48. On Schweitzer, see my essay, "God's Hammer," in *German Encounters with Modernism*, pp. 202–28.
49. Joseph Goebbels, 4 April 1936 [for 2 and 3 April 1936], *Die Tagebücher*, part 1, 2, p. 596. Tarnowski, *Ernst Barlach – Reinhard Piper. Briefwechsel*, p. 689, n 5, writes that the identity of the person who ordered the confiscation remains uncertain, but that it could not have been Goebbels because the order was issued before Goebbels's comment in his diary. This seems most unlikely. Not only did Goebbels state in a personal and confidential record that he had given the order, but if Schweitzer had taken the considerable risk of acting on his own, Goebbels would have noted the transgression. His diary is full of reports of dressing down subordinates, including Schweitzer.
50. Ernst Barlach to Prussian Secret State Police, 4 June 1936, draft, *Die Briefe*, 2, p. 641.
51. Ernst Barlach to Joseph Goebbels, 25 May 1936, ibid., pp. 636–38.
52. Ernst Barlach, undated draft (approximately 25 July 1936), Piper, *Nationalsozialistische Kunstpolitik*, pp. 177–78.

Five. German and Un-German Art

1. For a discussion of the character of these speeches, see Arne Fryksen, "Hitlers Reden zur Kultur. Kunstpolitische Taktik oder Ideologie?" *Probleme deutscher Zeitgeschichte, Lund Studies in International History*, 2, Lund, n.d. The author makes some interesting observations, but not surprisingly concludes that the speeches were neither exclusively tactical nor ideological: the speaker was pursuing ideological goals while paying due attention to the various tendencies within the party and to the competition for power of his senior lieutenants.
2. *Die Reden Hitlers am Reichsparteitag 1933*, Munich, 1934, p. 16.
3. Ibid., pp. 22–23.
4. Ibid., p. 25.
5. Ibid., pp. 30–31.
6. Ibid., p. 30.
7. Adolf Hitler, "Rede bei der Grundsteinlegung zum Hause der Deutschen Kunst," 15 October 1933, *Völkischer Beobachter*, North-German edition, 17 October 1933. In his speech, Hitler pronounced "the restoration of our people as the mission of our era and of our lives – not only of the economy, which is hurting, but equally of our culture, which is being threatened."
8. Joseph Goebbels, 2 September 1933, *Die Tagebücher*, part 1, 2, p. 463. Similar exclamations of praise are found in subsequent entries on the annual party rallies, for instance: 13 September 1935, "Clear statement concerning

current problems of cultural life . . . [Hitler] is not only an architect of policy and politics"; and on 10 September 1936, "The Führer speaks wonderfully beyond compare."

9. Hildegard Brenner, *Die Kunstpolitik des Nationalsozialismus*, p. 82. See "A Note on the Literature."

10. Note also the balanced evaluation in Reinhard Bollmus, *Das Amt Rosenberg*, p. 276 n 90: "The author can agree only in part with . . . Brenner's thesis . . . Modern art was still tolerated until the end of 1936. Hence Hitler at least avoided informing R[osenberg] and Goebbels of his 'decision.' "

11. For a good analysis of Hitler's rhetoric, see the study edited by Hildegard von Kotze and Helmut Krausnick, *"Es spricht der Führer,"* Gütersloh, 1966.

12. Adolf Hitler, "Die Kulturrede des Führers," *Der Parteitag der Freiheit*, Munich, 1935, p. 55.

13. Ibid., pp. 55–56.

14. Ibid., pp. 56–57.

15. Ibid., p. 57. The last sentence is an example of Hitler's often slovenly syntax, which, as in this case, is frequently untranslatable: "Ist die Kunst nicht letzten Endes eben doch nur ein für wenige bestimmter Luxus, statt das notwendige Brot zu geben für alle?" The words *zu geben* (= to give) are superfluous and destroy the intended parallel.

16. Ibid., pp. 57–58.

17. Ibid., p. 59.

18. Ibid., p. 59.

19. Ibid., pp. 59–60.

20. Ibid., p. 60.

21. Ibid., pp. 60–61.

22. Ibid., p. 62.

23. Ibid., p. 63.

24. Ibid., pp. 63–64. Some paragraphs later (p. 64) Hitler reiterated: "It is not the task of art to burrow in filth for the sake of filth, to paint humanity only in a state of decay, to draw cretins as symbols of pregnancy [*Mutterwerdung*], and to depict crooked idiots as representatives of masculine strength."

25. Ibid., p. 65.

26. Ibid, p. 69.

27. Ibid., pp. 59, 68.

28. Adolf Hitler, "Die grosse Kulturpolitische Rede des Führers," *Der Parteitag der Ehre*, Munich, 1936, p. 68. In a speech preceding Hitler's, Rosenberg thought it advisable to assure his listeners that National Socialism would not return to ideas and forms of the past. Ibid., p. 50.

29. Ibid., p. 59.

30. "Überzüchtete parasitäre Weltintellektuelle [die] einen andersvölklichen Nährboden benötigten," ibid., p. 57.

31. Ibid., p. 61.

32. Ibid, p. 66.

33. Ernst Barlach quoting Rust in a letter to Karl Fischoeder, 6 November 1936, *Die Briefe*, 2, p. 667.
34. Peter Suhrkamp of the S. Fischer Verlag to Friedrich Schult, the article's author, 10 December 1936, Ernst Barlach Stiftung, Güstrow, Archive, Nachlass Friedrich Schult, XVII C24.
35. Ernst Barlach, diary notes, 27–28 June 1937, *Die Prosa*, 2, pp. 721–22, notes to pp. 664, 670; Ernst Barlach to Hans Barlach, 5 July 1937, *Die Briefe*, 2, p. 713. Compare a similar statement by the mayor of Güstrow, in response to a question by a young admirer of Barlach, Paul Schurek, about how Barlach was to earn his living, Paul Schurek, *Begegnungen mit Barlach*, Gütersloh, 1954, p. 134. In my essay on Schweitzer, "God's Hammer," in *German Encounters with Modernism*, p. 249, n 17, I inadvertently gave the wrong reference for Schweitzer's statement.
36. On the history of the two exhibitions, above all see the excellent collection of essays by various authors, *Die "Kunststadt" München 1937: Nationalsozialismus und "Entartete Kunst,"* rev. ed., ed. Peter-Klaus Schuster, Munich, 1998. I am particularly indebted to the essay by Mario-Andreas von Lüttichau. Of great continuing value is the already cited pioneering study by a contemporary, the art historian Paul Ortwin Rave, *Kunstdiktatur im Dritten Reich*, Hamburg, 1949.
37. Joseph Goebbels, 1 July 1937, *Die Tagebücher*, part 1, 3, p. 192.
38. Joseph Goebbels, 6 June 1937, ibid., part 1, 3, p. 167.
39. Joseph Goebbels, 18 June 1937, ibid., part 1, 3, p. 177; Mario-Andreas von Lüttichau, " 'Deutsche Kunst' und 'Entartete Kunst,' " Schuster, *Die "Kunststadt" München 1937*, p. 87.
40. Mario-Andreas von Lüttichau, " 'Deutsche Kunst' und 'Entartete Kunst,' " p. 86.
41. Ernst Barlach to Karl Fischoeder, 30 April 1937, *Die Briefe*, 2, p. 704.
42. Mario-Andreas von Lüttichau, " 'Deutsche Kunst' und 'Entartete Kunst,' " p. 90.
43. Adolf Hitler, "Rede zur Eröffnung der 'Grossen Deutschen Kunstausstellung,' " 18 July 1937, reprinted in Schuster, *Die "Kunststadt" München 1937*, p. 252.
44. Ibid., pp. 244, 245, 252.
45. In the same paragraph he declared that many of the paintings submitted should have been sent to the exhibition of degenerate art. Adolf Hitler, "Rede bei Eröffnung der zweiten Grossen Deutschen Kunstausstellung," 10 July 1938, in the documentary section of Berthold Hinz, *Die Malerei im deutschen Faschismus*, Munich, 1984, p. 169.
46. Paul Ortwin Rave, *Kunstdikatur im Dritten Reich*, p. 53.
47. Paul Ortwin Rave, memorandum 1937, quoted by Mario-Andreas von Luttichau in " 'Deutsche Kunst' und 'Entartete Kunst,' " p. 96.
48. On 28 July 1937, Reinhard Piper sent Barlach a description of the exhibition, after he had walked through it. His letter is reprinted in Ernst

Piper, *Nationalsozialistische Kunstpolitik*, p. 196. In his careful reconstruction of the exhibition, Mario-Andreas von Lüttichau does not mention the label "*Kulturschänder*." But during its run, a number of objects were replaced with others, and some installations were changed.

49. Note, for instance, his letter to Heinz Priebatsch, 24 April 1938: "I have probably always lived in 'this' time. The time of tormented innocence, of witches, and of ecstatic souls . . . always existed, it has only taken on harsher colors." *Die Briefe*, 2, p. 769.

50. "Führer durch die Ausstellung Entartete Kunst," Berlin, n.d., pp. 2, 4, reprinted in the documentary section of Schuster, *Die "Kunststadt" München 1937*.

51. Ernst Barlach to Hermann F. Reemtsma, 28 July 1937, *Die Briefe*, 2, p. 716.

52. Ernst Barlach to the head of the Reich Chamber of the Fine Arts in Mecklenburg, undated draft after 26 November 1937, *Die Briefe* 2, pp. 740–41.

53. Ernst Barlach to Paul Schurek, 8 September 1937, ibid., p. 725. In his wide-ranging "kulturpolitische Rede" of 7 September 1937, Hitler referred to the works in the exhibition of degenerate art in such terms as "a rape of our artistic sense," and "pathetic pieces of junk [*erbärmlichsten Machwerke*]," which the "clever, even cunning *Jewish cultural propaganda* [emphasis in the original] . . . smuggled into our galleries." *Der Parteitag der Arbeit 1937*, Munich, 1938, p. 63. In a preceding talk, Rosenberg again sounded the themes of "left-wing" sectarians of the National Socialist party, who were attracted to modernism, and of the "spiritual arrogance of certain outsiders, who apparently still believe that the National Socialist *Weltanschauung* [as expressed in the arts] should be conceived and completed by non-National Socialists." Ibid., pp. 45, 46.

54. Ernst Barlach to Heinz Priebatsch, 23 October 1937, *Die Briefe*, 2, p. 735. To another admirer, a Swiss student who had visited him the previous year, Barlach wrote with what for him was a diplomatic formulation, referring to National Socialism by the innocuous "it": "From 1936 on, I doubted whether it would survive me, or I it. In 1937 the issue has become much sharper. . . . One doesn't know when, and on what murderous legs it approaches." A few months later he wrote to the same young man: "Much is happening to me that as a matter of course is unfavorable. That's just the way it is." Ernst Barlach to Max Altdorfer, 22 October 1937, 3 March 1938. Ernst Barlach Stiftung, Güstrow, Archive, Nachlass Friedrich Schult, A 758/619/6.

55. Ernst Barlach to Hans Barlach, 1 September 1937, *Die Briefe*, 2, p. 721.

56. Ernst Barlach to Rudolph Wallfried, 2 September 1937, ibid., pp. 721–22.

57. Editor's note to letter no. 1365, ibid., p. 864.

58. Bertold Brecht, "Notizen zur Barlach-Ausstellung," Jansen, *Ernst Barlach: Werk und Wirkung*, p. 500.

59. Ernst Barlach to Hans Barlach, 25 June 1938, *Die Briefe*, 2, p. 777.

Six. After the Fact

1. Otto Thomae, *Die Propaganda-Maschinerie*, Berlin, 1978, p. 122. On the press conferences, see Elke Fröhlich, "Die kulturpolitische Pressekonferenz des Reichspropaganda Ministeriums," *Vierteljahrshefte für Zeitgeschichte*, 22, no. 4 (1974). According to a note in the Archive of the Ernst Barlach Stiftung, Güstrow, Nachlass Friedrich Schult, A7, Barlach's obituaries were to be limited to ten lines, an injunction that evidently could be circumvented by adding an "evaluation of his personality."

2. *B.Z. am Mittag*, 26 October 1938, in Piper, *Nationalsozialistische Kunstpolitik*, p. 212.

3. *Hamburger Fremdenblatt*, 26 October 1938, ibid., pp. 212–13.

4. *Frankfurter Zeitung*, 27 and 28 October 1938. The text of 28 October is excerpted, ibid., p. 213. In the passage I cite, the original German "einer für gewöhnlich schwer beweglicher, ja sprachlosen Natur, deren Sicherheit darin lag, dass sie, einmal angetrieben, unbeirrbar voranging," requires a rather free translation.

5. *Deutsche Allgemeine Zeitung*, 28 October 1938, ibid., pp. 218–19.

6. *Deutsche Rundschau*, November 1938; *Die Hilfe*, 5 November 1938; and *Deutsche Zukunft*, 6 November 1938, ibid. pp. 221–25. The last article was by Paul Fechter, who had written the introduction to Barlach's *Drawings*.

7. *Meldungen aus dem Reich, 1938–1945*, ed. Heinz Boberach, Herrsching, 1984, 2, p. 115. The reference to Edvard Munch, who died in 1944, was to articles on his 75th birthday; Thomae, *Die Propaganda-Maschinerie*, p. 122, n 28.

8. "War Barlach+ Kulturbolschewist?" *Das Schwarze Korps*, 3 November 1938. Long excerpts of the article are printed in Elmar Jansen, *Ernst Barlach: Werk und Wirkung*, pp. 464–67; shorter quotations are in Piper, *Nationalsozialistische Kunstpolitik*, pp. 223–24; but the article deserves to be read in full.

9. Karl Scheffler, *Die fetten und die mageren Jahre*, Munich-Leipzig, 1948, p. 357.

10. *Basler Nachrichten*, 27 October 1938.

11. On a visit to Berlin, cited from Max Osborn, *Der bunte Spiegel*, New York, 1945, in Jansen, *Ernst Barlach: Werk und Wirkung*, p. 310. In his essay "Barlach: Einsprüche und Wiedersprüche," *Ernst Barlach: Werke Meinungen*, Vienna, 1984, pp. 25–37, Elmar Jansen uses the meeting of the two sculptors as the starting point of a wide-ranging essay on Barlach's place in European sculpture. The nature of German art, how to identify it and how to distinguish it from the art of other national cultures and their historical predecessors, continues to interest some German scholars. See, as an example, Werner Hofmann, *Wie deutsch ist die deutsche Kunst*, Leipzig, 1999; and my review article, "Three Perspectives on Art as a Force in German History," *Central European History*, 34, no. 1, (2001), pp. 83–89.

12. Ernst Barlach, "Als ich von dem Verbot der Berufsausübung bedroht war," *Die Prosa*, 2, p. 428.

13. Ernst Barlach to Hans Oberländer, 24 June 1932, *Die Briefe*, 2, p. 314.

14. Henry Picker, who recorded Hitler's "table talks," in comments on Hitler's soliloquies of 27 March 1942, Henry Picker, *Hitlers Tischgespräche im Führerhauptquartier*, Frankfurt a. M.-Berlin, 1999, p. 206.

15. Käthe Kollwitz, entry for July 1936, *Die Tagebücher*, ed. Jutta Bohnke-Kollwitz, Berlin, 1989, p. 684. She was forced to sign an affidavit for publication that the journalist had inaccurately reported her statements. With her husband she decided that if the affidavit would not save her from the concentration camp they would commit suicide.

16. See, for instance, Werner Haftmann's statement about Barlach in *Verfemte Kunst*, Cologne, 1986, p. 224: "More than any other German artist – only Käthe Kollwitz might be added – he occupied a place in the feelings of the people. . . . This rootedness in the Germans' body of enduring art [Diese Verwurzelung im Bildbestand der Deutschen] made it seem inadvisable to the new authorities to place Barlach too directly in the foreground of their assault on modern art, for too many people would have refused to go along." Even if the assumption were correct that in the 1930s Barlach's work enjoyed exceptional popularity, for which, so far as I can see, no proof exists, it remains difficult to understand what specifically the author has in mind when he writes that in the Third Reich "too many people would have refused to go along" with the state's persecution of Barlach!

17. Käthe Kollwitz to Friedrich Schult, 20 November 1939, Ernst Barlach Stiftung, Güstrow, Archive, Nachlass Friedrich Schult, XXII C29.

18. Käthe Kollwitz, entry of ? April 1921, *Die Tagebücher*, p. 498.

Documents and Works Cited

Ernst Barlach Stiftung, Güstrow. Nachlass Friedrich Schult A7; A31; A758/619/5; A758/619/6; XVII C24; XXII C29; Korrespondenz Willy Katz.

Barlach, Ernst. *Die Briefe*, 1 and 2. Edited by Friedrich Dross. Munich-Zurich, 1968–1969.

Barlach, Ernst. Correspondence with Reinhard Piper. In *Ernst Barlach – Reinhard Piper. Briefwechsel, 1900–1938*, edited by Wolfgang Tarnowski. Munich-Zurich, 1997.

Barlach, Ernst. *Die Prosa*, 1 and 2. Edited by Friedrich Dross. Munich-Zurich, 1973–1976.

Barlach, Ernst. *Ein selbsterzähltes Leben*. Berlin, 1928.

"Bekenntnis zu Adolf Hitler! Ein Aufruf der Kulturschaffenden." *Völkischer Beobachter*, 18 August 1934.

Beloubek-Hammer, Anita. "Die 'entarteten' deutschen Bildhauer und ihr Erbe in der DDR." In *Deutsche Bildhauer 1900–1945 Entartet*, edited by Christian Tümpel. Zwolle, 1992.

Beloubek-Hammer, Anita. "Ernst Barlach und die Avantgarde." In *Ernst Barlach: Artist of the North*, edited by Jürgen Doppelstein, Volker Probst, and Heike Stockhaus. Hamburg-Güstrow, 1998.

Berliner Hochschulblatt (Beiblatt), 6, 14 July 1933.

Besnard-Bernadac, Marie-Laure, and Metken, Günter, eds. *Paris-Berlin, 1900–1933*. Paris, 1992.

Bollmus, Reinhard. *Das Amt Rosenberg und seine Gegner*. Stuttgart, 1970.

Bracher, Karl Dietrich. *Die deutsche Diktatur*. Cologne-Berlin, 1969.

Brenner, Hildegard. *Die Kunstpolitik des Nationalsozialismus*. Reinbek bei Hamburg, 1963.

Browning, Christopher. *The Path to Genocide*. New York, 1992.

Dahm, Volker. "Anfänge und Ideologie der Reichskulturkammer." *Vierteljahrshefte für Zeitgeschichte*, 34, no. 1 (1986).

"Ernst Barlach." *Völkischer Beobachter*, North-German edition, 9 March 1934.

"Der Fall Hoetger." *Das Schwarze Korps*, 26 June 1935.

Fechter, Paul. *Der Expressionismus*. Munich, 1914.

Fleckner, Uwe. "Carl Einstein und einige seiner Leser." In *Überbrückt*, edited by Eugen Blume and Dieter Scholz. Cologne, 1999.

Fröhlich, Elke. "Die kulturpolitische Pressekonferenz des Reichspropaganda Ministeriums." *Vierteljahrshefte für Zeitgeschichte*, 22, no. 4 (1974).

Fryksen, Arne. "Hitlers Reden zur Kultur. Kunstpolitische Taktik oder Ideologie?" *Probleme deutscher Zeitgeschichte, Lund Studies in International History*, 2. Lund, n.d.

Führer durch die Ausstellung Entartete Kunst. Berlin, n.d. Reprinted in the documentary section of *Die "Kunststadt" München 1937: Nationalsozialismus und "Entartete Kunst,"* rev. ed., edited by Peter-Klaus Schuster. Munich, 1998.

Germer, Stefan. "Kunst der Nation: Zu einem Versuch die Avantgarde zu nationalisieren." In *Kunst auf Befehl: Dreiundreissig bis Fünfundvierzig*, edited by Bazon Brock and Achim Preiss. Munich, 1990.

Goebbels, Joseph. *Goebbels-Reden*, 1, *1932–1939*. Edited by Helmut Heiber. Düsseldorf, 1971.

Goebbels, Joseph. *Die Tagebücher von Joseph Goebbels: Sämtliche Fragmente*, part 1, 1–3, edited by Elke Fröhlich. Munich, 1987.

Grosshans, Henry. *Hitler and the Artists*. New York-London, 1983.

Haftmann, Werner. *Verfemte Kunst*. Cologne, 1986.

Hagemann, Jürgen. *Presselenkung im Dritten Reich*. Bonn, 1970.

Hildebrandt, Friedrich. Speech of 16 February 1934. *Lübecker General-Anzeiger*, 18 February 1934.

Hildebrandt, Friedrich. Speech of 1 June 1935. *Niederdeutscher Beobachter*, 2 June 1935.

Hinderer, Walter. "Theory, Conception, and Interpretation of the Symbol." In *Perspectives in Literary Symbolism: Yearbook of Comparative Literature*, edited by J. Strelka, University Park-London, 1968.

Hitler, Adolf. *Die Reden des Führers nach der Machtübernahme*. With an introduction by Philipp Bouhler. Berlin, 1939.

Hitler, Adolf. "Rede bei der Grundsteinlegung zum Hause der Deutschen Kunst." *Völkischer Beobachter*, North-German edition, 17 October 1933.

Hitler, Adolf. "Rede zur Eröffnung der 'Grossen Deutschen Kunstausstellung' 1937." Reprinted in *Die "Kunststadt" München 1937: Nationalsozialismus und "Entartete Kunst,"* rev. ed., edited by Peter-Klaus Schuster. Munich, 1998.

Hitler, Adolf. "Rede bei Eröffnung der zweiten Grossen Deutschen Kunstausstellung." Reprinted in Berthold Hinz, *Die Malerei im deutschen Faschismus*. Munich, 1984.

Hitler, Adolf. *Die Reden Hitlers am Reichsparteitag 1933.* Munich, 1934.

Hitler, Adolf. "Rede auf der Kulturtagung," *Der Kongress zu Nürnberg 1934.* Munich, 1934.

Hitler, Adolf. "Rede auf der Kulturtagung." *Der Reichsparteitag 1934.* Munich, 1934.

Hitler, Adolf. "Rede auf der Kulturtagung des Reichsparteitages 1935." *Die Reden Hitlers am Parteitag der Freiheit.* Munich, 1935.

Hitler, Adolf. "Die Kulturrede des Führers." *Der Parteitag der Freiheit.* Munich, 1935.

Hitler, Adolf. "Rede auf der Kulturtagung des Reichsparteitages 1936." *Der Parteitag der Ehre.* Munich, 1936.

Hitler, Adolf. "Rede auf der Kulturtagung des Reichsparteitages 1937." *Der Parteitag der Arbeit 1937.* Munich, 1938.

Hitler Adolf. *Sämtliche Aufzeichnungen, 1905–1924.* Edited by Eberhard Jaeckel and Alex Kuhn. Stuttgart, 1980.

Hoffmann, Heinrich. *Hitler wie ich ihn sah.* Munich-Berlin, 1974.

Hofmann, Werner. *Wie deutsch ist die deutsche Kunst.* Leipzig, 1999.

Hüneke, Andreas. "Der Versuch der Ehrenrettung des Expressionismus als 'deutsche Kunst' 1933." In *Zwischen Anpassung und Widerstand, Kunst in Deutschland, 1933–1945.* Berlin (east), 1978.

Hüttenberger, Peter. *Die Gauleiter.* Stuttgart, 1969.

Jaeckel, Eberhard. *Hitlers Weltanschauung. Entwurf einer Herrschaft.* Stuttgart, 1991.

Jansen, Elmar. "Barlach: Einspruche und Widersprüche." In *Ernst Barlach: Werke Meinungen,* edited by Elmar Jansen. Vienna, 1984.

Jansen, Elmar. *Ernst Barlach: Werk und Wirkung.* Frankfurt a. M., 1972.

Jansen, Elmar. *Ernst Barlach – Käthe Kollwitz.* Berlin, 1989.

Kershaw, Ian. *Hitler, 1889–1936: Hubris.* New York, 2000.

Kollwitz, Käthe. *Die Tagebücher,* edited by Jutta Bohnke-Kollwitz. Berlin, 1989.

Kotze, Hildegard von, and Krausnick, Helmut, eds. *"Es spricht der Führer."* Gütersloh, 1966.

Krebs, Albert. *Tendenzen und Gestalten der NSDAP: Erinnerungen an die Frühzeit der Partei.* Stuttgart, 1959.

Lüttichau, Mario-Andreas von. " 'Deutsche Kunst' und 'Entartete Kunst.' " In *Die "Kunststadt" München 1937: Nationalsozialismus und "Entartete Kunst,"* rev. ed., edited by Peter-Klaus Schuster. Munich, 1998.

Mathieu, Thomas. *Kunstauffassungen und Kulturpolitik im Nationalsozialismus.* Saarbrücken, 1997.

Meldungen aus dem Reich, 1938–1945, 2. Edited by Heinz Boberach. Herrsching, 1984.

Nemitz, Fritz. "Der Zeichner Barlach und die Zeit." *Berliner Tageblatt,* 10 March 1936.

Paret, Peter. *The Berlin Secession.* Cambridge, Mass., 1980.

Paret, Peter. *German Encounters with Modernism, 1840–1945.* New York-Cambridge, 2001.

Paret, Peter. "Three Perspectives on Art as a Force in German History." *Central European History*, 34, no. 1 (2001).

Peters, Olaf. *Neue Sachlichkeit und Nationalsozialismus*. Berlin, 1998.

Petropoulos, Jonathan. *Art as Politics in the Third Reich*. Chapel Hill, 1996.

Petropoulos, Jonathan. *The Faustian Bargain*. New York, 2000.

Picker, Henry, ed. *Hitlers Tischgespräche im Führerhauptquartier*. Frankfurt a. M.-Berlin, 1993.

Piper, Ernst. *Nationalsozialistische Kunstpolitik*. Munich, 1987.

Probst, Volker, ed. *Ernst Barlach. Das Güstrower Ehrenmal*. Güstrow, 1998.

Rave, Paul Ortwin. *Kunstdiktatur im Dritten Reich*. Hamburg, 1949.

Reuth, Ralf Georg. *Goebbels*. Munich-Zurich, 1990.

Rosenberg, Alfred. *Blut und Ehre*. Edited by Thilo von Throtha. Munich, 1934.

Rosenberg, Alfred. *Letzte Aufzeichnungen*. Göttingen, 1955.

Rosenberg, Alfred. *Der Mythus des 20. Jahrhunderts*. Munich, 1934.

Rosenberg, Alfred. "Revolution in der bildenden Kunst?" *Völkischer Beobachter*, 6 July 1933.

Rosenberg, Alfred. "Revolutionäre an sich!" *Völkischer Beobachter*, 14 July 1933.

Rosenberg, Alfred. "Warnende Zeichen." *Völkischer Beobachter*, North-German edition, 11/12 March 1934.

Scheffler, Karl. *Die fetten und die mageren Jahre*. Munich-Leipzig, 1948.

Schlemmer, Oskar. *Briefe und Tagebücher*. Edited by Tut Schlemmer. Munich, 1958.

Schmidt, Diether, ed. *In letzter Stunde, 1933–1945*. Dresden, 1964.

Scholz, Dieter. "Otto Andreas Schreiber, die *Kunst der Nation* und die Fabrikausstellungen." In *Überbrückt*, edited by Eugen Blume and Dieter Scholz. Cologne, 1999.

Scholz, Robert. "Für und gegen den Futurismus." *Völkischer Beobachter*, North-German edition, 28 March 1934.

Scholz, Robert. "Futuristische Flugmalerei." *Völkischer Beobachter*, North-German edition, 4 April 1934.

Scholz, Robert. "Hausse in Verfallskunst." *Völkischer Beobachter*, North-German edition, 16 March 1934.

Schult, Friedrich. *Barlach im Gespräch*. Edited by Elmar Jansen. Leipzig, 1985.

Schurek, Paul. *Barlach*. Munich, 1961.

Schurek, Paul. *Begegnungen mit Barlach*. Gütersloh, 1954.

Schuster, Peter-Klaus, ed. *Die "Kunststadt" München 1937: Nationalsozialismus und "Entartete Kunst."* Rev. ed. Munich, 1998.

Selz, Peter. *German Expressionist Painting*. Berkeley-Los Angeles, 1974.

Speer, Albert. *Erinnerungen*. Frankfurt a. M., 1969.

Steinweis, Alan E. *Art, Ideology, and Economics in Nazi Germany: The Reich Chambers of Music, Theater, and the Visual Arts*. Chapel Hill, 1993.

Stockhaus, Heike. "Das Nordische, das Germanische, das Gotische: Ernst Barlach und der Geist seiner Zeit." In *Ernst Barlach: Artist of the North*,

edited by Jürgen Doppelstein, Volker Probst, and Heike Stockhaus. Hamburg-Güstrow, 1998.

Tarnowski, Wolfgang. *Ernst Barlach und der Nationalsozialismus.* Hamburg, 1989

Tarnowski, Wolfgang. "Ein unbekannter Brief Barlachs aus dem Jahre 1934." In *Ernst Barlach Gesellschaft: Mitteilungen.* 1988.

Thamer, Hans-Ulrich. *Verführung und Gewalt: Deutschland, 1933–1945.* Berlin, 1986.

Thomae, Otto. *Die Propaganda-Maschinerie: Bildende Kunst und Öffentlichkeitsarbeit im dritten Reich.* Berlin, 1978.

Tümpel, Christian, ed. *Deutsche Bildhauer 1900–1945 Entartet.* Zwolle, 1992.

"War Barlach+ Kulturbolschewist?" *Das Schwarze Korps,* 3 November 1938.

Werckmeister, O. K. "Hitler the Artist." In *Critical Inquiry,* 23 (Winter 1997).

Index

The names Barlach and Hitler, which appear very frequently throughout the text, are listed selectively, in connection with particular subjects.

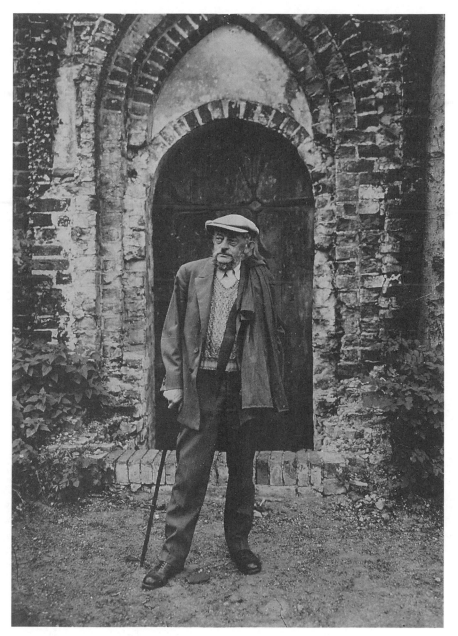

1. Ernst Barlach before the Chapel of St. Gertrude in Güstrow, 1934.

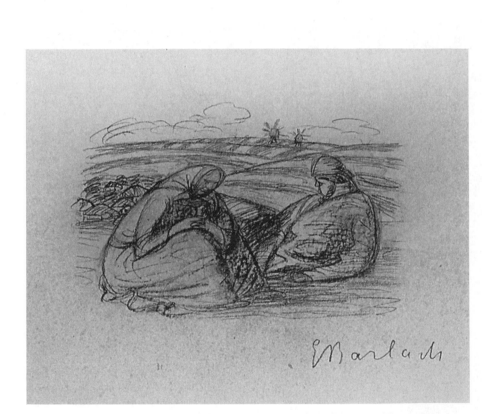

2. Ernst Barlach: *A Russian Couple*, 1906. Pencil and crayon, H. 200 mm, W. 248 mm. Private collection.

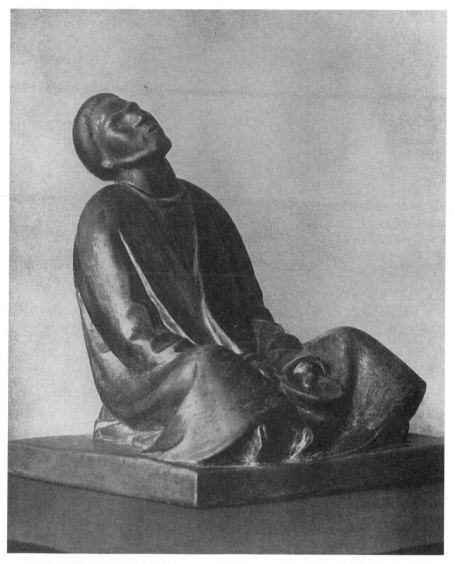

3. Ernst Barlach: *Blind Beggar*, 1906. Ceramic, H. 254 mm, W. 235 mm, D. 228 mm. Private collection.

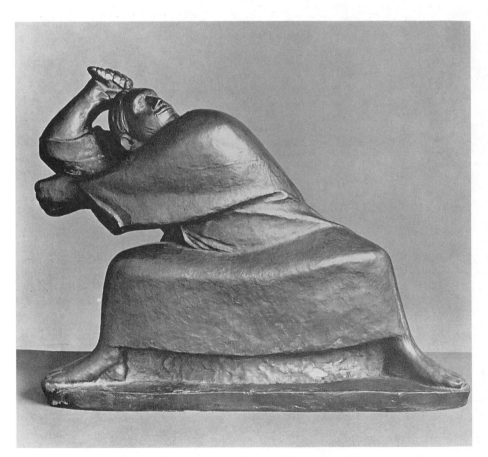

4. Ernst Barlach: *The Berserker*, 1910. Bronze, H. 547 mm, W. 700 mm. Ernst Barlach Haus, Hamburg.

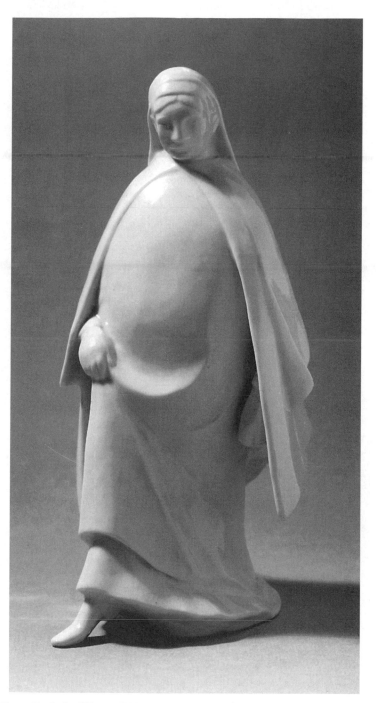

5. Ernst Barlach: *Woman Walking*, 1910. Porcelain, H. 250 mm, W. 125 mm, D. 137 mm. Ernst Barlach Haus, Hamburg.

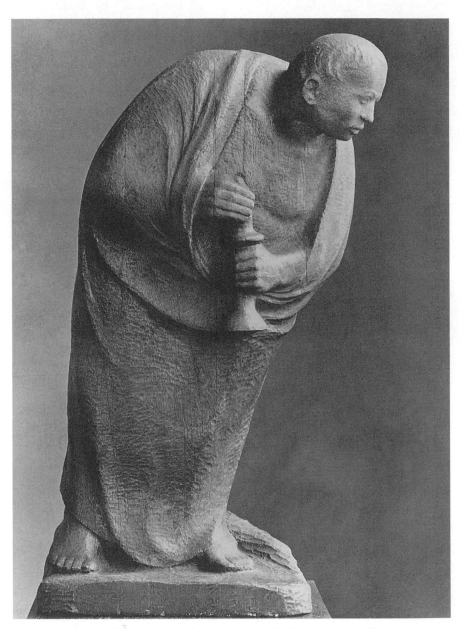

6. Ernst Barlach: *The Lonely Man*, 1911. Oak, H. 870 mm, W. 400 mm, D. 320 mm. Hamburger Kunsthalle.

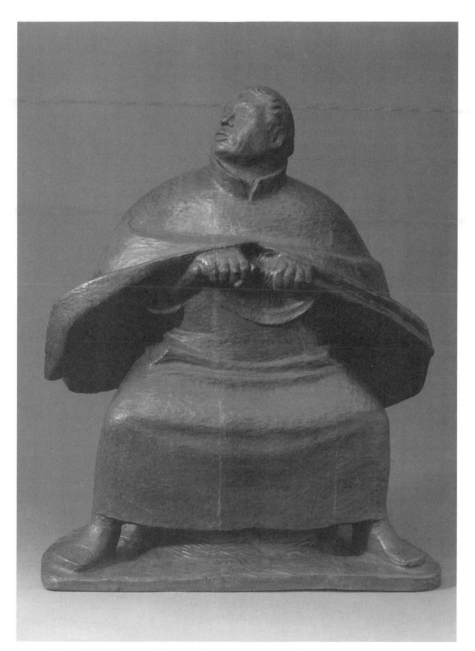

7. Ernst Barlach: *Man Drawing Sword*, 1911. Wood, H. 750 mm, W. 610 mm, D. 280 mm. Ernst Barlach Haus, Hamburg.

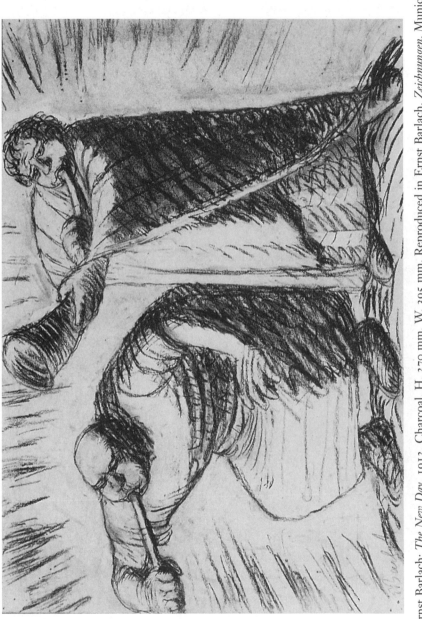
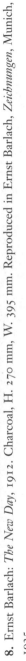

8. Ernst Barlach: *The New Day*, 1912. Charcoal, H. 270 mm, W. 395 mm. Reproduced in Ernst Barlach, *Zeichnungen*, Munich, 1935.

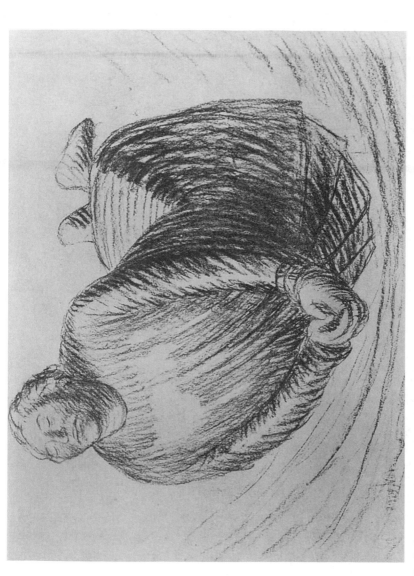

9. Ernst Barlach: *Man Floating*, 1912. Charcoal, H. 290 mm, W. 395 mm. Reproduced in Ernst Barlach, *Zeichnungen*, Munich, 1935.

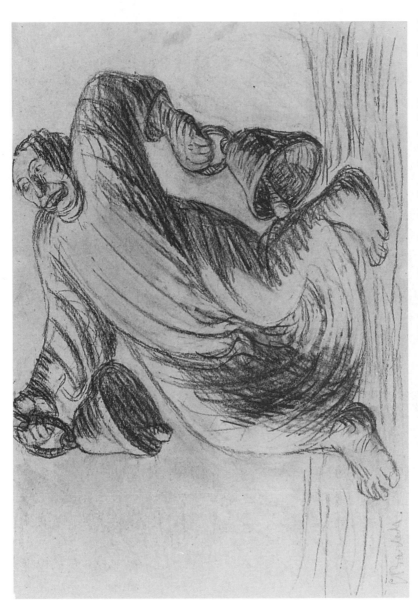

10. Ernst Barlach: *Bellringer*, 1912. Charcoal, H. 272 mm, W. 395 mm. Reproduced in Ernst Barlach, *Zeichnungen*, Munich, 1935.

11. Ernst Barlach: *The Avenger*, 1914. Glazed stucco, H. 460 mm, W. 605 mm, D. 240 mm. Ernst Barlach Stiftung, Güstrow.

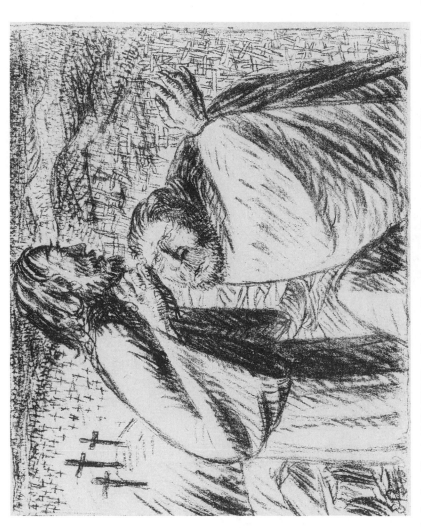

12. Ernst Barlach: *Anno Domini MCMXVI Post Christum Natum*, 1916. Lithograph from *Der Bildermann*, H. 186 mm, W. 227 mm. Private collection. The devil shows Jesus a world full of graves.

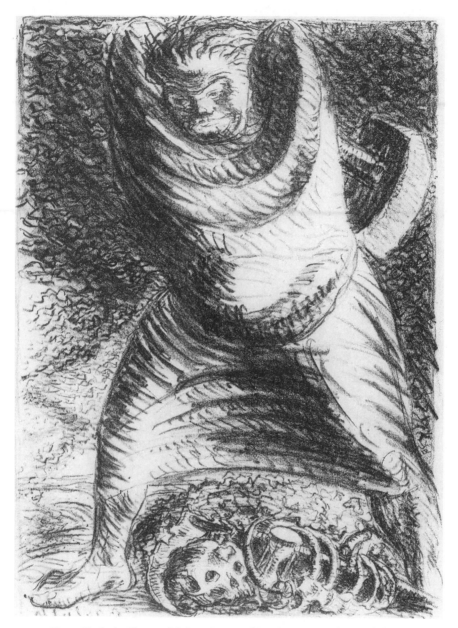

13. Ernst Barlach: *From a Modern Dance of Death*, 1916. Lithograph from *Der Bildermann*, H. 296 mm, W. 206 mm. Private collection.

14. Ernst Barlach: Detail from carved paneling of a fireplace, 1916. Wood, H. 2,200 mm, W. 1,300 mm. D. approx. 180 mm. Destroyed in the Second World War.

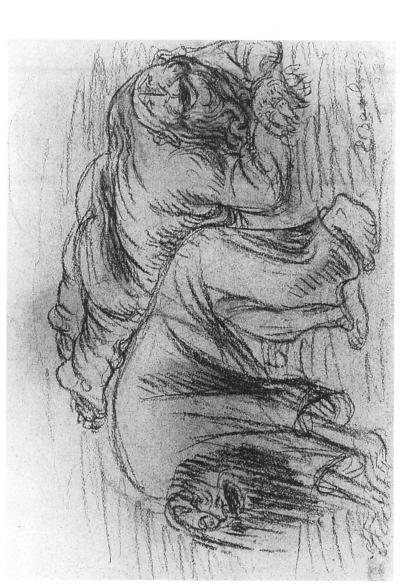

15. Ernst Barlach: *Animal People*, 1920. Charcoal and pencil, H. 252 mm, W. 349 mm. Reproduced in Ernst Barlach, *Zeichnungen*, Munich, 1935.

16. Ernst Barlach: *Mater Dolorosa*, The Kiel Memorial, 1921. Oak, H. 2,380[?] mm, W. 2,210[?] mm. Destroyed in the Second World War.

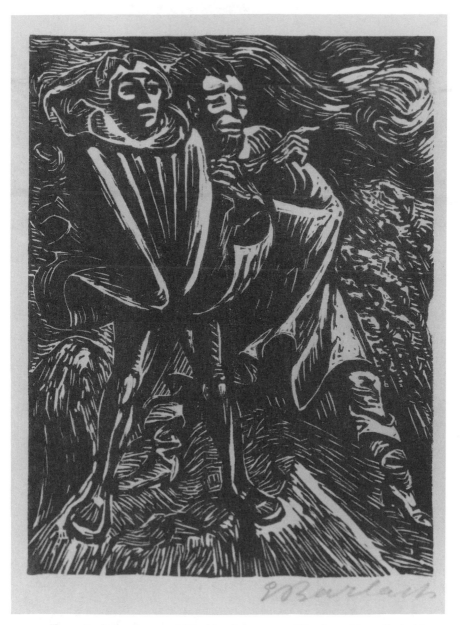

17. Ernst Barlach: *Faust and Mephistopheles*, 1922. Woodcut. From Barlach's illustrations to Goethe's *Walpurgisnacht*, 1923. H. 188 mm, W. 141 mm. Private collection. The woodcut was a model for the later charcoal drawing, reproduced in Ernst Barlach, *Zeichnungen*, Munich, 1935.

18. Ernst Barlach: *The Waiting Man*, 1922. Charcoal, H. 348 mm, W. 248 mm. Reproduced in Ernst Barlach, *Zeichnungen*, Munich 1935.

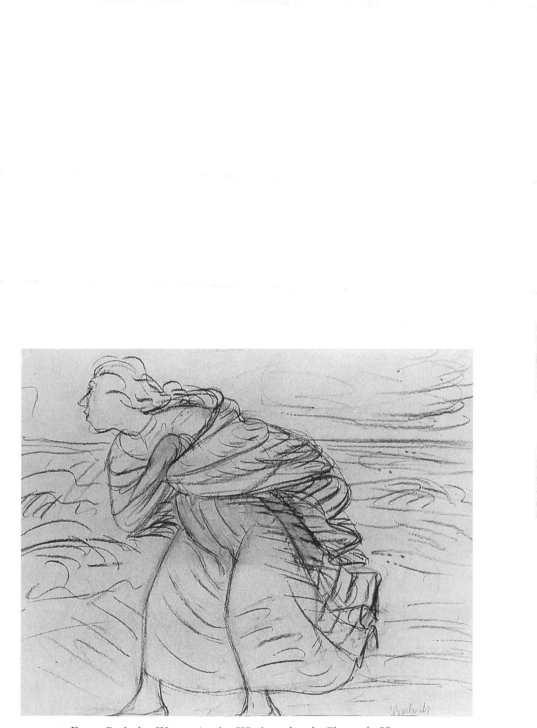

19. Ernst Barlach: *Woman in the Wind*, undated. Charcoal, H. 420 mm, W. 515 mm. Private collection.

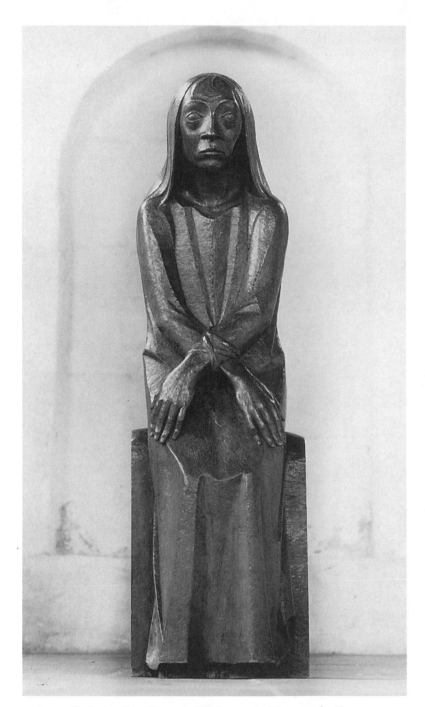

20. Ernst Barlach: *The Fettered Witch*, 1926. Limewood, H. 1,120 mm, W. 320 mm, D. 260 mm. Ernst Barlach Stiftung, Güstrow.

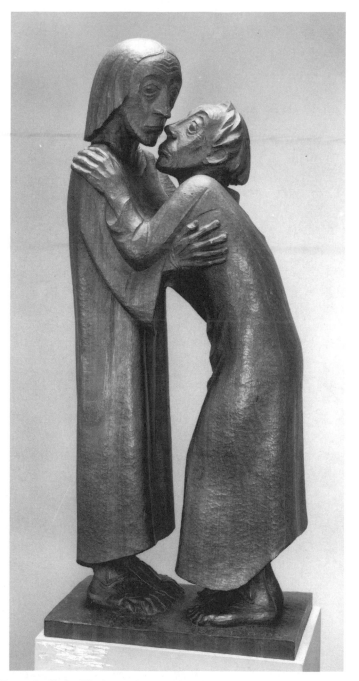

21. Ernst Barlach: *The Reunion*, 1926. Walnut, H. 1,030 mm, W. 400 mm, D. 260 mm. Ernst Barlach Haus, Hamburg.

22. Ernst Barlach: *The Güstrow Memorial*, 1927. Bronze, H. 710 mm, W. 745 mm, D. 2,170 mm.

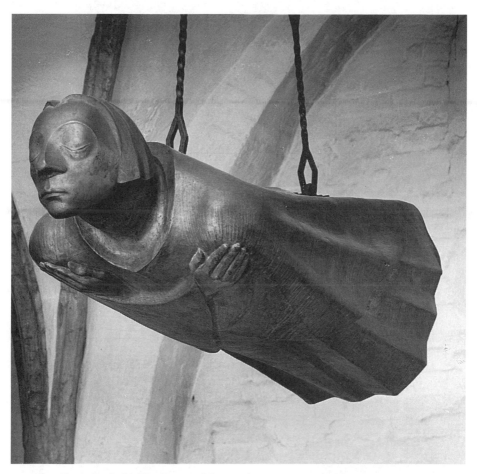

23. Ernst Barlach: *The Güstrow Memorial.*

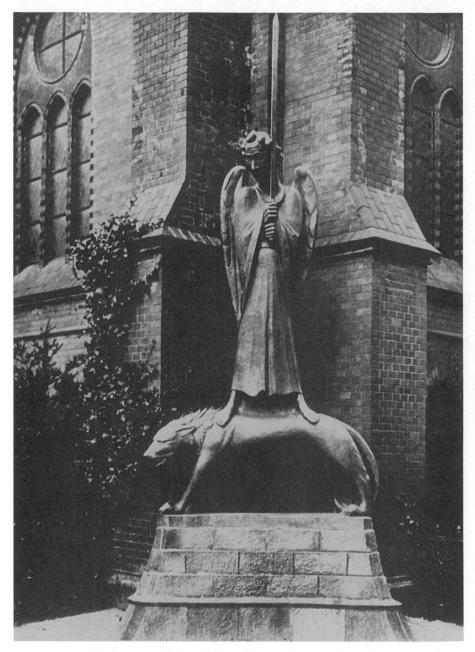

24. Ernst Barlach: *The Fighter of the Spirit*, 1928. Bronze, H. 4,800 mm. The figure in its original location, before the University Church, Kiel, which was destroyed in the Second World War.

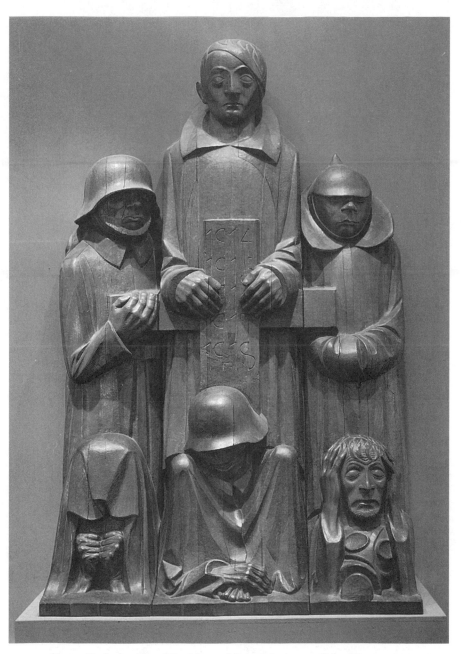

25. Ernst Barlach: *The Magdeburg Memorial*, 1929. Oak, H. 2,550 mm, W. 1,540 mm, D. 750 mm.

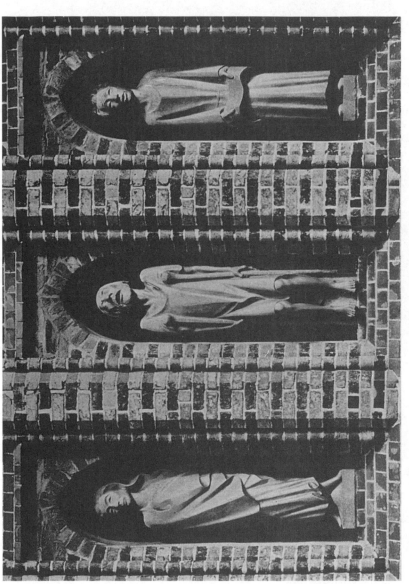

26. Ernst Barlach: Three figures from *The Community of Holy Ones* in the facade of St. Catherine's Church, Lübeck, 1930–1932. Glazed brick. Center figure (*Beggar*): H. 2,070 mm, W. 550 mm, D. 430 mm.

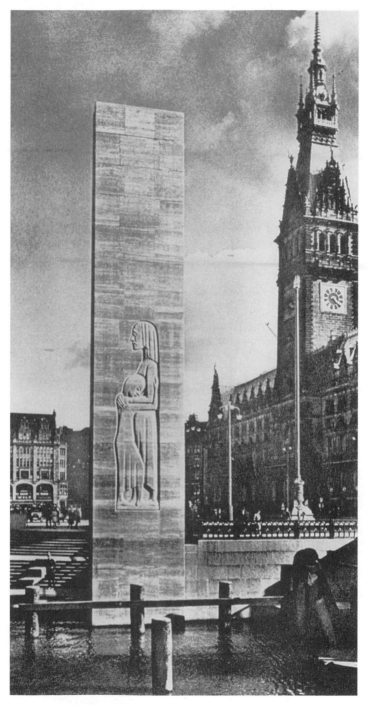

27. Ernst Barlach: *The Hamburg Memorial*, 1931. Limestone. The relief:
H. 7,560 mm, W. 1,900 mm, D. 90 mm.

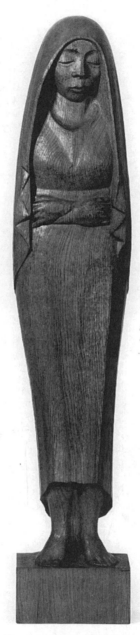

28. Ernst Barlach: *The Dreamer* from *The Frieze of Listeners*, 1931. Oak, H. 1,095 mm, W. 220 mm, D. 120 mm. Ernst Barlach Haus, Hamburg.

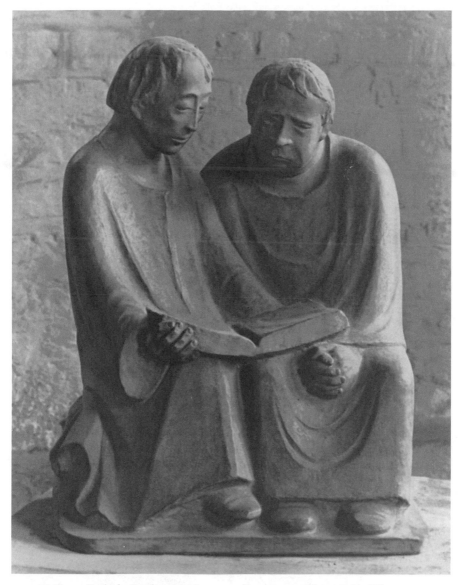

29. Ernst Barlach: *Reading Monks*, 1932. Cast stucco, H. 590 mm, W. 450 mm, D. 350 mm. Ernst Barlach Stiftung Güstrow.

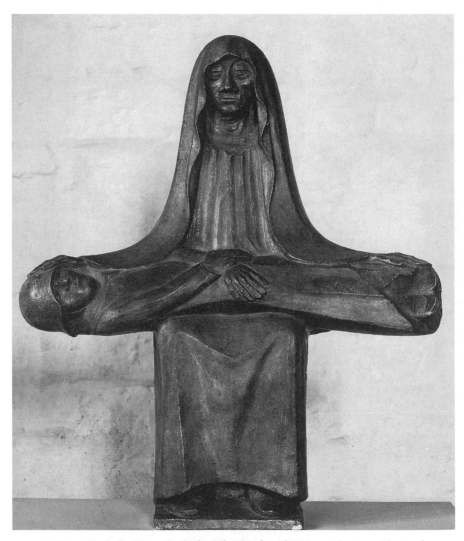

30. Ernst Barlach: *Pieta*. Study for The Stralsund Memorial, 1932. Clay under shellac, H. 645 mm, W. 542 mm, D. 220 mm. Ernst Barlach Stiftung, Güstrow.

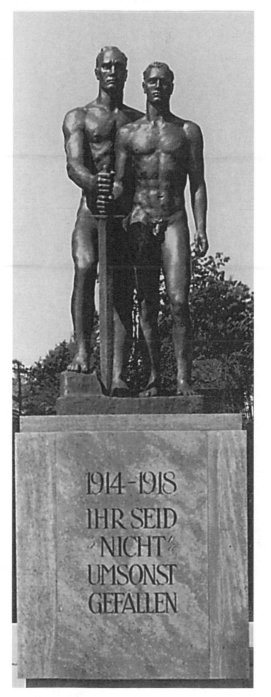

31. Georg Kolbe: *You Have Not Died in Vain*. The Stralsund Memorial, 1935.

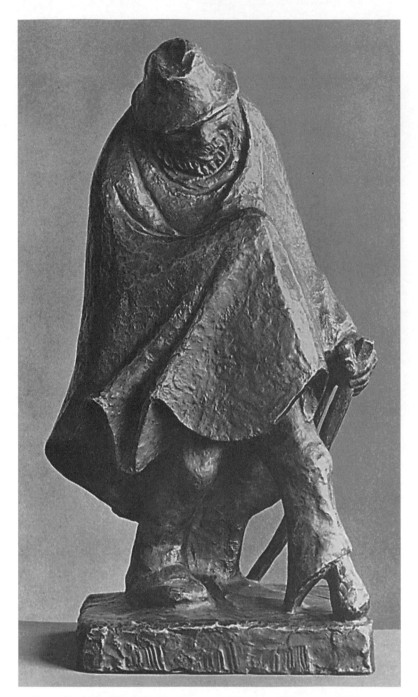

32. Ernst Barlach: *The Jolly Peg-Leg*, 1934. Bronze, H. 540 mm, W. 305 mm, D. 212 mm. The Art Museum, Princeton University.

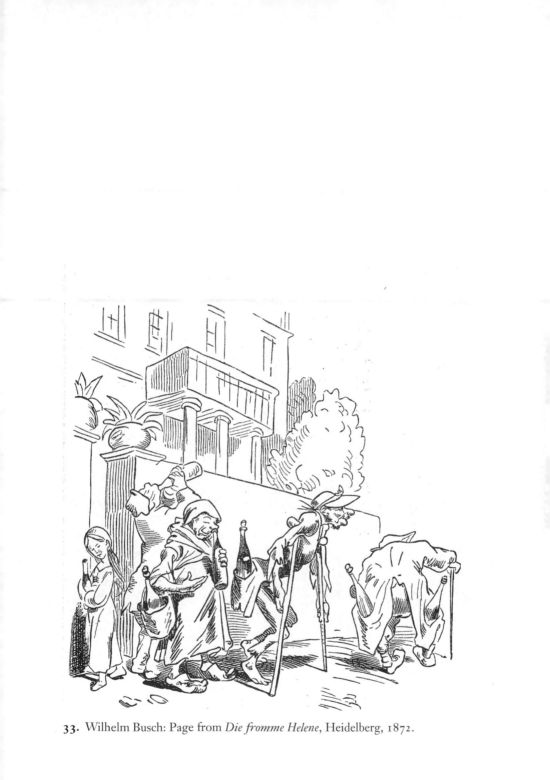

33. Wilhelm Busch: Page from *Die fromme Helene*, Heidelberg, 1872.

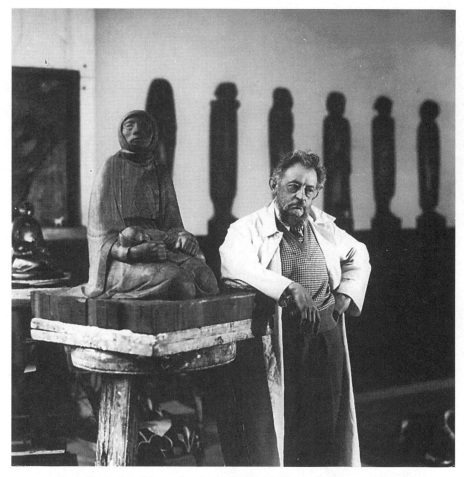

34. Ernst Barlach in his studio, 1935. Behind him are the figures of *The Frieze of Listeners*.

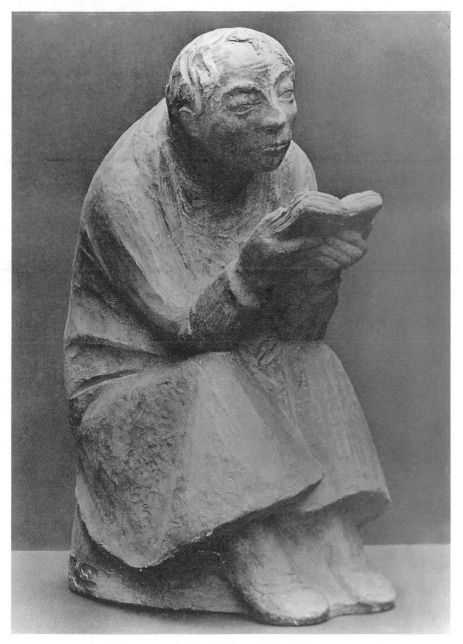

35. Ernst Barlach: *Man Reading in the Wind*, 1936. Stucco under shellac, H. 470 mm, W. 220 mm, D. 310 mm. Ernst und Hans Barlach GbR Lizenzverwaltung Ratzeburg.

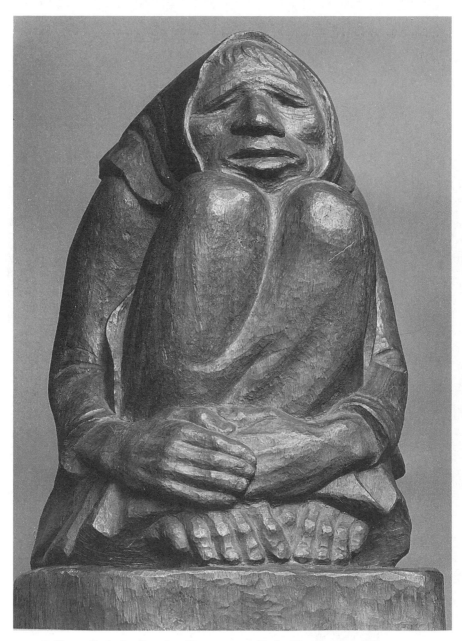

36. Ernst Barlach: *Freezing Crone*, 1937. Teak, H. 550 mm, W. 340 mm, D. 390 mm. Ernst Barlach Stiftung Güstrow.

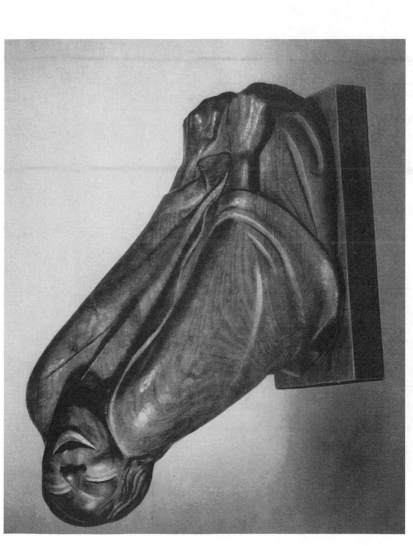

37. Ernst Barlach: *Laughing Crone*, 1937. Walnut. H. 480 mm, W. 630 mm, D. 225 mm. Ernst Barlach Stiftung, Güstrow.

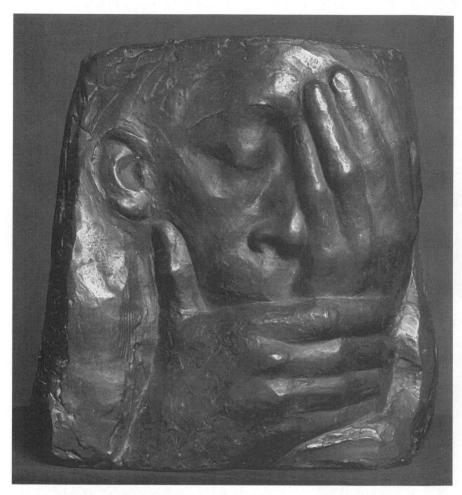

38. Käthe Kollwitz: *Lament*, 1938. Bronze, H. 285 mm, W. 257 mm, D. 99 mm. Collection Harold and Vivian Shapiro.